DADA & SURREALISM

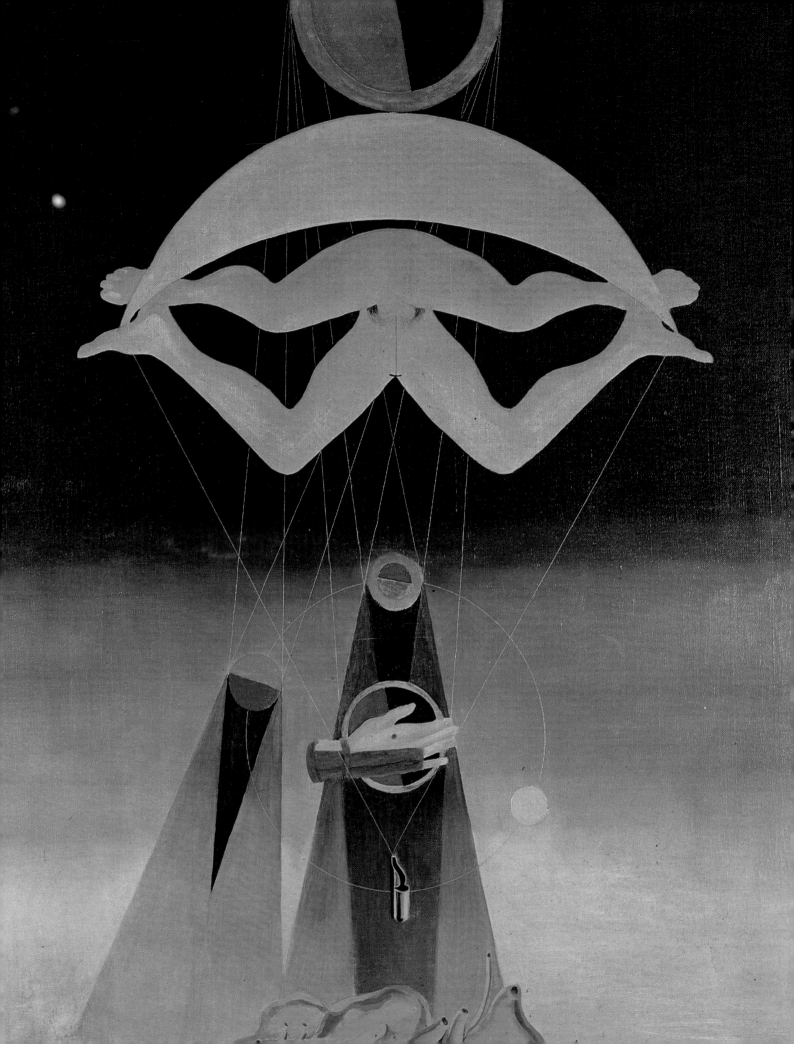

DADA & SURREALISM

Robert Short

LAURENCE KING

To Lucien and Octavia

First published in paperback 1994 by Laurence King Publishing

ISBN 1 85669 056 3

Printed in Hong Kong

Front cover: Salvador Dali, *The night and day of the body*, (detail, *see* p. 145).
Back cover: René Magritte, *Act of violence*, (see p. 135).

For a complete catalogue, please write to:

Laurence King Publishing
71 Great Russell Street
London WC1B 3BN

1. (*Frontispiece*) Max Ernst, *Of this men shall know nothing*, 1923.
Oil on canvas, 31½ × 25 in (80 × 63.5 cm). London, Tate Gallery.

Contents

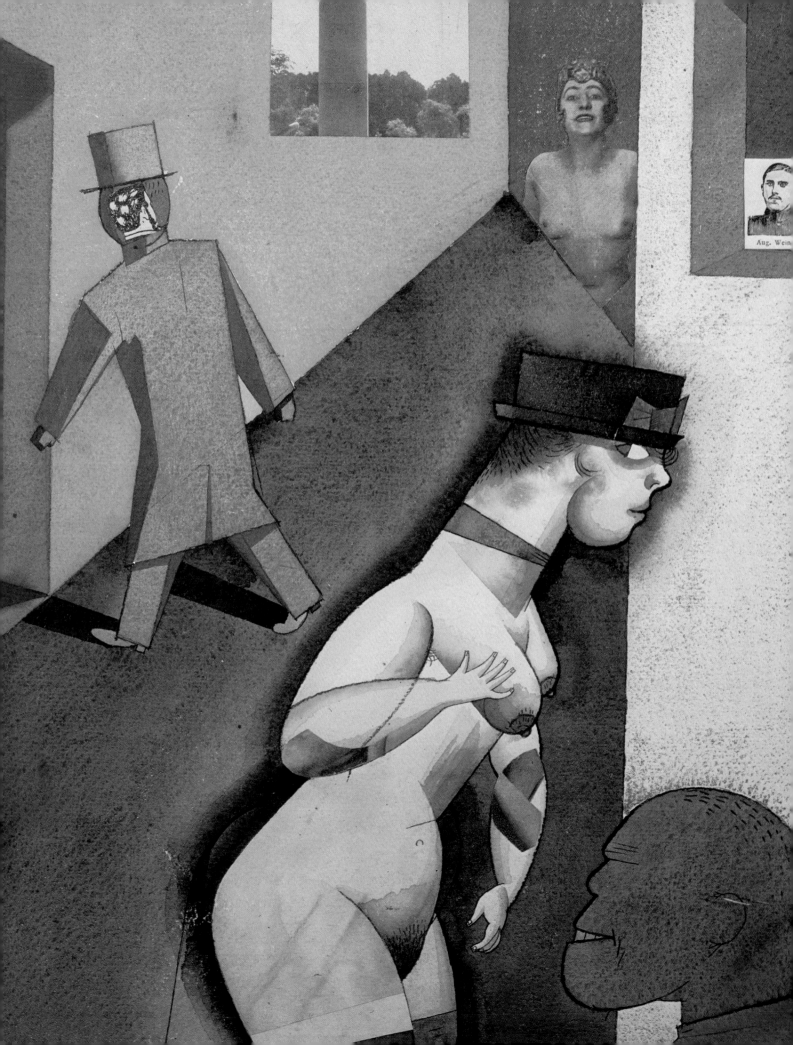

Aug. Wein

1
Dada lives!

Dada's name was its fortune. The pair of sharply repeated, percussive syllables formed 'the magic word', as Raoul Hausmann recalled, a catalyst which helped poets, artists and disaffected intellectuals in a dozen countries during the Great War to focus their hatred and ideals into a programme of cultural action. Like Coca Cola, which had been invented thirty years before, the word Dada became an instantly recognizable brand image transcending national boundaries. No wonder that after its early demise, Dada's 'grey beards' went on quarrelling about the paternity of the word until finally silenced by their recent deaths.

Then, as now, everybody thought they knew what Dada meant. Dada's brilliant impresarios, Tristan Tzara, Francis Picabia and Richard Huelsenbeck, only had to spell out in their provocative manifestos what was already implicit in the name. A manifesto in itself, it is a word which has stuck. According to the stereotype, it stands for a movement of radical, cultural revolt: the disgusted response of artists to the débâcle of Western civilization and its values in the First World War. Dada represents a revolt against art by artists themselves who, appalled by developments in contemporary society, recognized that art was bound to be a product, reflection and even support of that society and was therefore criminally implicated. Dada stands for exacerbated individualism, universal doubt and aggressive iconoclasm. Debunking the canons of reason, taste and hierarchy, of order and discipline in society, of rationally controlled inspiration in imaginative expression, Dada resorted to the arbitrary, to chance, the unconscious and the primitive, where man is at the behest of nature and gives up pretending to be its master. Dada delighted in the shock effect of its blasphemies among the right-thinking.

The Dadas themselves energetically promoted such an idea of their action and it is this image which has passed into history. At the same time as they insisted that Dada was indefinable, they stressed its simplicity for the sake of maximum impact. And we too seem to require the presence of a totally nihilistic movement to complete the cast-list of 'isms' that played out the drama of modernism in the first half of the twentieth century. Nevertheless, for all its attractive clarity, this stereotype is incomplete and misleading. It is erroneous not merely because it oversimplifies the extraordinary diversity of Dada and ignores contradictory currents in the movement, but more seriously, because it

2. George Grosz, *Life model,* c. 1919. Watercolour, ink and collage on paper, 16 × 11½ in (40 × 29 cm). Fischer Fine Art Ltd.

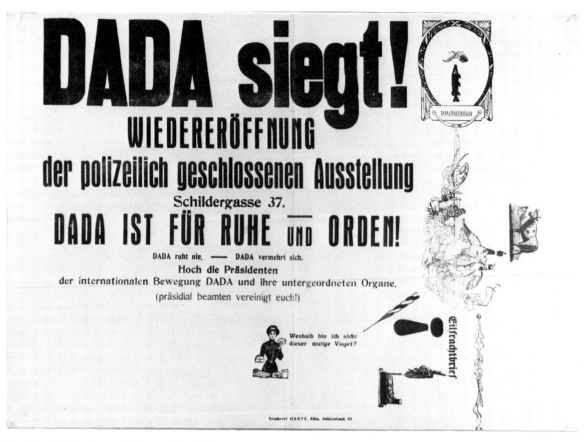

3. (*Above*) Max Ernst, *Dada siegt!* (Dada lives) poster for the Brauhaus Winter Exhibition in Cologne, 1920.

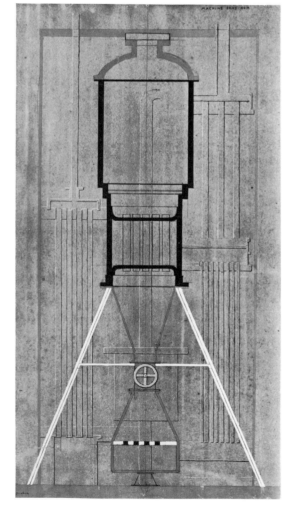

4. (*Right*) Francis Picabia, *Machine without a name*, 1915. Gouache and metallic paint on board, 47½ × 26 in (120.5 × 66 cm). Pittsburgh, Museum of Art, Carnegie Institute.

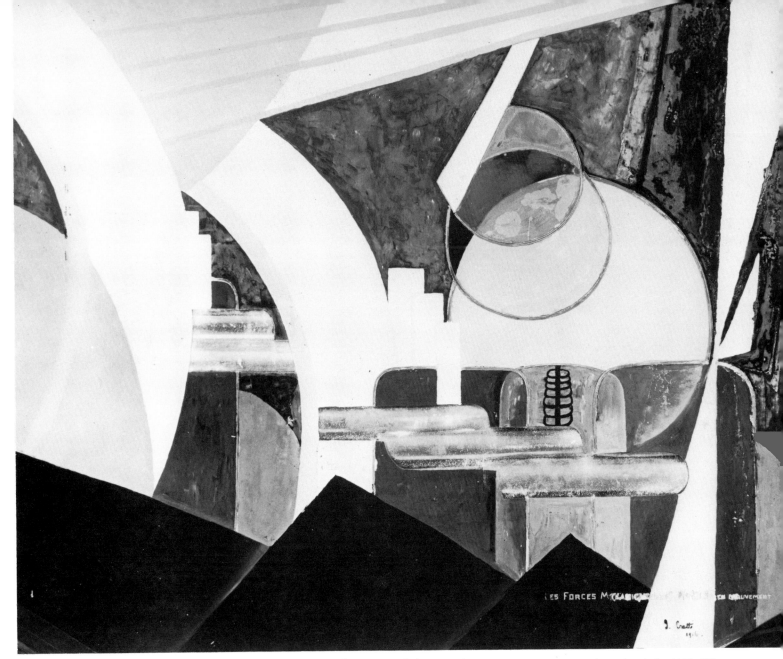

LES FORCES M... ...UVEMENT

J. Crotti
1916

obscures the fundamental and fruitful paradoxes that were inherent in a programme devised by gifted artists to do away with art.

Faced with the Dada phenomenon, a reviewer in the *Times Literary Supplement* showed understandable perplexity when he asked: 'How is one to define, let alone confine, a movement which cannot be identified with any one personality or place, viewpoint or subject, which affects all the arts, which has a continually shifting focus and is moreover intentionally negative, ephemeral, illogical and inconclusive?'[1] The term Dada refers at once to an avant-garde movement, a cluster of existential attitudes and, as is evident from Dada writings, to a conception of the life force itself at work in the world. Between 1915 and 1923, there was Dada activity in New York, Zurich, Barcelona, Berlin, Cologne, Hanover and Paris. Other countries to receive Dada visitations were Holland, Belgium, Italy, Spain, Yugoslavia, Czechoslovakia, Rumania, Poland and Russia. Each incarnation of Dada was unique. It could never appear exactly the same twice because it made itself an accusingly distorted reflection of the milieu in which it happened to find itself. In New York, Dada did not yet know its name. Zurich baptized it

5. Jean Crotti, *Mechanical twilight,* 1920. Oil on canvas, 37½ × 25½ in (95 × 65 cm). Milan, Collection Guido Rossi.

9

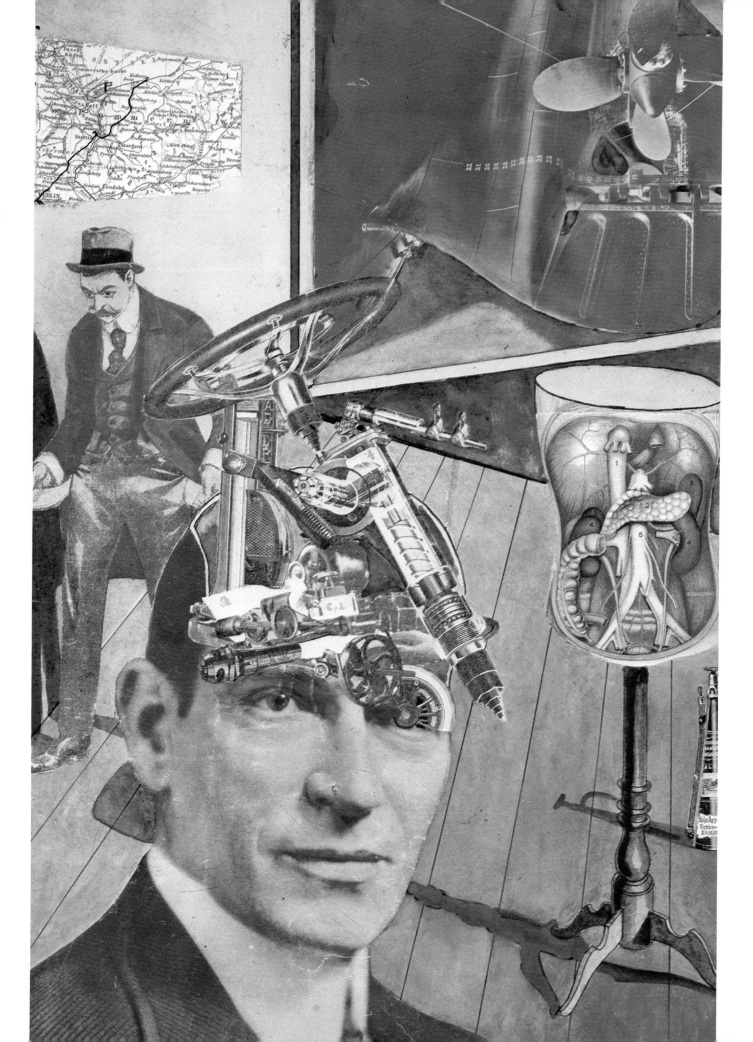

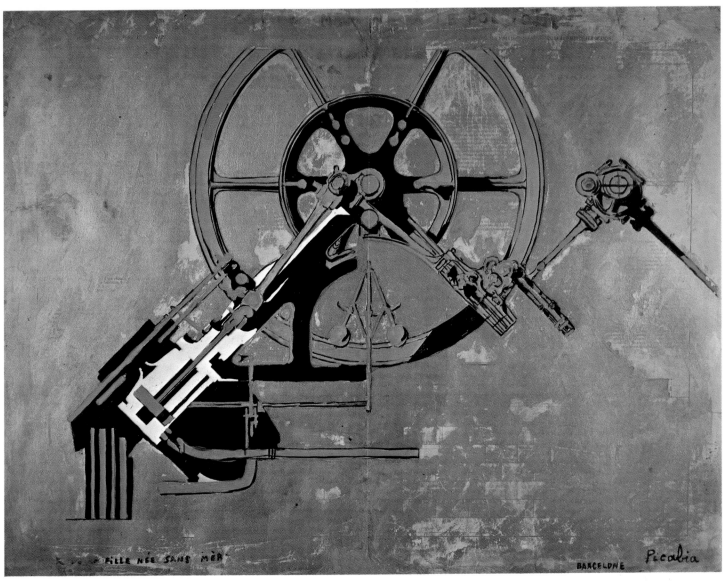

7. (*Above*) Francis Picabia, *That's the girl born without a mother*, 1916–17. Watercolour and oil on board, 25½ × 19¾ in (76 × 51 cm). Private Collection.

8. (*Left*) Man Ray, *The rope dancer accompanies herself with her shadows*, 1916. Oil on canvas, 51½ × 72½ in (132 × 186.5 cm). New York, Museum of Modern Art (Gift of G. David Thompson).

6. (*Opposite*) Raoul Hausmann, *Tatlin at home*, 1920. Collage on paper and gouache, 16 × 11 in (41 × 28 cm). Stockholm, Moderna Museet. Tatlin was a leading Russian artist of the 'Productivist' school. Although the title might suggest that this collage was intended as a gesture of solidarity with him, Hausmann has since explained that it came about more accidentally. Hausmann was primarily 'interested in showing the image of a man who had only machines in his head'. He came across a photograph of a man in an American magazine, who, for no special reason, 'automatically' reminded him of Tatlin.

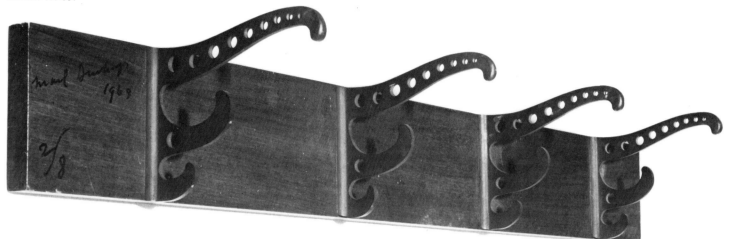

9. Marcel Duchamp, *Trap (Trébuchet)*, 1917. Ready-made: coat rack (wood and metal), 7½ × 4½ × 39½ in (19 × 11.7 × 100 cm). New York, Xavier Foucade Inc.
Not all the objects which Duchamp subsequently called 'ready-mades' were acquired with that in mind. The coat-rack was bought to hang coats on but Duchamp never got around to fixing it to the wall. Impatient at seeing it lying about on the floor, he nailed it down and so it joined the 'ready-mades'. '*Trébuchet*' is a chess term which refers to a pawn which 'trips' an opponent's piece.

but no one could subsequently agree who had invented or discovered its name. In turn, the offspring of Zurich Dada bore little family resemblance. In Berlin, Dada found its identity in its rivalry with Expressionism; but lost it again when the tension went out of the fertile internal conflict between art-action and revolutionary action. It owed its long and peaceful life-span in Hanover to the fact that it was the creation of one man, Kurt Schwitters, and he called it MERZ. The balance between Dada's twin functions of cultural desecration and affirmation of life was constantly shifting in each Dada capital, and within the heart of most Dada individuals as well. Tristan Tzara was right in saying that there were as many Dada attitudes as Dada had presidents, that is 391. The true Dadas, Tzara later wrote, were against Dada. No sooner had the potent slogan been absorbed than the Dadas set about sabotaging by mischievous self-contradiction any attempt to codify their project or elaborate a coherent programme. As a final gesture of defiance, leading Dadas have subsequently baffled the efforts of critics and historians to pin down their movement by publishing mystifying and mutually incompatible accounts of their past exploits and of the significance to be attributed to them.

A tentative understanding of Dada's real identity must be sought somewhere between the misleading simplicity of the label and the diversity of Dada's manifestations. A starting point may lie in the title of George Grosz's autobiography, *A Little Yes and a Big No*. Dada's 'Big No' was to the whole Western humanist tradition as it had developed since the Renaissance. Dada's negative in turn drew its inspiration from half a century of critical undermining of 'bourgeois credos' by such varied figures as Nietzsche, Bakunin, and Bergson, by Einstein and Heisenberg in physics, by Freud in psychology and Saussure in linguistics. The Dadas ridiculed Western confidence in the autonomy of the rational ego and the efficacy of reason. They denounced the post-Renaissance anthropocentric conception of reality which assumed that the world was organized according to humanly intelligible laws. They condemned bourgeois culture's deadening determination to stabilize and categorize all phenomena. For the Dadas, nature was a state of constant flux. It was energy and motion in a simultaneous process of becoming and disintegration, alien and indifferent to the affairs of men. The same lawlessness held true for the human psyche where uncontrolled

10. (*Opposite*) Raoul Hausmann, *Dada cino*, 1920–21. Collage, 12½ × 9 in (32 × 23 cm). Collection Philippe-Guy E. Woog.

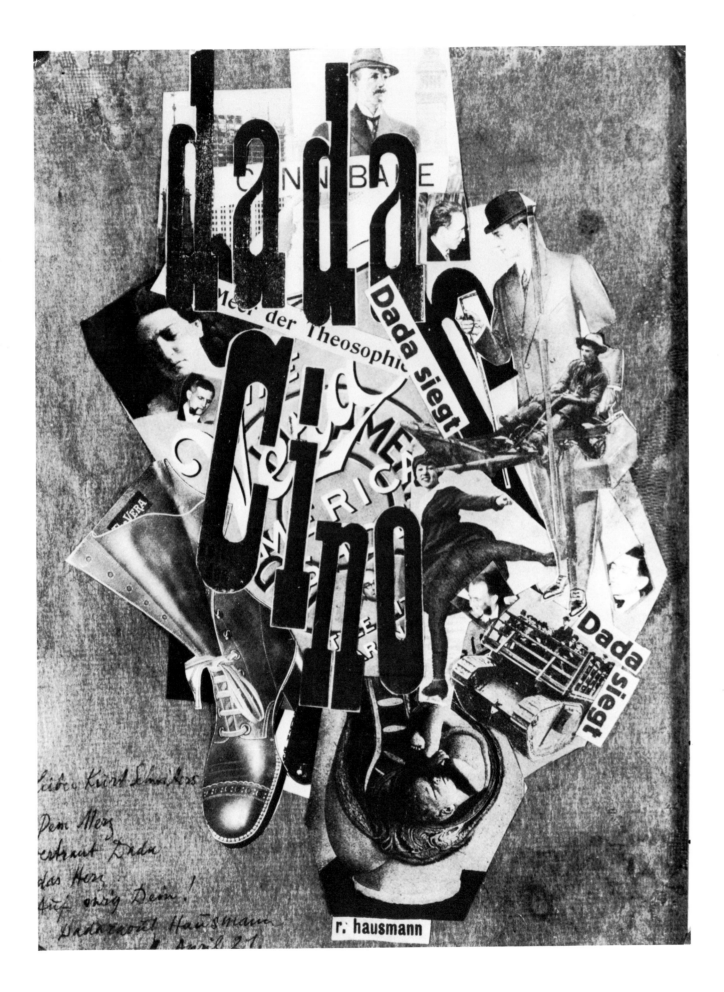

11. (*Left*) Jean Arp, *Earth Forms*, 1917. Painted wood relief, 33½ × 23½ in (85 × 60 cm). Private Collection.

12. Kurt Schwitters, *MZ.439*, 1922. Collage, 7½ × 6½ in (19 × 17.5 cm). London, Marlborough Fine Art (London) Ltd.

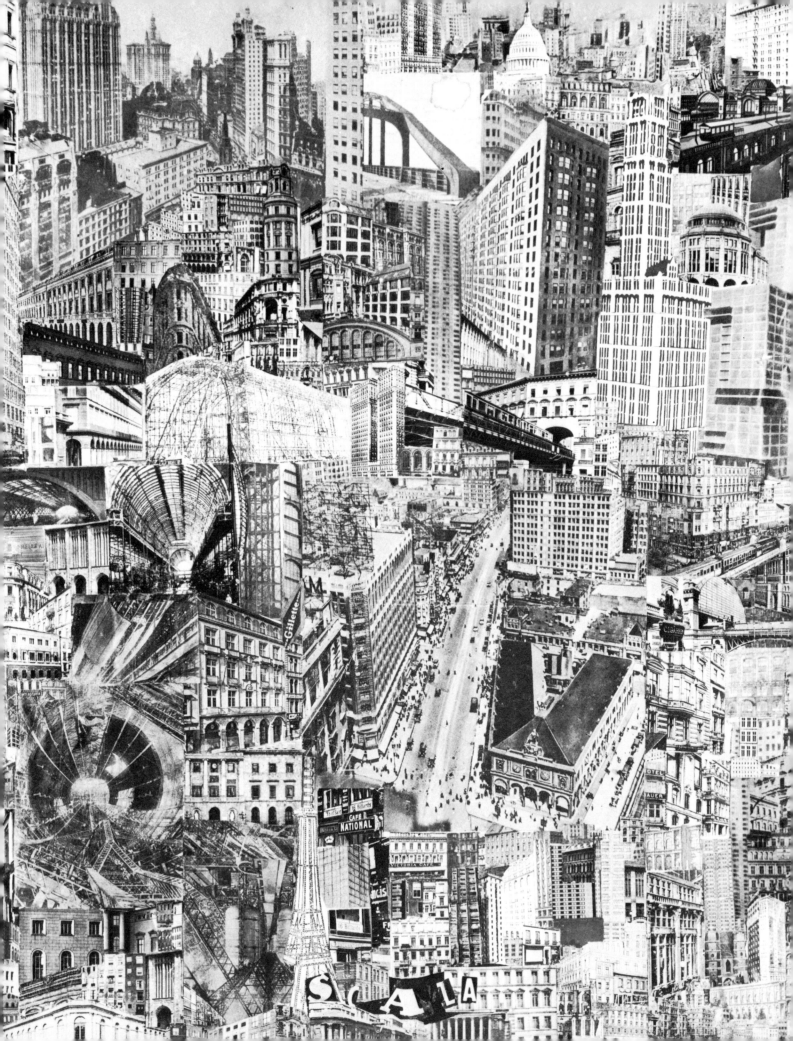

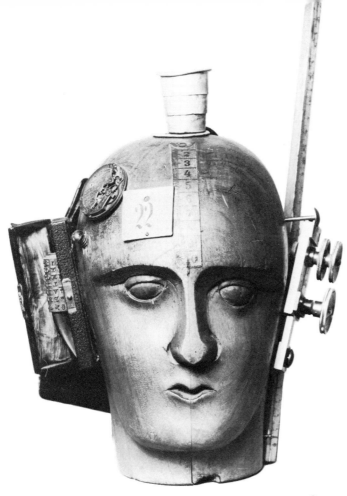

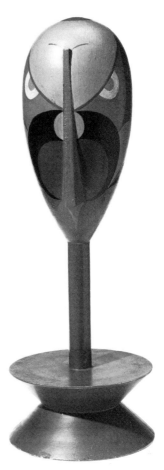

and contradictory currents made mere flotsam of man's conscious intentions, and demonic drives deflected them from their purpose. For the Dadas, the First World War was the great come-uppance for the hubris and megalomania of modern Western man. The War showed how the anarchic forces in nature which men should acknowledge and respect had become murderously destructive through neglect by an excessively cerebral, mechanistic civilization. As Richard Sheppard has observed, the Dadas believed that the War was a 'direct product of the competitive urge of industrial capitalism, with its mechanized trench warfare as a grotesque and monstrous version of the productive process itself'.[2]

It followed from their rejection of the belief in progress, in tameable nature and rational man, that the Dadas should cast doubt on the power of language, literature and art to represent reality. The information which the senses communicated to men was misleading, even the ideas of the individual 'personality' and the external world were elusive and incoherent. How then could language, by definition an instrument of public communication, do other than deform and betray life's authentic character as a discontinuous sequence of immediate experiences? The Dadas answered that words were mere fictions and that there was no correspondence between the structures of language and those of reality. Thus the belief in order which the power of a common, inherited language inculcated was illusory.

The 'No' in which most Dadas measured the degree of their alienation from the contemporary order of things was thus a very big 'No' indeed. So big that it might seem surprising that the Dadas refrained from collective suicide, let alone that most of them managed to remain

14. (*Left*) Raoul Hausmann, *The spirit of our time*, c. 1921. Assemblage, 13 in (33 cm) high. Paris, Musée National d'Art Moderne. From De Chirico onwards, the dummy, mannequin or lay figure was a recurring image in Dada and Surrealist art. This head expresses the brutal determinism which Hausmann saw operating on the minds of contemporary city-dwellers: 'An everyday man only has the capacities chance has glued to his cranium; his brain is empty.'

15. (*Above*) Sophie Taeuber-Arp, *Dada head, portrait of Jean Arp*, 1918. Oil on wood, 10 in (25 cm) high. Private Collection.

13. (*Opposite*) Paul Citroen, *Metropolis*, 1923. Photocollage, 30 × 23 in (76 × 58.5 cm). Holland, Printroom of the University of Leiden.
A Dutchman who collaborated in various Dada ventures in Holland and Germany, Citroen's work had strong affinities with Constructivism. His series of montages of urban scenes convey both the excitement and the threat of the city which seems to be assuming a life of its own.

16. Hans Richter, *Portrait of Baader*, 1916. Ink on paper, 9 × 8 in (23 × 20 cm). Milan Collection Guido Rossi.

artists and poets. We must remember, however, that it was balanced by a 'little Yes'. The differences between various manifestations of Dada can be broadly charted by the extent and nature of the new affirmatives they felt confident enough to proffer. Dadas such as Francis Picabia, Marcel Duchamp, Walter Serner, Georges Ribemont-Dessaignes and Tristan Tzara seem to correspond closely to the stereotype, nihilistic image of Dada sketched out at the beginning. For them, reality was absurd and chaotic; it was stubbornly inimical to human notions of law and order. But even these nihilists found moral satisfaction in the intellectual honesty which led them to keep faith with the prevailing chaos and to maintain a certain wry personal integrity in the context of absurdity. Tzara aimed at a severe, desolate and cosmic beauty in poetry which expressed the voluntary shedding of the poet's identity in the universal flux and in which equal importance was given 'to each object, being, material, organism in the universe'. Other Dadas believed that full acknowledgment of the void and immersion in the flux would reveal the principles of an immanent if obscure pattern within the dynamic flow of nature. Glimmers of this structure to which reason was blind were occasionally vouchsafed to the poetic imagination. Hans Arp, Hugo Ball, and some other German Dadas shared this confidence in discovering alternative possibilities of order amidst confusion. And Arp distinguished between a purely destructive energy residing in nature and a beneficent, spiritual force. Dadas also suggested that natural energies only became demonic and bestial as a result of being ignorantly repressed. Finally, for all the pessimism implicit in its metaphysics, Dada was saved from the obsessive anxiety and overblown despair of early Expressionism, which in other ways shared its prior tenets, by its irrepressible sense of humour. Dadas behaved as if they had come through the experience of life as tragedy and emerged on the other side. Their most fatalistic statements were always punctured by self-irony. They accepted the confusion of things, playfully mimicking in their work the ebullient anarchism of the life-force. To paraphrase Roger Shattuck in his conclusion to *The Banquet Years*, the rug had been pulled from underneath the artists' feet and they had to dance to keep their balance, but they accomplished the feat of acting as if this was exactly the way they wanted things to be.

So it can be seen why the Dadas insisted so vehemently that Dada was not some new 'ism' seeking its place among the movements of modern art, but a frame of mind or 'a moral revolution'. As André Breton put it in his manifesto *Geography Dada*:

'Cubism was a school of painting, futurism a political movement: DADA is a state of mind. To oppose one to the other reveals ignorance or bad faith.

'Free-thinking in religion has no resemblance to a church. Dada is artistic free-thinking.'[3]

At their most intransigent, the Dadas turned their backs on art as a dangerous mystification. Art conferred a false stability on the ephemeral, giving substance to the illusion of an anthropocentric universe. As a

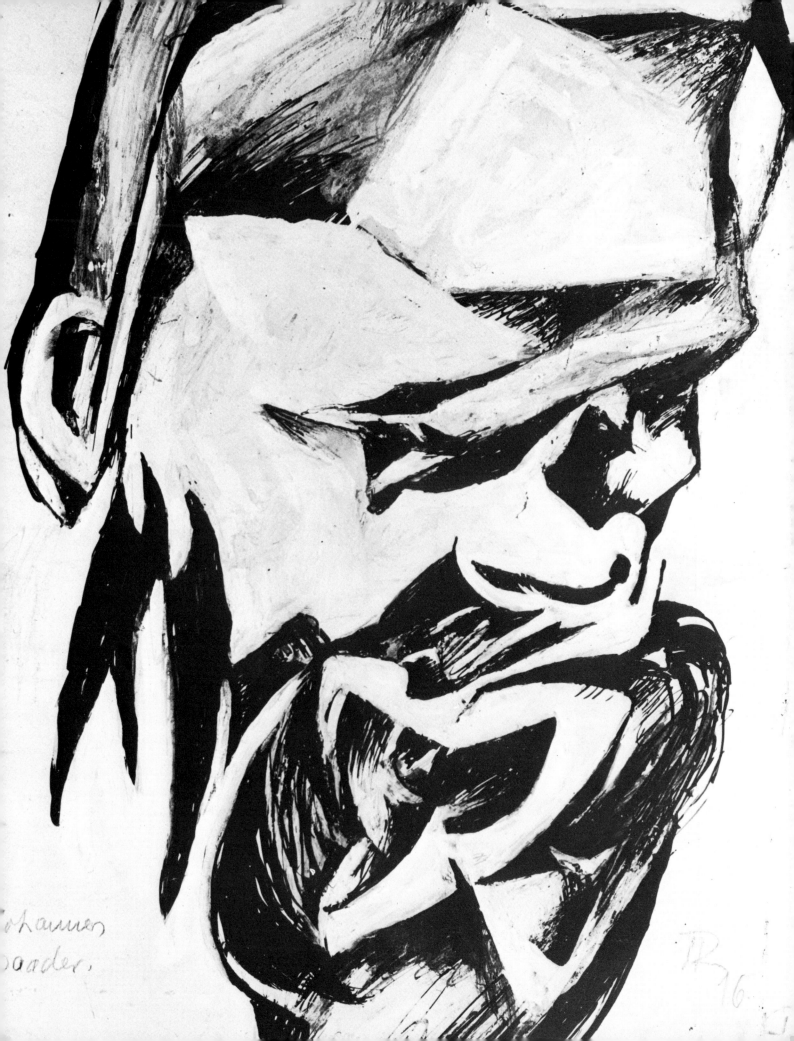

Johannes
Baader,

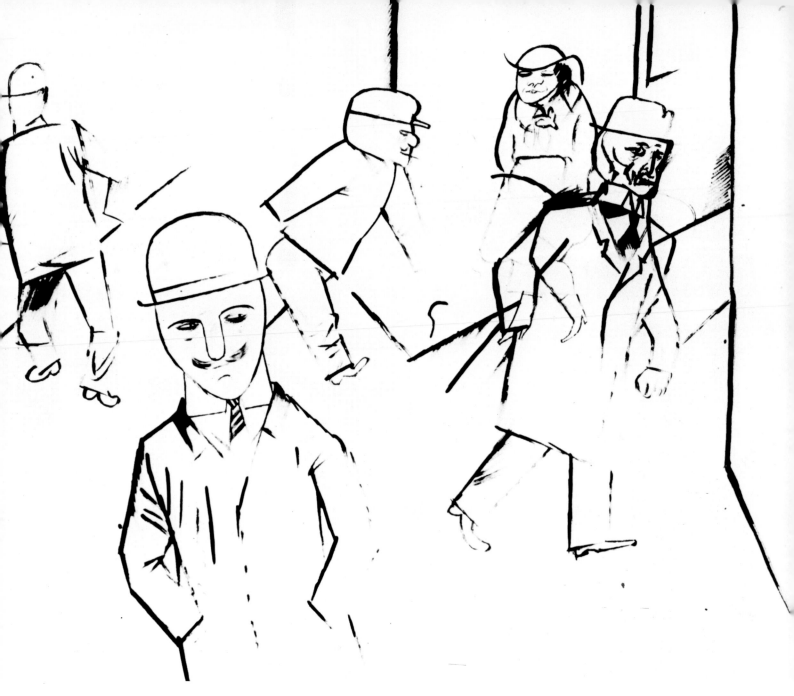

17. George Grosz, *In the street*, 1919. Ink on paper, 18 × 23¼ in (46 × 59 cm). Paris, Galerie Claude Bernard.

compensation or comfort in the midst of life's confusion, it deflected men's attentions away from the real source of their problems. At best, it was a pretentious luxury undeserved by a civilization which had just permitted the holocaust.

Despite the bald assertions of artists like Francis Picabia that 'Art is useless and impossible to justify', the Dadas' repudiation of art paradoxically turned out to be a tremendous stimulus to art. Dada's exaltation of the powers of the imagination at the expense of rationalism was bound to encourage artistic expression. Like Descartes, the Dadas were first making a *tabula rasa* in order to establish a sure basis from which to start afresh. What Dada proposed was not the end of art as such but a radically new conception of creative activity, a fresh equation between the variables: art-self-reality. It was here that Dada's originality lay rather than in its artifacts which, in form, were often unabashedly derivative of Cubism, Futurism and Expressionism. Dada, like Surrealism after it, envisaged the artist as a spiritual adventurer for whom

productivity was of secondary importance. Poetic significance and value was attributed to a certain stance before life. Moral exigencies were given priority over aesthetic ones. Since there was no longer any point in writing about experience, the act of the poet or artist was to put his whole sensitivity in direct contact with the universe in a state of cosmic passivity. In harmony with the Dadas' belief in an obscure force working in the world, the artist was characterized by his availability to chance, to the promptings of unconscious and internal impulses, and to everything that occurred spontaneously.

This broad definition of artistic activity permitted the Dada label to be applied to a great variety of art. Stylistically, the Dadas borrowed from many of their more aesthetically-oriented predecessors: collage from Cubism, typographical acrobatics and 'bruitism' (noise music) from Futurism, the unconstrained use of colour from Expressionism, spontaneous techniques from Kandinsky and poetic inventions from Apollinaire and Max Jacob. Often the Dadas employed the techniques of modernism in such a way as to mock and subvert the aims of their original inventors. At the same time, individual Dada painters, such as Marcel Janco or Hans Richter, were often privately experimenting with pure abstraction while publicly exhibiting more provocative, polemical work under the Dada banner.

Fortunately, however, there are quite a number of sure indicators of the presence of the Dada spirit in art. The most obvious of these is satire which could range from the wry debunking of sacred cows such as Picabia's ink-blot which he called *The Holy Virgin* to the savage denunciations of corruption in George Grosz's Berlin street sketches (plate 17). Dada art pilloried pretension and hypocrisy wherever they might lurk and its irony did not spare the artist himself. Dada art eschewed any attempt to reduce complex reality to a single ordering principle. Therefore, its works took the form of analogues of the flux they evoked. Lacking any identifiable centre for the beholder to focus on, such works randomly juxtaposed elements from different levels of reality. The Dada artist no longer claimed to be in full control of the creative process. Therefore, he left scope at various stages of the act of creation for the intervention of chance which he acknowledged to be an obscure power in its own right behind the unfolding of worldly events. The work of art is thus presented as a natural organism with its own autonomous life.

Crediting the imagination of primitive peoples with a surer grasp of the truth of things than modern scientific attitudes, the Dadas had recourse to African music, poetry and dance. The African evenings at the Cabaret Voltaire in 1916 were inspired by primitivistic masks made by Marcel Janco. Again, like much primitive art, Dada art was both public and ephemeral. The Dadas revalued and revived ritual, tribal dance, puppet theatre, graffiti. Anticipating the later efforts of museum curators to reduce them to artists like any others, they put their best inspiration into periodicals printed on cheap paper which failed after the first number, into wall posters and insulting stickers like those Grosz pasted onto the windows of Berlin cafés. Dada art compelled the

18. Marcel Janco, *Project for a Dada poster in the Cabaret Voltaire*, 1917–18. Charcoal, 28¾ × 21¾ in (73 × 55 cm). Milan, Private Collection.

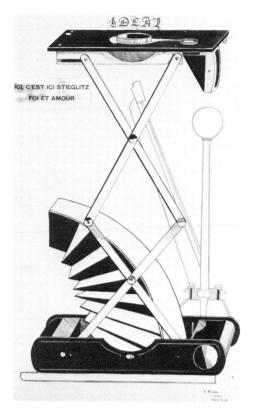

19. Francis Picabia, *Here, this is Stieglitz (Ici, c'est Stieglitz)*, 1915. Ink on paper, 28¾ × 19 in (73 × 48.5 cm). New York, Metropolitan Museum (Alfred Stieglitz Collection).

20. (*Opposite above*) Man Ray, *The rope-dancer accompanies herself with her shadows*, 1918. Aerograph, 13½ × 17½ in (34 × 44 cm). Chicago, Collection Mr and Mrs Morton Neumann.
In his effort to escape from the constraints and pretensions of traditional easel painting, Man Ray employed a spray-gun borrowed from the publisher's office where he worked. He later recalled his pleasure in using the air-brush technique: 'It was thrilling to paint a picture, hardly touching the surface – a pure cerebral act as it were.'

21. (*Opposite*) Francis Picabia, *City of New York seen across the body*. 1913. Watercolour on paper, 22 × 29½ in (55.7 × 75 cm). Geneva, Galerie Jan Krugier.

22

spectator or listener to rethink his position not merely by the novel force of the image or sound presented to him but by deliberately changing the context in which art was to be experienced. Thus the Dadas could propose as 'artistic' events a boxing match between Arthur Cravan and Jack Johnson or a 'sermon' by Johannes Baader from the pulpit of Berlin Cathedral. Finally, Dada art derided the idea that the artist was deserving of special status. The artist was a fallible mortal like everyone else. Conversely, everyone else was capable of the same creative freedom as the artist.

Since Dada was essentially a mental attitude, efforts to determine the priority of its appearance at one particular time and place are largely vain. A good case can be made for New York, however, where the Dada spirit was unmistakably active well before its official baptism in Zurich in February 1916. There were two main Dada rallying points in New York. One was the circle of Alfred Stieglitz, the pioneer art photographer. Stieglitz founded the avant-garde magazine *Camera Work* and its successor *391*, the latter taking its title from the number of the gallery on Fifth Avenue where he had staged the first American exhibitions by the major artists of European modernism. The second was the informal, chess-playing salon of the poet and art collector, Walter Conrad Arensberg. New York Dada owed its impetus to the arrival from Europe in June 1915 of Francis Picabia, Marcel Duchamp and Jean Crotti. Both Picabia and Duchamp had already caused a commotion in New York by their contributions to the notorious 1913 Armory Show of avant-garde art, Duchamp in particular with his idio-syncratically Cubist painting, *Nude descending a staircase*. Like their counterparts in Zurich, Duchamp and Picabia were in flight from the war, Duchamp after being exempted from military service because of a heart complaint and Picabia, ostensibly on an official mission to Cuba to buy molasses for the troops. Their shared taste for paradox, blasphemy and demoralization had cemented a friendship that went back to 1910.

The triumvirate of Dada animators in New York was completed by Man Ray, a man of insatiable curiosity and inventiveness in the making of objects and in the field of new techniques, especially those involving mechanical processes. The three were united in their determination to 'unlearn painting', to challenge the assumptions that underpinned the institution of art in the West – even that of the avant-garde – and to question the very principles of the creative act. But New York Dada never acquired a programme. It produced several short-lived reviews but its main preoccupation was artistic, not literary. Its mood was spontaneous, undogmatic and irresponsible, that of an urban carnival carried on amidst what Gabrielle Buffet-Picabia called 'an unimaginable release of sex and an outburst of jazz and alcohol'.[4]

Marcel Duchamp's Dada gestures had begun in 1913 when he decided that Cubism was a dead end. He announced that he was abandoning painting altogether and selected his first 'readymades' – everyday objects raised to the status of works of art by the single fact of their choice by the artist. The 'readymade' is exemplary of the tension

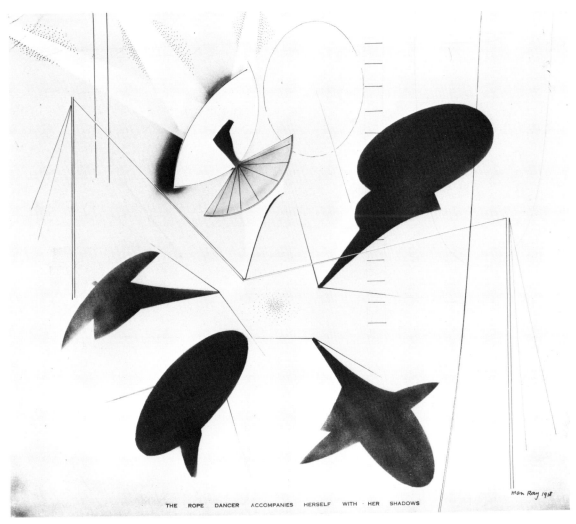

THE ROPE DANCER ACCOMPANIES HERSELF WITH · HER · SHADOWS

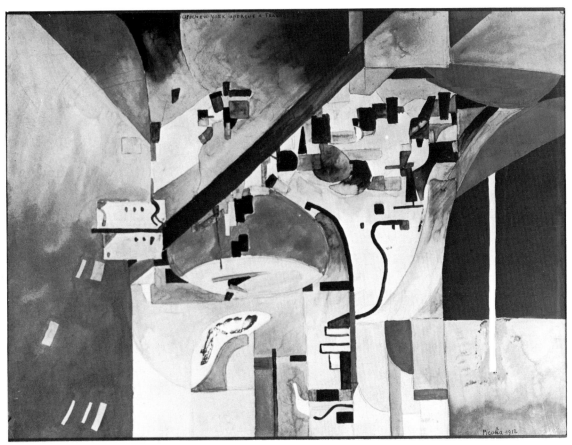

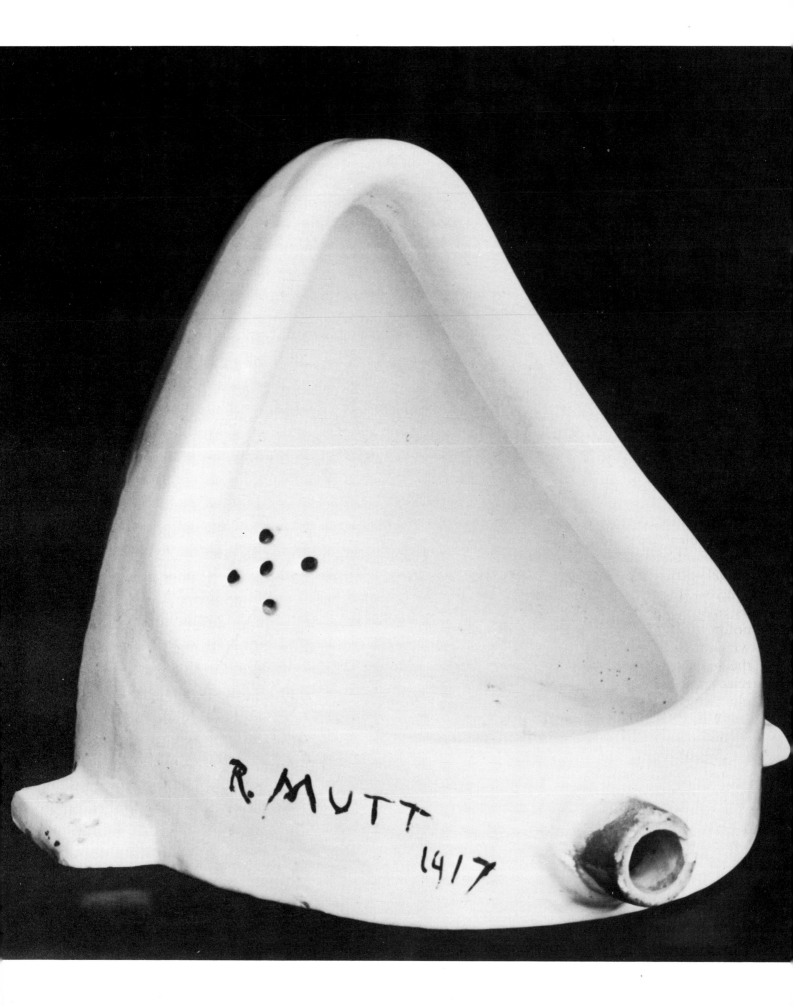

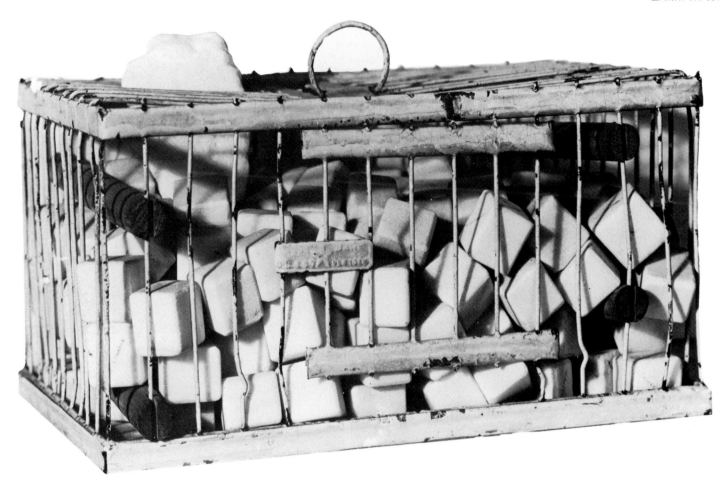

within all Dada art on account of the two opposed readings to which it is susceptible. On the one hand, Duchamp was evidently claiming that the most humble manufactured objects – a bottle-drier, hat-rack or snow-shovel – could be elevated into a work of art; on the other he was equally evidently breaking down the hierarchy of art in order to debase its masterpieces to the level of mundane objects. Duchamp's most notorious 'readymade' was the gentleman's urinal turned on its back which he titled *Fountain* (plate 22), signed 'R. Mutt', and submitted to the Independents exhibition in 1917. When the hanging committee rejected it, on the grounds that it was a plagiarism and a plain piece of plumbing, Duchamp replied:

> 'Whether Mr. Mutt with his own hands made the fountain or not has no importance. He CHOSE it. He took an ordinary article of life, placed it so that its usual significance disappeared under the new title and point of view – created a new thought for that object. As for plumbing, that is absurd. The only works of art America has given are her plumbing and her bridges.'

In New York, Duchamp's philosophical thinking played a role equivalent to that of Dada's anarchic cabaret performances in Zurich in destroying the myth of Art with a capital 'A'. Duchamp's revolt against 'retinal art' and determination to put painting once again at the service of the mind was nowhere better realized than in his most complex and studied work, *The Bride stripped bare by her bachelors even* (plate 27), which was begun shortly after his arrival in 1915 and left 'definitively incomplete' in 1923. *The Large Glass* as it is commonly known, developed themes in

23. Marcel Duchamp, *Why not sneeze Rrose Sélavy*, 1921. 4¼ × 8½ × 6¼ in (11 × 22 × 16 cm). Paris, Private Collection. Commissioned by Dorothea Dreier for $300, this object, composed of marble blocks in the shape of sugar lumps, a thermometer, a piece of wood and a cuttle bone in a bird-cage, horrified its intended purchaser and her sister so much that they returned it to the artist. It is surprisingly heavy and has to be lifted if one is to experience its disorienting effect to the full. Rrose Sélavy was the name coined by Duchamp for his tirelessly punning female *alter ego*.

22. (*Opposite*) Marcel Duchamp, *Fountain*, 1917. Ready-made: urinal turned on its back, 24 in (61 cm) high. New York, Sidney Janis Gallery.

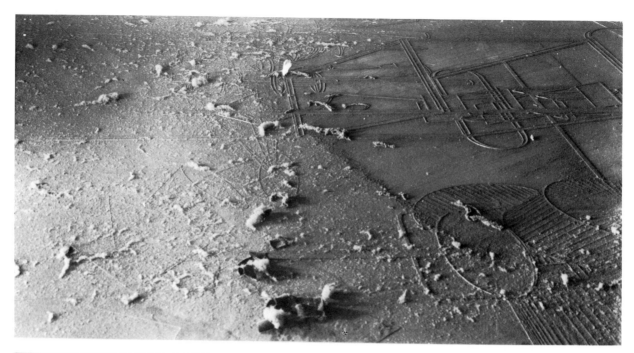

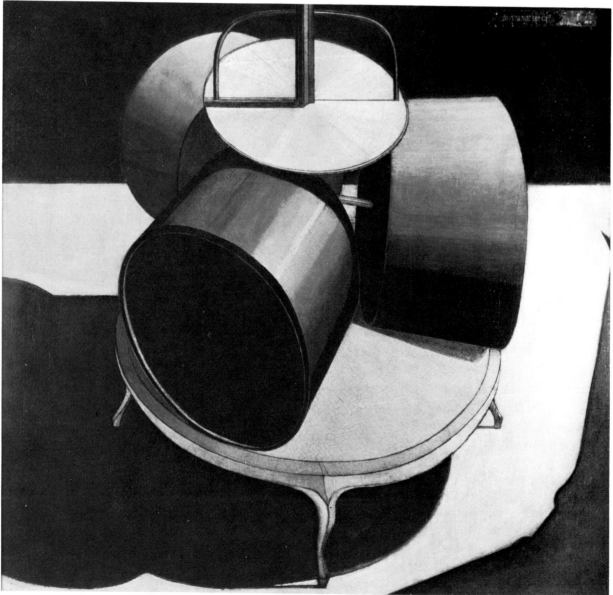

Duchamp's iconography from *The Chocolate Grinder* (plate 25) on-wards. It required the invention of its own system of mathematical measurement, its own internal logic and network of literary allusions. Duchamp himself felt obliged to publish a collection of study sheets explaining the ideas illustrated in this work and many volumes have since been devoted to its interpretation. An immensely elaborate joke, a game which throws doubt on the seriousness of all human endeavour, *The Large Glass* is an amalgam of the arbitrary and the systematic, slyly suggesting that all systems are erected on arbitrary foundations. At numerous points in its composition, Duchamp solicited the intervention of chance. For example, the half-completed glass was laid horizontal for some months in his apartment and allowed to accumulate a layer of dust. After it had been photographed by Man Ray (plate 24), the dust was removed from all but the areas of the 'Seven Sieves' where it has been glued down with varnish. As Breton said, *The Large Glass* is 'a mechanistic and cynical interpretation of the phenomena of love'.[5] It is divided into two domains, that of the bride above and that of the bachelors below. Almost all the components of a fully functional, utopian 'love machine' are assembled. But its fatal incompleteness rules out a successful union and promises nothing more fulfilling, as Robert Lebel has it, than 'onanism for two'.

The reduction of human activity to mechanical movement and the treatment of man as a piece of mechanical biology – an automaton operated by forces outside its control – was a central theme in the work of Francis Picabia during the period of New York Dada. In a *New York Tribune* interview in 1915, Picabia said:

'The machine has become more than a mere adjunct of human life – perhaps the very soul. In seeking forms through which to interpret ideas or by which to expose human characteristics, I have come at length upon the form which appears most brilliantly plastic and fraught with symbolism.'[6]

Now, of course, the Futurists had also shown a great interest in the metaphorical possibilities of the machine. But whereas Futurist art was a naive celebration of mechanical dynamism, that of Duchamp and Picabia treated the machine with distrust and a sardonic irony. They exploited the man/machine analogy to empty life of its spiritual content. As so often with the antecedent 'isms' on whose formal innovations the Dadas drew, they betrayed their model and substituted new meanings of their own. From 1915, Picabia made a series of 'symbolic portraits' of his friends (plate 19), representing them by precisely drawn machine parts taken from technical journals such as *The Scientific American*.

Dada did not have roots in New York any more than in Zurich. New York Dada was imported there from France. Duchamp had mounted his bicycle wheel on a stool in Paris in 1913. Such objects were only given the name 'readymade' in New York. Similarly, many of the study notes for *The Large Glass* were already done before his arrival. Man Ray was the only prominent New York Dada who was a native American; the rest – Jean Crotti, Henri-Pierre Roche and Arthur Cravan – like

24. *(Opposite above)* Man Ray, *The breeding ground of dust*, 1920. Photograph. Paris, Private Collection.

25. *(Opposite below)* Marcel Duchamp, *Chocolate Grinder*, 1913. Oil on canvas, 24¾ × 25½ in (63 × 65 cm). Philadelphia, Philadelphia Museum of Art (Louise and Walter Arensburg Collection).
Inspired by an antique chocolate-grinder in a Rouen confectioner's shop, this was Duchamp's first painting after he had vowed to renounce art. It shows his growing interest in mechanical motion. The radial lines on the face of the rollers link it to the bicycle-wheel which Duchamp mounted on a stool in the same year, thereby producing the first of the 'ready-mades'. The image of the chocolate-grinder was to become the centre-piece of the 'bachelor apparatus' in the lower half of *The Large Glass* (plates 24 and 27).

26. *(Overleaf left)* Man Ray, *Coat-stand*, 1920. Wood and cardboard. Paris, Private Collection.

27. *(Overleaf right)* Marcel Duchamp, *The Large Glass (The bride stripped bare by her bachelors even)*, 1944. Paris, Collection Jean-Jacques Lebel.

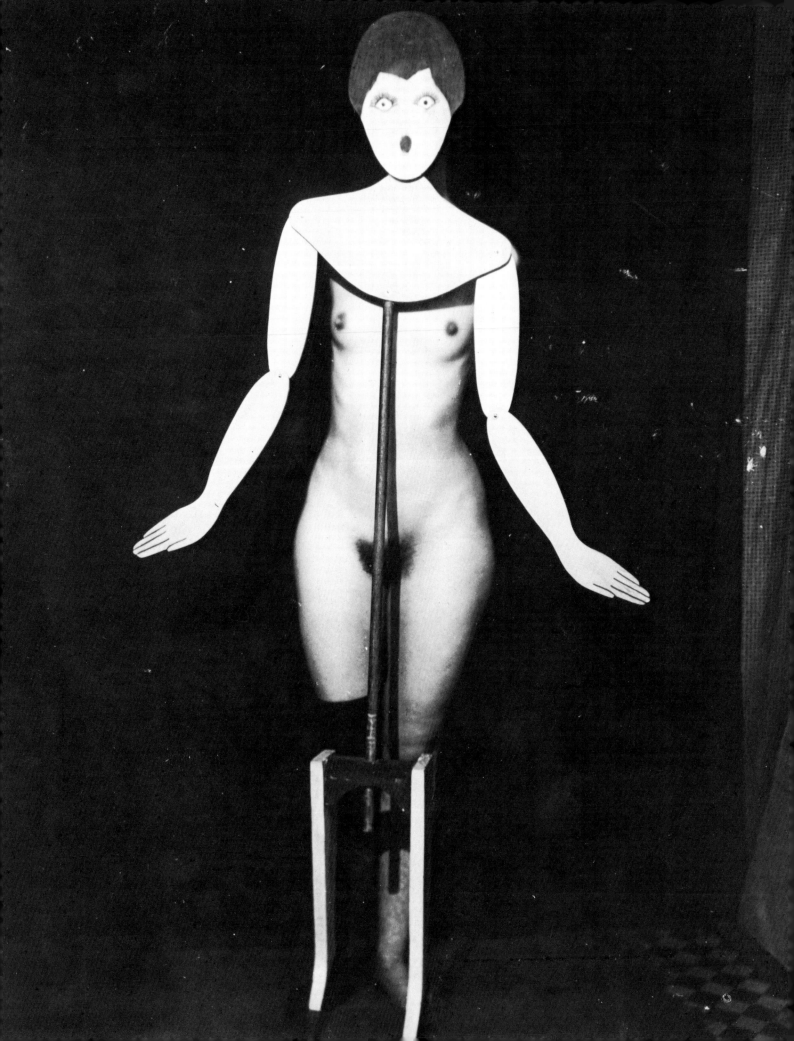

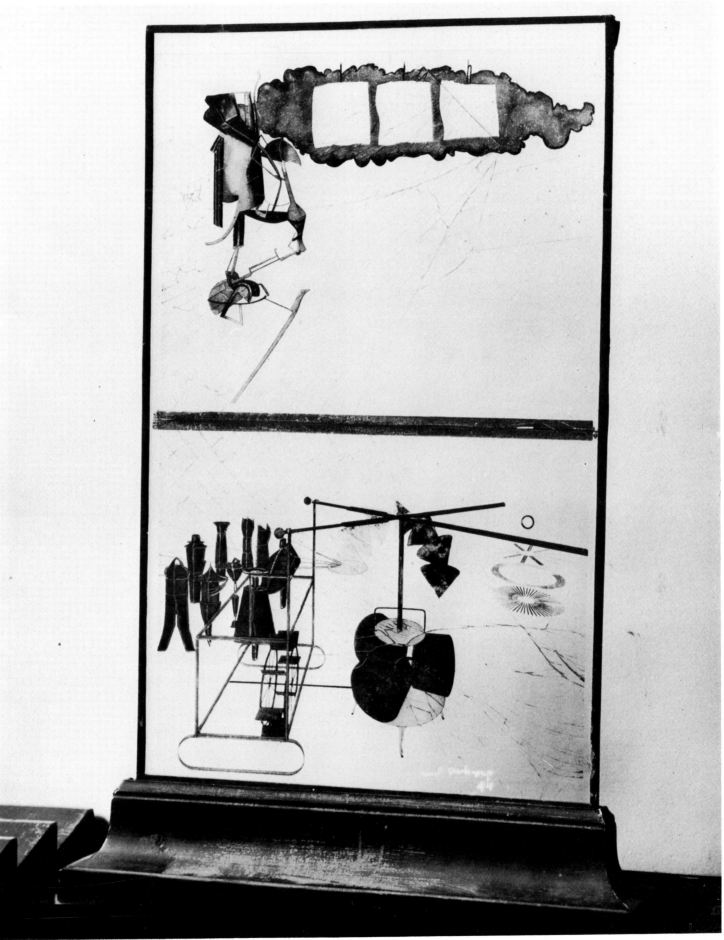

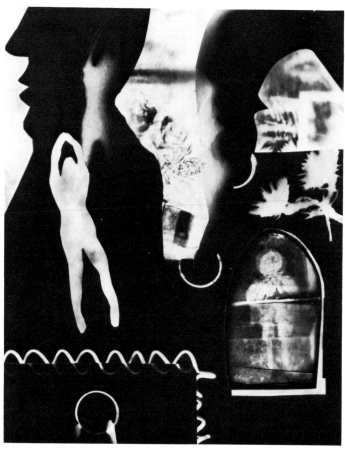

28. (*Above*) Johannes Baader, *Letztes Manifest (Last manifesto)*, c. 1925. Collage, 11¼ × 8¾ in (28.6 × 22 cm). Private Collection.

29. (*Above right*) Christian Schad, *Untitled*. Schadograph, 19¼ × 15 in (49 × 38.5 cm). Milan, Collection Guido Rossi.
Baptized 'Schadograph' by Tzara in one of his less inspired moments, the technique involved exposing everyday objects directly to photosensitive paper. Man Ray was to exploit this technique further in Paris with his 'Rayograms'.

30. (*Opposite*) Jean Arp, *Collage with squares arranged according to the laws of chance*, 1916–17. Paper, 19 × 13½ in (48.5 × 34.6 cm). New York, Museum of Modern Art (Gift of Philip Johnson).

Picabia and Duchamp, were European expatriates sitting out the war. With the ending of hostilities and their return to Europe, New York Dada languished. Under the patronage of Katherine S. Dreier, an attempt was made in 1921 to establish an 'official' Dada centre called the 'Société anonyme' but the group was dissolved the same year when Man Ray departed for Paris.

Dada acquired its identity and self-consciousness in Zurich and it was from there that the manifestos, reviews and letters issued out which were to internationalize the Dada movement. Yet it was also here that Dada was most heterogeneous, derivative and difficult to pin down, especially in its early stages. The context provides the main explanation. Neutral Switzerland was a country with no significant artistic traditions which Hugo Ball described in war time as being a 'bird cage surrounded by roaring lions'. In this highly artificial, land-locked sanctuary, a motley collection of artists – Symbolists, Cubists, Futurists, Expressionists – found themselves thrown together, united only by their abhorrence of the war and their determination to keep out of it.

The diversity which characterized the Zurich community of expatriates, pacifists, deserters and revolutionaries of many colours (Lenin, Romain Rolland, Wedekind and James Joyce among them) extended to the group which from February 1916 staged entertainments at the Cabaret Voltaire. The only native Swiss among the original Dadas was Sophie Taeuber, who married the Alsatian poet and painter,

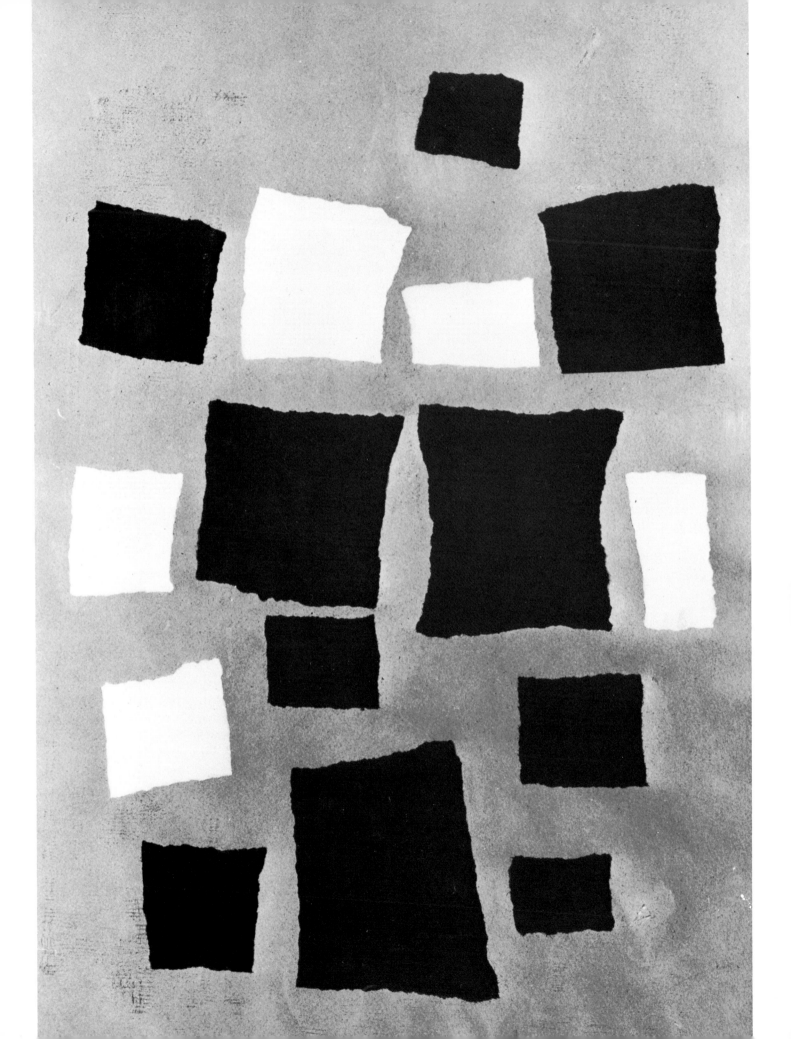

31. Jean Arp, *Oiseau hippique (Hippic bird)*, 1916. Painted wood, 7 × 6½ × 5 in (18 × 16.5 × 12.5 cm). Basle, Private Collection.

Hans Arp. Tristan Tzara and Marcel Janco were Roumanians; Walter Serner was from Austria, Marcel Slodki from the Ukraine; the other central figures, Hugo Ball, his wife Emmy Hennings, Richard Huelsenbeck and Hans Richter were Germans. No wonder that Dada activity lacked definition. But for the rumble of battle in the distance, Zurich Dada in its first years could be described as the uninterrupted development of pre-war avant-garde tendencies in a situation which forced them to intermingle. The persistence of a strong Futurist element is seen in the central role of the simultanist poem and 'bruitism' in the programmes of the Cabaret Voltaire and in the influence of Marinetti's 'words at liberty' in Dada typography and the *mise-en-page* of its reviews.

Equally evident, especially among the Dadas who hailed from Germany, was a strong Expressionist current. With its distrust of reason, hostility to bourgeois, industrial society, its cultivation of the absurd and rejection of representational art, Expressionism prefigured Dada in many respects. The provocation attempted by Ball and Huelsenbeck at the 'Expressionist Evening' which they had staged at the Harmoniumsaal in Berlin in May 1915 likewise anticipated similar attacks on the audience in Zurich. Dada was also able to absorb impulses from contemporary art movements such as De Stijl and Constructivism. This meant that the imagery of the Dada artists was very eclectic and diffuse in its sources even if we have little difficulty today, for the reasons outlined earlier, in identifying it as Dada.

By the summer of 1916, the mood and mental climate of Dada had been recognizably established at the Cabaret Voltaire. An extraordinary barrage of all the arts greeted the audience at its ever-changing, nightly performances. Arp has evocatively described the frenzied reactions of the paying customers as the Dadas succeeded in their aim of 'liberating' them from their normal self-discipline and turning them too into Dadas:

'Total pandemonium. The people around us are shouting, laughing and gesticulating. Our replies are sighs of love, volleys of hiccups, poems, moos, and miaowing of medieval Bruitists. Tzara is wriggling his behind like the belly of an oriental dancer, Janco is playing an invisible violin and bowing and scraping. Madame Hennings, with a Madonna face, is doing the splits. Huelsenbeck is banging away non-stop on the great drum, with Ball accompanying them on the piano, pale as a chalky ghost. We were given the honorary title of Nihilists.'[7]

But it was an error to suppose that the title 'nihilist' fitted all or even the majority of Zurich Dadas. As the months went by, it became clear that there were two broad conceptions of what Dada might be which gradually came into conflict. For the first year and a half, it was the mystical and constructive-minded figures of Hugo Ball and Hans Arp who set the tone rather than the mercurial and increasingly nihilistic Tzara. Gabrielle Buffet-Picabia was struck by the contrast between the frigid humour and studied indifference that was the hallmark of New York Dada, and Zurich where she found 'a less egotistical, more

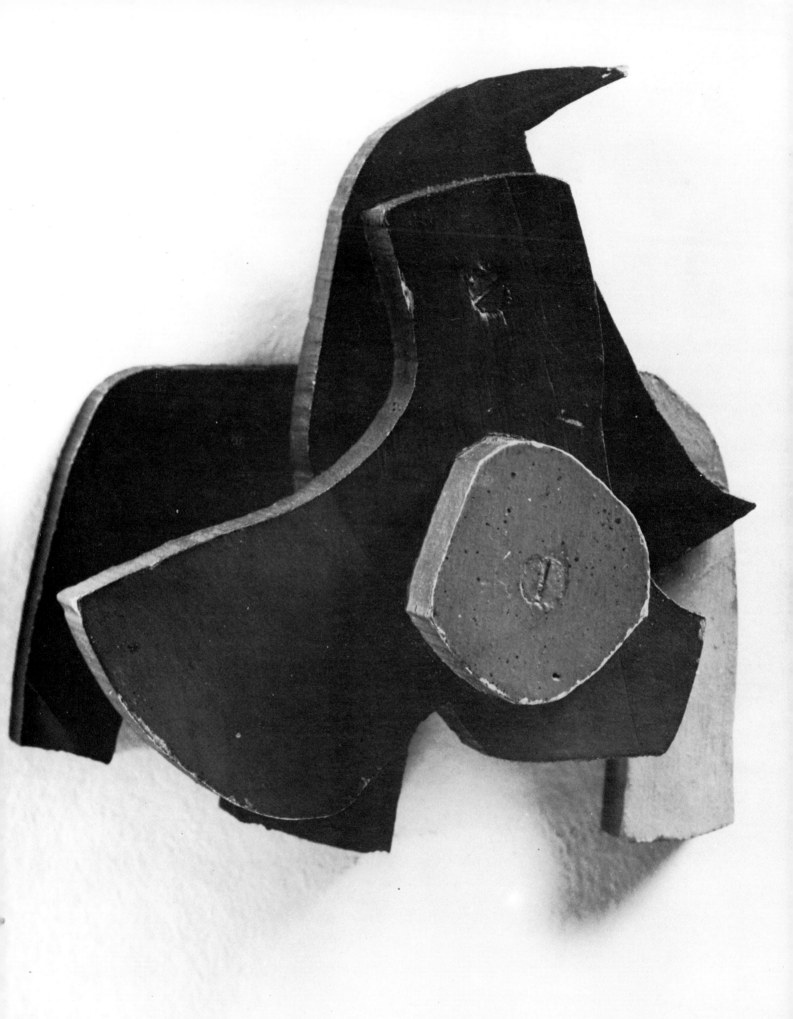

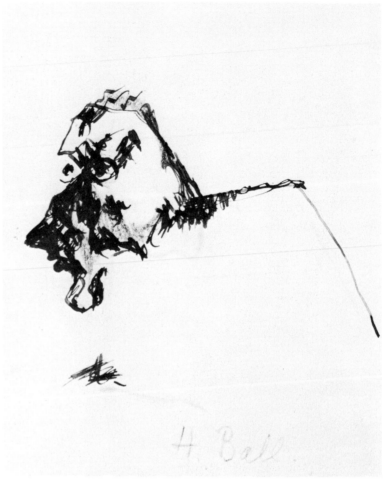

32. (*Above*) Hans Richter, *Visionary portrait*, 1916–17. Oil on canvas. Paris, Musée d'Art Moderne.
Heavily influenced by Expressionism and Cubism, Richter's work illustrates the eclectic nature of early Zurich Dada. His highly-coloured 'visionary portraits', which were rapidly executed in a semi-hypnotic state, exemplify a 'subjectivist' tendency in Dada which was later to die out.

33. (*Above right*) Hans Richter, *Portrait of Hugo Ball*, 1917. Ink on paper, 7½ × 6½ in (18.5 × 16 cm). Milan, Private Collection.

34. (*Opposite*) *Jedermann sein eigner Fussball (Everyman his own football)*, 1919. London, British Library.
In this, as in some other Berlin reviews, the Dada spirit was almost eclipsed by political preoccupations. But the way it was sold was certainly Dada. According to Walter Mehring: 'We hired a char-a-banc of the sort used for Whitsuntide outings, and also a little band, complete with frock-coats and top hats, who used to play at ex-servicemen's funerals. We, the editorial staff, paced behind, six strong, bearing bundles of *Jedermann sein eigner Fussball*.'

mystical, naive attitude – seeking recourse to primitive, automatic, universal forces, rather than individual exasperation'.[8]

Hugo Ball's journal, *Die Flucht aus der Zeit* ('Flight out of Time', 1927) reveals the earnest intent that lay behind the rowdyism of the Cabaret Voltaire. Significantly, Ball had not named his Cabaret thus in order to ridicule the philosopher of the Enlightenment but because he wanted to offer there 'our kind of Candide against the times'. For Ball, image-smashing was only a preliminary act of mental hygiene after which the real task of rehabilitating art as 'a meaningful instrument of life' could begin. The primitivism of the sound poem was a step towards a pristine, adamic language, and the invocation of unconscious forces was part of a controlled psychological regression which would form the basis of a social 'rebeginning'. But as a result of seeing human brutality at first hand when he visited the front as a civilian volunteer late in 1914, Ball's attitude to the irrational in man began to change. Little by little, he lost faith in the possibility of harmony between the demonic and spiritual principles in nature. Finally, he came to decry man's Dionysian and imaginative faculties and took refuge in the arms of the Church. The sense of Ball's spiritual itinerary was evident when he closed the Cabaret Voltaire in July 1916. In May 1917, he made his definitive break with Dada and left Zurich for the Ticino. In 1920, he was converted to Catholicism.

Unlike Ball, Hans Arp never renounced his Dada aspirations. He credited art with the power of healing, of ending the great rift between Man and Nature that had led to the ongoing suicide of civilization. His

Einzelnummer: 30 Pf, zugestellt 40 Pf., Abonnement: Quartal (6 Nummern incl. Zustellung) 2 Mark. Vorzugs-Ausgabe: 100 numm. Exemplare 1–20 sign. auf echt Zanders Bütten à 10 M., 21–100 à 3 M

Preis 30 Pf.
Durch Post und Buchhandel
40 Pf.

Anzeigenpreise: 1 Quadratzentimeter 0,50 Mark, einmal wiederholt 10%, Rabatt, zweimal wiederholt 20%, Rabatt. Exzentrischer Satz: 1 Quadratzentimeter 1,00 Mark, bei gleichen Rabattsätzen.

"Jedermann sein eigner Fussball"

Illustrierte Halbmonatsschrift

1. Jahrgang Der Malik-Verlag, Berlin-Leipzig Nr. 1, 15. Februar 1919

Sämtliche Zuschriften betr. Red. u. Verl. an: Wieland Herzfelde, Berlin-Halensee, Kurfürstendamm 76. Sprechst.: Sonntags 12–2 Uhr

Preisausschreiben!
Wer ist der Schönste??

Deutsche Mannesschönheit 1 (Vergl. Seite 4)

Die Sozialisierung der Parteifonds

Eine Forderung zum Schutze vor allgemein üblichem Wahlbetrug

(Diese Ausführungen sollen den Unfug unserer Nationalversammlung selbst vom Gesichtspunkt der Demokraten aus illustrieren, jener Leute, die meinen, ein Volk dürfe keine Regierung besitzen, deren Niveau dem seines eigenen Durchschnitts überlegen ist.)

Man mag Demokrat sein, deutsch-sozialistischer Untertan oder Kommunist, man mag mit Schiller sagen: Verstand ist stets bei wenigen nur gewesen oder behaupten auf jede Stimme komme es (sogar mit Recht) an, die Tatsache wird man nicht bestreiten: Wahlen gehören zu den ge-

OFFEAHBDC
BDQ „qjyE!

35. (*Above left and right*) Raoul Hausmann, *Phonetic poem poster*, 1918. Ink, paper and cardboard, 13 × 19 in (33 × 48 cm). Paris, Musée National d'Art Moderne.

remedy for discord at first took the form of austere, geometrical work whose symmetry and abstraction seemed to him to possess the quality of universality. In 1916, after being struck by the pattern made on the floor by the fragments of a drawing he had torn up, he began to make collages 'arranged according to the laws of chance'. He explained that the introduction of chance was part of his search for 'essential order'. At about the same time, Arp was making coloured reliefs by superimposing two or more layers of wood or metal in which the precision of the forms cut out for him by a carpenter and the masking of the raw material in ripolin paint rendered them impersonal, eliminated the hand-writing of the artist and turned them into natural objects (plate 31).

After the final exit of Hugo Ball, Tristan Tzara become the director of the movement and, casting himself in the role that Marinetti had played for Futurism, set about making the Dada enterprise known throughout Europe. Since 1916, Tzara's tone had hardened from derisive humour to a destructive scepticism. His 1918 *Dada Manifesto* published in the third number of his review *Dada*, not only put further distance between the Zurich movement and Futurism and Expressionism but also marked the revival of activity which had languished since the summer of 1917 and the closure of the Galerie Dada. That this new

fmsbwtözäu
pggiv-..?mï

burst of activity was more single-mindedly aggressive and nihilistic was partly due to the emergence of the formerly hostile Walter Serner as a central figure of Zurich Dada and partly to the influence of Francis Picabia who, after commuting between New York and Barcelona, settled in Lausanne in the summer of 1918. Victim of extravagant living and a nervous disposition that kept him perpetually on the move, Picabia was equally unwilling to hold to any fixed philosophical position. He had little sympathy with the cultivation of spontaneity or the unconscious as means of communicating authentic experience; for him they were principles of dissolution only.

Zurich Dada climaxed with a massive soirée at the Saal zur Kaufleuten on 9 April 1919. But by now the conflict within the movement between those who wished to create something aesthetically new and those who only wished to destroy, was irresolvable. A parallel rift separated artists from writers. For painters like Richter, Janco, Baumann and Arp, the freedom to experiment offered by the individualistic climate of Dada had always been the main attraction. For all that Dada might be a mental attitude shared by all, the writers found it much easier to express revolt by means of verbal protest than the painters did to deny the value of art through paintings. While the writers progressed towards silence with

36. Hannah Höch, *Da-dandy*, 1919. Collage and photomontage, 12 × 9½ in (30 × 24 cm). Private Collection.
Less aggressive and polemical than the photomontages of other Berlin artists such as Grosz and Hausmann, Höch's images tend to be autobiographical and whimsical. The figures are not locked in claustrophobic interiors but float freely in space.

ever gayer blasphemies and ever more playful scepticism, the artists were seeking to become once again 'a positive force in life'. In the same month as the final soirée, after forming the Association of Radical Artists, they published a manifesto in terms which were closer in their cloudy idealism to the spirit of the tamed activist wing of Expressionism, now turned social-democrat, than to anarchistic Dada. 'The spirit of abstract art', they declared, 'represents an enormous widening of man's sense of liberty. We believe in a brotherly art; this is art's mission in society. Art demands clarity, it must serve towards the formation of a new man.'

Although the Association of Radical Artists lasted only a few weeks, this manifesto, with its appeal that the artist be accorded a dignified place in post-war society, shows how ephemeral and fugitive the Dada mood had been for many Dadas. It was as if with the ending of the war, the demands of normality and the necessity to make a career reasserted themselves. The exiles were now free to travel again, to return to their native lands. Picabia and later Tzara headed for Paris. Arp joined Max Ernst in Cologne.

Richard Huelsenbeck, the phonetic poet who employed savage negro rhythms 'to drum literature into the ground', returned to Berlin to continue his medical studies in January 1917. He found a city at war beset with such corruption, scarcity and exploitation that, beside it, life in Zurich seemed a 'smug, fat idyll'. He denounced his erstwhile comrades for turning Dada into a 'manicure salon for the fine arts'. To have any relevance or bite in war-torn Germany, he decided, Dada would have to be made of sterner stuff. The Dadas would have 'to discard (their) patent leather pumps and tie (their) Byronic cravats to the doorpost'; they would have to be ready 'to make literature with a gun'.

Huelsenbeck was soon joined by a number of other intellectuals and artists: Franz Jung, an already established writer who later helped to found the Rhineland Communist Party; Raoul Hausmann, a young Czech who was at once phonetic poet, painter and photomontagist; the caricaturist, Georges Grosz, the only Berlin Dada who was exclusively an artist; the Herzfelde brothers; and Johannes Baader, older than the others, who claimed to be 'Super-Dada', founded 'Christ & Co. Ltd.' and whose manic genius for scandal led him to invade the Weimar Diet and hurl down armfuls of leaflets declaring himself President of the Globe.

Unlike New York, where Picabia and Duchamp had been lionized as the leaders of modern art, and Zurich, where Dada had no rivals, the fledgling Berlin Dada Club had to contend with a highly organized and active Expressionist movement from which most of the Dadas were themselves renegades. In a sustained polemical battle which reached its height in 1919 and 1920, Dada rejected Expressionism's cult of inwardness, urging that the soul only revealed its true qualities in action. Self-obsessed, the Expressionist consciousness veered erratically between suicidal despair at one extreme and the most naive optimism at the other, between a yearning for Utopia and a resignation to totalitarianism.

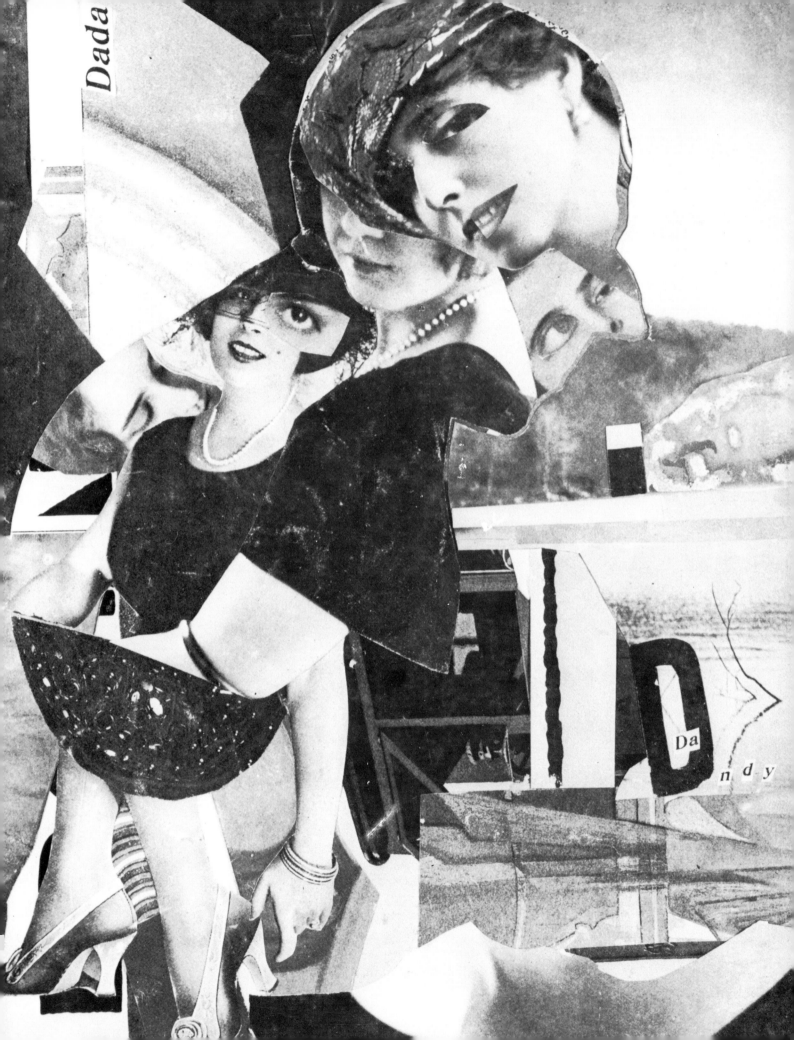

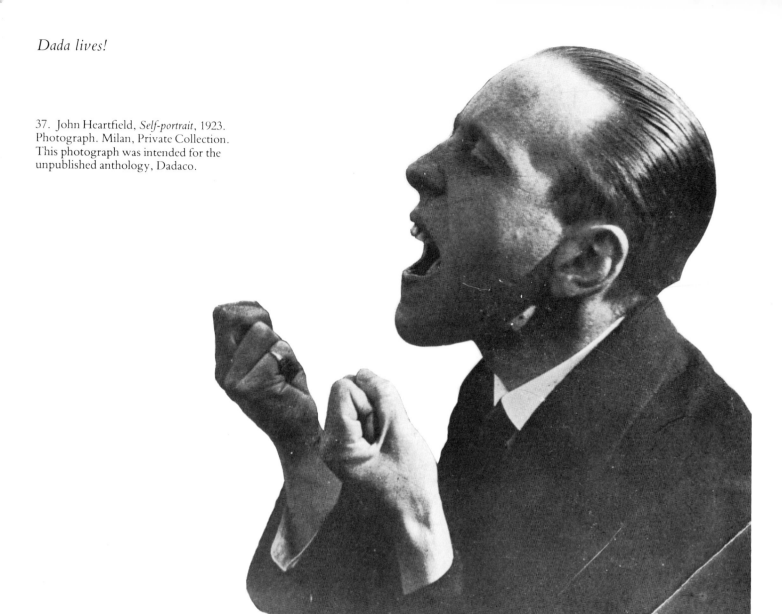

37. John Heartfield, *Self-portrait*, 1923.
Photograph. Milan, Private Collection.
This photograph was intended for the
unpublished anthology, Dadaco.

When defeat was followed in Germany by revolutionary upheavals and
civil war, the Expressionists greeted the new bourgeois republic as if it
would usher in the millennium. Dada was never under any such
illusions. Realism, said the Dadas, required that men acknowledge the
persistent fact of their own violence, that they accept the complex nature
of the psyche and the world rather than seek to impose a simple order
upon reality. The mastering of man's fear of his own irrational powers,
the conquest of psychic freedom and personal autonomy, Dada insisted,
was a prerequisite of any social revolution.

Nowhere was Dada more politically committed than in Berlin. It
could not have been otherwise when the immediate socio-economic
situation exhibited a state of flux which corresponded so closely to
Dada's own picture of the natural order. In the confrontations that
followed the flight of the Kaiser in December 1918 over whether the
new Republic should have a middle-class or a working-class base, the

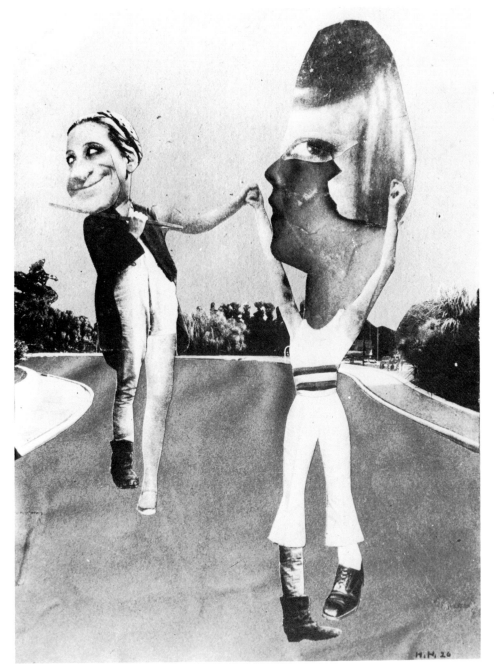

38. Hannah Höch, *Vagabond*, 1926. Collage and photomontage, 14 × 10 in (35 × 25 cm). Milan, Collection Guido Rossi.

Dadas naturally took the side of the Leftist-Communist Spartakist League against the majority Social Democrats who were bent on retrenchment. The Dadas promoted a whole series of political reviews with titles like *Everyman his own football*, *Bloody earnest*, *The Pill*, and *Bankruptcy*, often no sooner off the press than banned by the authorities on the twin charges, which amounted to the same thing, of anti-militarism and obscenity. At their 'First International Dada Fair' in 1920, they paid tribute to post-revolutionary art in Russia with the slogan 'Art is dead. Long live the new machine art of Tatlin'. A dummy dressed in a German officer's uniform hung from the gallery ceiling; it had a pig's head and a placard, 'Hanged by the Revolution'. Hausmann's manifesto *What is Dadaism and what does it want in Germany?* parodied Woodrow Wilson's 14 points in a mixture of apparently serious suggestions for social reform and absurdist proposals for making the world more Dada. Hausmann urged that the simultanist poem become the 'Communist

39. John Heartfield, *Hurrah, the butter is finished*, 1935. Berlin, Akademie der Kunst der DDR.

state prayer' and that churches be requisitioned for Dada performances. In 1919 and 1920, the Berlin Dadas mounted a spectacular 'concert tour' in Central Europe, taking in the cities of Dresden, Hamburg, Leipzig and Prague – evenings of lectures and performances which quickly degenerated into prolonged exchanges of insults between the Dadas and their audiences. But the 'First Grand International Dada Fair' of June 1920 which the papers called 'The Great Dada Monster Show' proved to be the climax of the movement. The rout of the revolution along with growing ideological differences within the group meant that Dada activity thereafter went into decline and soon petered out.

Kurt Schwitters distinguished between those Berlin Dadas for whom Dada was a political weapon and those for whom Communism was a Dadaistical weapon. There was a faction which saw anarchy and anti-art as a sufficient programme in itself and a second faction which saw anarchy merely as a provisional precondition for the introduction of new values. Huelsenbeck, Baader and Hausmann among others belonged to the first group; Georges Grosz, Wieland Herzfelde and his brother John Heartfield (he had anglicized his name during the war out of disgust with German militarism) were more Marxist. But it is possible to exaggerate the political commitment of Berlin Dada. In large part, its politically revolutionary appearance was the product of the accidental conjunction of artistic revolt and the unstable political structure. What would have passed off as harmless pranks in Zurich looked like subversion in Berlin. But more importantly there was a basic incompatibility between Dada and Marxism-Leninism, which had no time for the irrational well-springs of the personality. In the last analysis, most Dadas were sceptical of all programmes and ideologies. They stood for revolt and sided with the workers because at this time the workers were in revolt. Beyond an attachment to the idea of an informally structured, anarchist community, the Dadas had no belief that the world could significantly be improved by politics.

The art of Berlin Dada accurately reflects both the extent and the limits of the group's political engagement. It was an art of satire rather than of positive statement. Its principal targets were the mentality and institutions of the bourgeoisie and it delighted in exposing the fraud by which the new Republic was dressing up the old exploitative structures in 'democratic' clothes. Berlin Dada invented the technique of 'photo-montage', incorporating everyday visual material such as newspaper headlines, photographs and advertisements in a new medium which revealed, according to Hausmann, 'a visually and conceptually new image of the chaos of an age of war and revolution'.[9] The great practitioners of this medium, Hausmann, Heartfield, Grosz and Hannah Hoch, brought together the most jumbled and disparate elements in collages which both reaffirmed Dadaist faith in simultaneity and preserved the content of the various components in order to make a sardonic comment on the culture from which they issued. In this way, the Berlin Dadas achieved an immediate critical impact which was missing from the culturally neutral assemblages of Dadas such as Arp.

40. (*Overleaf left*) George Grosz, *Remember Uncle August the unhappy inventor*, 1919. Oil on canvas, collage and buttons, 18½ × 15 in (47 × 38 cm). Paris, Musée National d'Art Moderne.

41. (*Overleaf right*) George Grosz, *The face of the ruling class*, 1921. From a book with 55 reproductions of drawings, 9 × 10 in (23 × 26 cm). Berlin, Kupferstichkabinett, Staatliche Museen Preussischer Kulturbesitz.

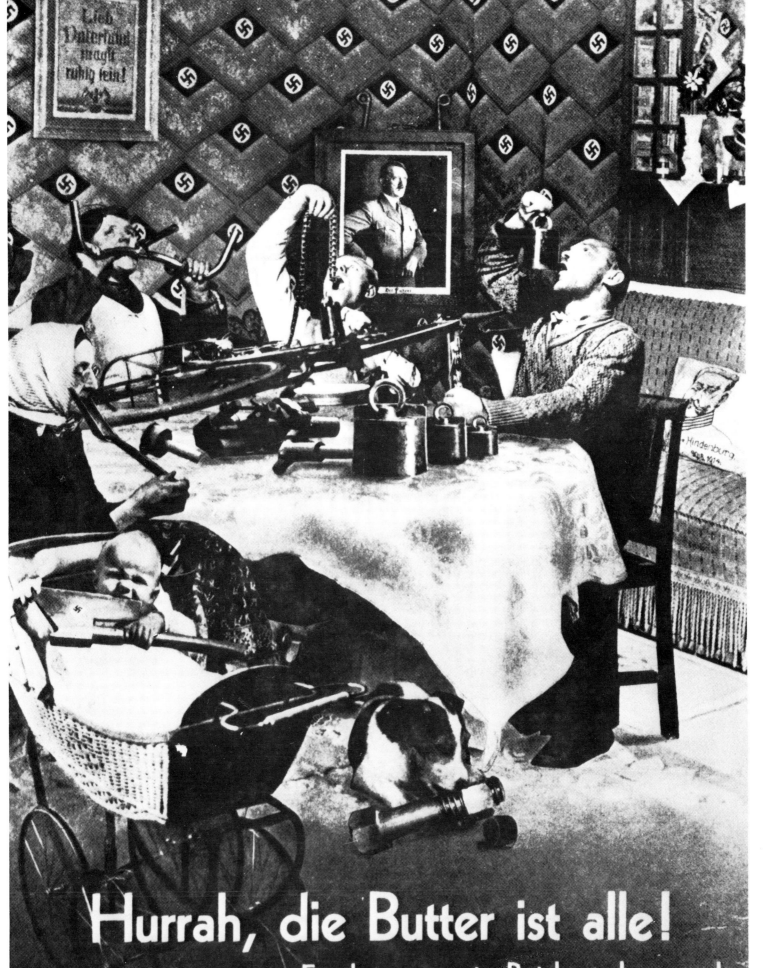

Hurrah, die Butter ist alle!

Goering in seiner Hamburger Rede: „Erz hat stets ein Reich stark gemacht, Butter und Schmalz haben höchstens ein Volk fett gemacht"

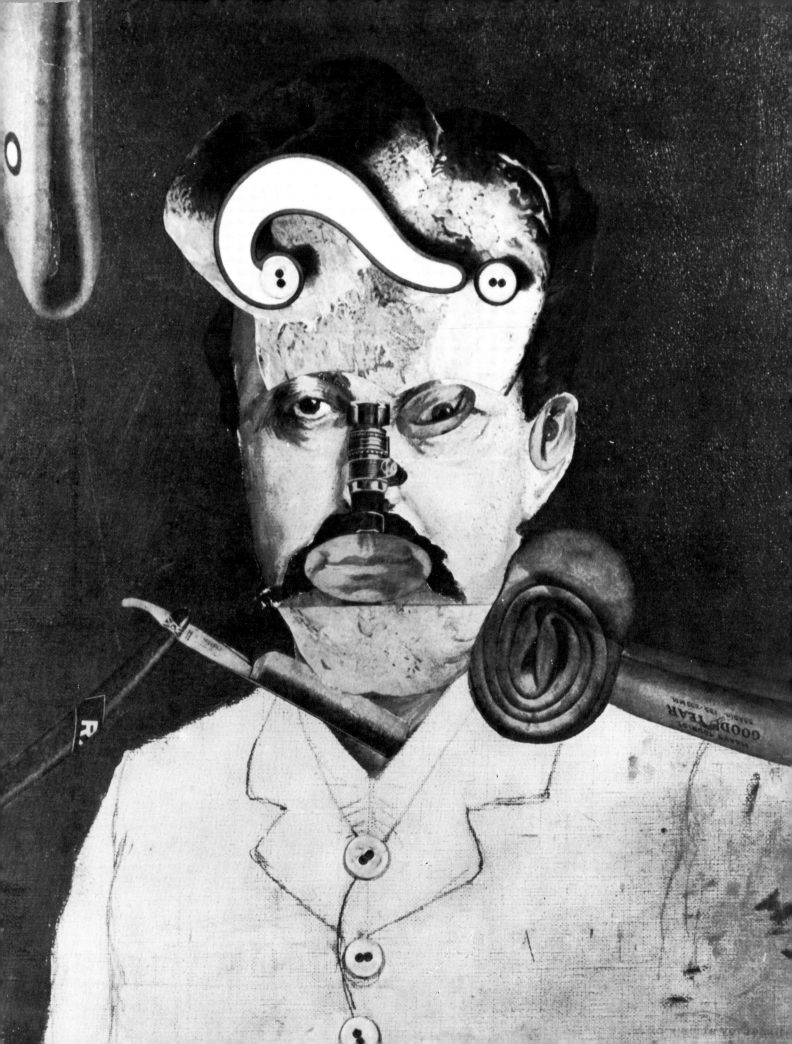

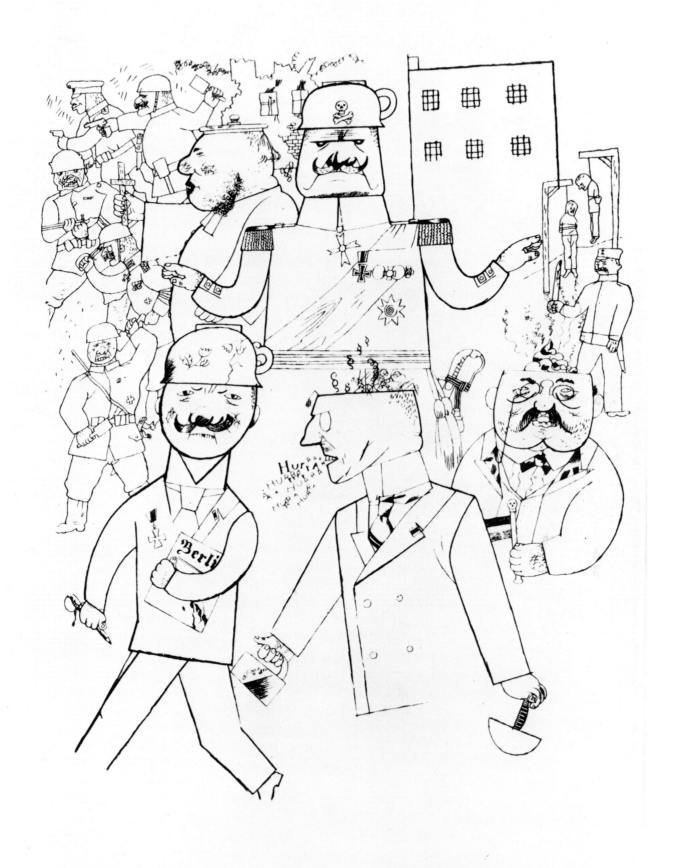

6 Wir treten zum Beten vor Gott den Gerechten!

Heartfield was to persevere with the photomontage medium into the era of Nazism which he pilloried with devastating effect until he was forced into exile in 1933 (plate 39).

The most savage critique of the times was unquestionably that made by Georges Grosz. If Grosz's favourite butts were the ubiquitous military, civil and religious survivors of Imperial Germany, his satire cut both a deeper and a wider swath. Nicknamed 'the saddest man in Europe', Grosz's art reduced all the species of contemporary society – good burghers, mutilated veterans, prostitutes and ragged children alike – to transparent graffiti, figures adrift in a concrete limbo. Although ostensibly a Marxist and member of the Communist Party, Grosz's ferocious drawings unmistakably suggest that he understood evil to be less the product of industrial capitalism than of an incorrigible animality in the depths of human nature (plates 2 and 41).

Kurt Schwitters was a German Dada who had no truck at all with politics and was proud to be considered an artist pure and simple. This solitary, energetic and versatile free spirit was virtually a one-man Dada movement in his native Hanover, where Dada showed its greatest capacity for survival perhaps precisely because there was no one else to quarrel with or stage a schism. Schwitters had broken with Expressionism and representational art in 1918. But this did not satisfy Huelsenbeck when Schwitters applied to join the Berlin Dada Club the following year. Huelsenbeck blackballed him on account of what he called his 'bourgeois personality'. In revenge, Schwitters dropped the word Dada and labelled his subsequent work, his review and even himself 'MERZ' although all three were clearly imbued with the Dada spirit of rupture and reorientation.

Dada's destruction/creation dialectic is admirably illustrated by the medium of abstract assemblage (*Merzbilder*) which Schwitters made his own. He would gather a whole variety of litter off the streets – ticket stubs, paper wrappers, old letters, labels, advertising leaflets, tin-lids – and would then nail and glue them together and finally add colour. Thanks to Schwitters' visual sensibility in his choice of materials and to his subtlety as a designer and colourist, he created a long series of wonderfully harmonious compositions. And in addition to their purely abstract qualities, these *Merzbilder*, by preserving as art so many fragile, despised vestiges of everyday reality, expressed with simultaneous humour and pathos the fleetingness of life. He went on to build a series of 'Merzbau', the first of which in Hanover was a huge architectural-sculptural column that eventually pierced the ceiling of its original room and climbed to the next storey. In 1919 he composed an ironical-sentimental 'Merz-poem', *Anna Blume*, out of a patchwork of cuttings from the popular press, homely sayings and phrases from pop-songs. Five years later came his astonishing *Ursonata*, a hybrid of music and language, a sound-poem based on phonetic vibrations for a solo voice, which takes over half an hour to perform.

Although space does not permit reference to all the places on which Dada left its mark in the years immediately following the Great War,

brief mention must be made, before turning to Paris, of yet one more German city, Cologne, where a highly distinctive Dada offshoot enjoyed a brilliant spell of existence from early 1919 to April 1920. Cologne Dada was animated by the recently demobilized Max Ernst and his friend, Alfred Grünewald. The son of a rich local industrialist, Grünewald had turned Communist militant and adopted the pseudonym of Johannes Theodor Baargeld (cash-money). The two were joined from time to time by Hans Arp, now leading a peripatetic existence between the various Dada centres.

At first, Ernst and Baargeld collaborated on a radical left-wing paper, *The Ventilator*, which was similar in tone and content to the Berlin publications of the time. Distributed at factory gates, the paper is said to have reached a circulation of twenty thousand copies by its sixth issue when it was banned by the British Army of Occupation. According to Hans Richter, Baargeld's father was anxious about his son's political leanings and sought the help of Arp and Ernst. They succeeded in convincing Baargeld that Dada went further than Communism and that its combination of new-found inner freedom and powerful external expression could do more to set the whole world free. In return, Grünewald senior financed the publication of a new international Dada magazine *Die Schammade*. The title of this review, which typically ran for only one number, was a portmanteau neologism which, unpacked, referred to a charade, a witch doctor, and a military signal for retreat.

42. (*Above left*) Kurt Schwitters, *Funny animal*, 1919. Collage with pencil, watercolour, crayon and rubber stamp, 9½ × 7¾ in (24 × 19.5 cm). London, Marlborough Fine Art (London) Ltd.

43. (*Above*) Johannes Baargeld, *Fördebär*, c. 1919. Ink on paper, 19½ × 14 in (49 × 36 cm). Milan, Collection Guido Rossi.

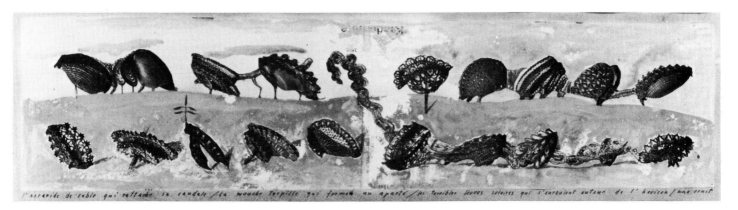

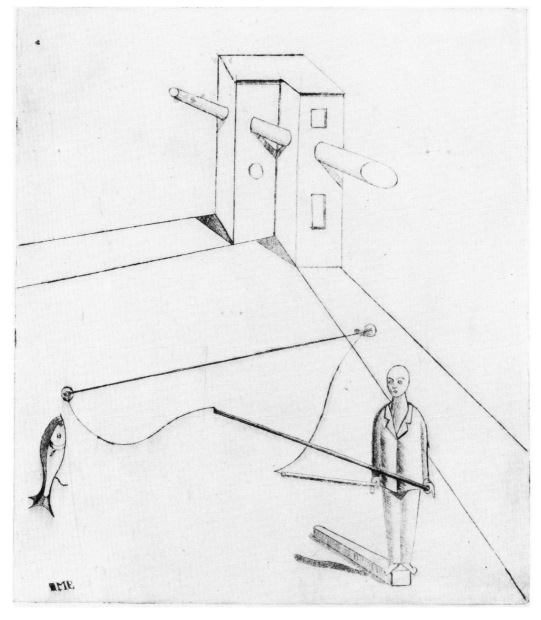

45. (*Above*) Max Ernst, *The Sandworm*, 1920. Collage, gouache and pencil on paper. 4¾ × 20 in (12 × 50.5 cm). Private Collection.

46. (*Left*) Max Ernst, *Etching dedicated to Angelica and Heinz Hoerle*, 1919. Etching, 8 × 7 in (20 × 18 cm). Krefeld, Collection Ernst O. E. Fischer.

44. (*Opposite*) Max Ernst, *Katherina Ondulata*, 1920. Collage with gouache and pencil on paper, 12 × 10½ in (31 × 27 cm). Private Collection.
With mechanical and organic elements almost equally balanced, *Katherina Ondulata* is typical of those Cologne works in which Ernst took a ready-made diagram or mechanical drawing and altered it out of all recognition by overpainting, cutting and pasting. The central figure here is a fragment of highly decorated wallpaper.

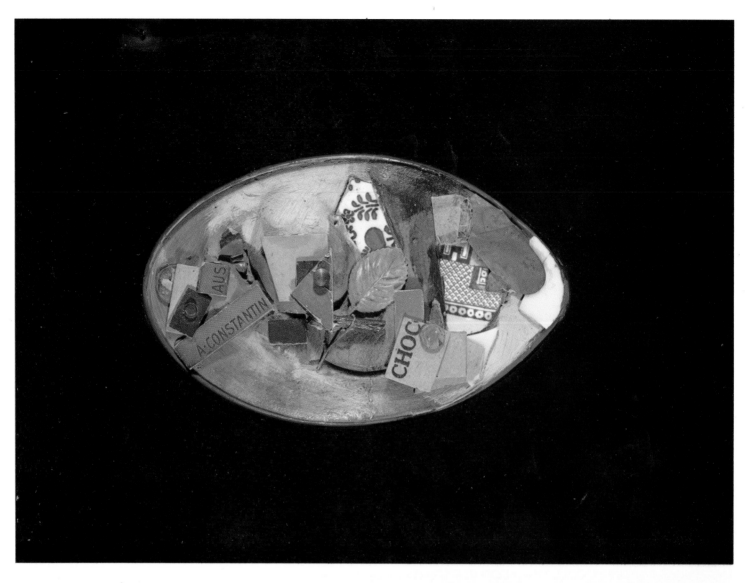

47. Kurt Schwitters, *Mirror Collage*, 1920. Mixed media on ivory with velvet surround, 7 × 4½ × 1¼ in (18 × 11 × 3 cm). Private Collection.

The Cologne Dadas specialized in the creation of group assemblages, the individual contributors to which remained anonymous. They called these productions 'Fatagagas' (*Fabrications de tableaux garantis gazométriques*).

In April 1920, Cologne Dada staged one of the most memorable of the whole movement's exhibitions. It was mounted in the courtyard of the Winter Brewery and could only be entered by way of a public lavatory. Among the 'exhibits' in this 'Dada Spring Awakening' was a young girl in communion dress reciting obscene verses, Ernst's destructible object with an axe beside it and an invitation to hack at it, and a bizarre object by Baargeld consisting of an aquarium filled with red fluid from which protruded a polished wooden arm and on whose surface floated a head of woman's hair.

Much that went on in the fabulous hothouse that was Cologne that year marks the transition between the climate of Dada and that of Surrealism. This was hardly surprising given the key role that Arp and

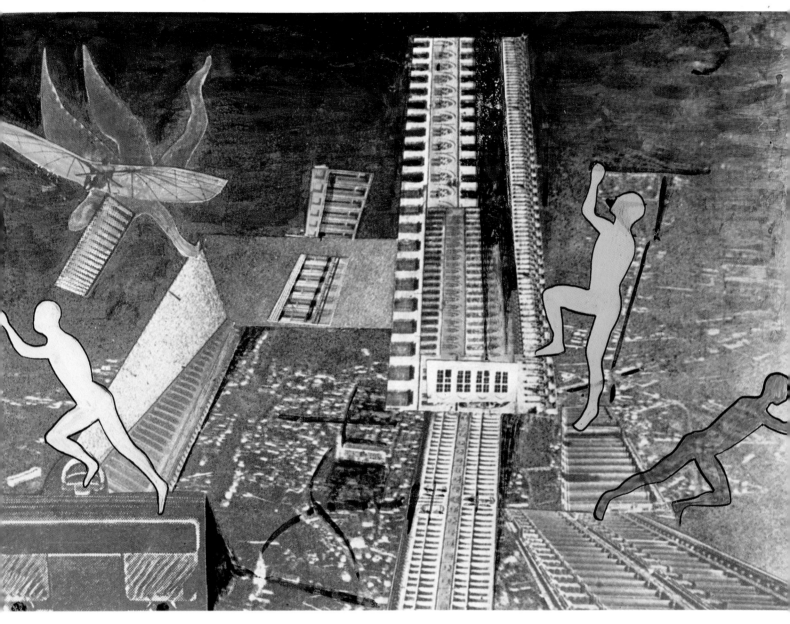

Ernst were so soon to play in Breton's movement. Max Ernst was already making his first collages with components cut out of popular science journals from the previous century. From images which had once celebrated the knowability of Nature, Ernst slyly composed new ones which stressed Nature's primal, bestial and erotic powers and the limitations of reason (plate 44). In the art of Cologne Dada, it was always the fantastic and the poetic that was to the fore, rather than the abstract. The many contributions from French poets to *Die Schammade* further indicate that Cologne Dada was anxious to associate itself with Paris, where Surrealism was already in embryo, rather than with Berlin. The no-man's land between Dada and Surrealism was crossed when Arp left for the French capital in 1920. A seminal exhibition of Ernst's work was shown at the Sans Pareil Gallery in May of the following year. And finally, after endless visa problems caused by his dangerous Dada reputation, Ernst himself reached Paris in 1922 to participate in the advent of Surrealism.

48. Max Ernst, *Massacre of the innocents*, 1921. Collage, 8½ × 11½ in (21.5 × 29 cm). Chicago, Private Collection.

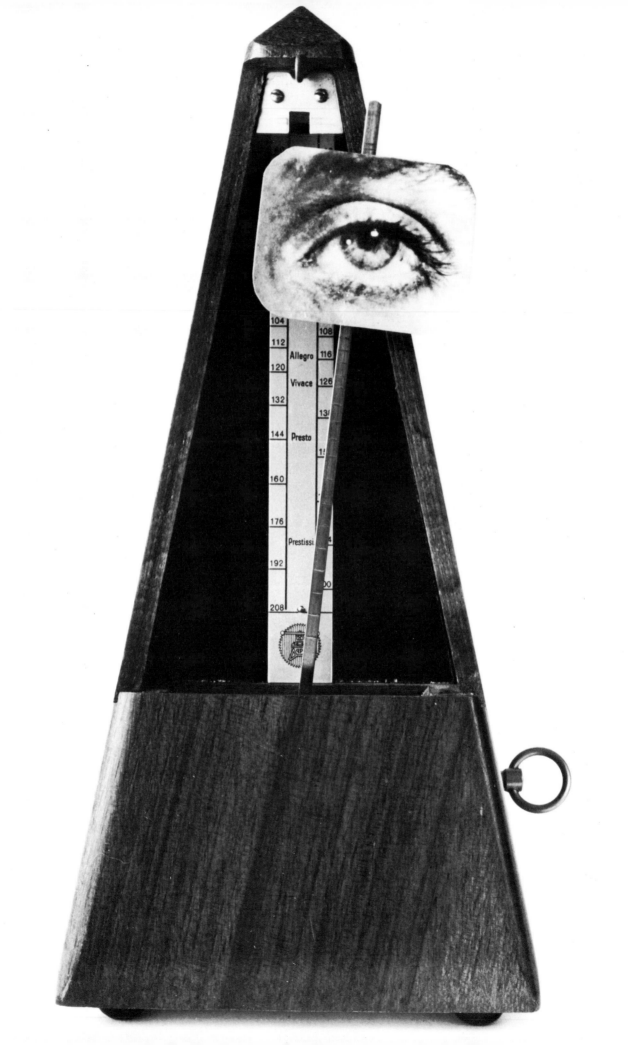

2
Surrealism
versus Dada

Paris was the scene both of Dada's apogee and of its most spectacular disintegration; it was the only city where Dada did not simply fade discreetly away and give place to a resumed, 'business-as-usual' artistic and literary round. Instead, a faction of Paris Dadas stubbornly persisted in their revolt and out of the ruins of Dada built up a movement which was every bit as uncompromising but which showed a much greater gift for survival: Surrealism. The great majority of future Surrealists had been involved in Dada activity which began in Paris in January 1920. The founding charters of Surrealism, André Breton's first *Manifesto* and Louis Aragon's *Une vague de rêves*, were not published until late 1924. There thus appears to be a strong *prima facie* case for thinking that Surrealism was no more than Dada with a changed name and added goals, or, as Michel Sanouillet has argued, was 'the French form of Dada'. In the same vein, Lucy Lippard has said, 'Surrealism is in fact house-broken Dada, postgraduate Dada, Northern fantasy subjected to French lucidity, chaos tamed into order'.[10] It is evident that much more is at stake than historical questions of antecedence or originality. On our reading of this vexed question will depend our whole subsequent understanding and evaluation of Surrealism. In what follows, the view that Surrealism was a derivative of Dada will be directly challenged and an alternative interpretation proposed. This will argue first that the salient principles of Surrealism had already been established by the young Parisian writers prior to and independently of the arrival of Dada in Paris. This is to say that Breton was right when he called the years 1919 to 1925 'the intuitive period' of Surrealism and when he claimed that Surrealism already had five years of uninterrupted experimental activity behind it when the *Manifesto* appeared in 1924. Secondly, it will be argued that, although Dada, as it developed elsewhere, *could* have contributed positively to Surrealism's evolution, it in fact played only a restricted and marginal role in this because of the particular form which Dada assumed in Paris.[11]

Nowhere more accurately than in Paris did Dada correspond to the stereotype that has gone down in history – a compound of noisy demonstrations, destructive humour, categorical revolt and universal doubt. Without Paris Dada our image of the movement would be hazy and obscure. It was the immense magnification of the Dada voice in the capital of European Modernism that added power and significance retrospectively to its earlier provincial cries. With the end of hostilities,

49. (*Left*) Man Ray, *Indestructible object*, 1923. Metronome with photograph of an eye, 9 × 4½ in (22.5 × 11 cm). Private Collection. Originally titled, *Object to be destroyed*, an onlooker took Man Ray at his word, so he named its replacement *Indestructible object*. Like Duchamp's *Why not sneeze?*, the suggestiveness of Man Ray's Dada objects anticipates the 'symbolically functioning' Surrealist objects of the thirties.

50. (*Overleaf left*) Francis Picabia, *Dada portrait*, 1920. Collage. Paris, Musée National d'Art Moderne.

51. (*Overleaf right*) Giorgio De Chirico, *Portrait of Guillaume Apollinaire*. Oil on canvas, 34 × 27 in (86.2 × 69 cm). Paris, Musée National d'Art Moderne.

54

391

Au pluriel

« Une définition n'a jamais été qu'un mal pour un autre — et le commat des mortels l'appelle erreur ».

De plus en plus, de moins en moins. Trois cent quatre vingt onze est un oiseau à poils, la Vierge satisfaite le tient dans ses bras, la pluie des grands jours, un biceps bien tendre, une ombre à plusieurs, les paupières comme des ongles ou les ongles comme des heures ou.

Petit, petit trois cent quatre vingt onze de ma mère et ses liqueurs de dessert, de plus en plus, de moins et moins, une lumière derrière un coup de poing, un coup de poing sur une lumière.

Je suis comme les autres, je vais au café. Aussitôt j'entends : "Garçon un 391 des dimanches ". Je suis discret, je ne répète jamais ce que j'écoute dans les water-closets.

Un aimable désordre simule or n'étant qu'un effet de l'art, j'ai pu enjamber deux ou trois fois dans ma vie une belle religieuse aux cornes d'ivoire, une belle, très belle.

Le livre sur lequel j'écris est ouvert à la page 202.

En le lisant, les Cubistes ont bien pleuré.

PAUL ELUARD.

TABLEAU DADA par MARCEL DUCHAMP

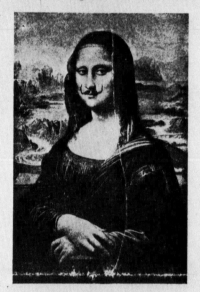

L H O O Q

Manifeste DADA

Les cubistes veulent couvrir Dada de neige ; ça vous étonne mais c'est ainsi, ils veulent vider la neige de leur pipe pour recouvrir Dada.

Tu en es sûr ?

Parfaitement, les faits sont révélés par des bouches grotesques.

Ils pensent que Dada peut les empêcher de pratiquer ce commerce odieux : Vendre de l'art très cher.

L'art vaut plus cher que le saucisson, plus cher que les femmes, plus cher que tout.

L'art est visible comme Dieu ! (voir Saint-Sulpice).

L'art est un produit pharmaceutique pour imbéciles.

Les tables tournent grâce à l'esprit ; les tableaux et autres œuvres d'art sont comme les tables coffres-forts, l'esprit est dedans et devient de plus en plus génial suivant les prix de salles de ventes.

Comédie, comédie, comédie, comédie, comédie, mes chers amis.

Les marchands n'aiment pas la peinture, ils connaissent le mystère de l'esprit..........

Achetez les reproductions des autographes.

Ne soyez donc pas snobs, vous ne serez pas moins intelligents parce que le voisin possédera une chose semblable à la vôtre.

Plus de chiures de mouches sur les murs.

Il y en aura tout de même, c'est évident, mais un peu moins.

Dada bien certainement va être de plus en plus détesté, son coupe-file lui permettant de couper les processions en chantant " Viens Poupoule ", quel sacrilège !!!

Le cubisme représente la disette des idées.

Ils ont cubé les tableaux des primitifs, cubé les sculptures nègres, cubé les violons, cubé les guitares, cubé les journaux illustrés, cubé la merde et les profils de jeunes filles, maintenant il faut cuber de l'argent !!!

Dada, lui, ne veut rien, rien, rien, il fait quelque chose pour que le public dise : "nous ne comprenons rien, rien, rien".

" Les Dadaïstes ne sont rien, rien, rien, bien certainement ils n'arriveront à rien, rien, rien ".

Francis PICABIA

qui ne sait rien, rien, rien.

Dada activists from across the globe converged on the 'city of light': Duchamp and Man Ray came over from New York, as did Picabia, via Barcelona, Lausanne and Zurich; Walter Mehring came from Berlin, and Tristan Tzara and Walter Serner from Zurich; Arp and finally Ernst arrived from Cologne. The hesitant apprenticeship of the early Zurich and Berlin years was long since past. From their very first public evening, the Dadas displayed the fluency and assurance of old hands who were giving Paris the benefit of a performance which had been well rehearsed elsewhere. The strategy for bringing public indignation to a crescendo which Tristan Tzara used in Zurich at the Saal zur Kaufleuten in April 1917 was repeated at the Paris Dada series of soirées, lectures and salons in the first six months of 1920. The experiment and improvisation which had been integral to Ball's and Huelsenbeck's early Zurich entertainments, were now sacrificed to a single calculated end: assault on the public. The technique was to arouse expectations with tantalizing publicity – the Dadas would shave their heads bald, Charlie Chaplin would appear in person, Dada would reveal its sex – and then to disappoint these hopes with insults and nonsense so that the audience would be forced to realize the futility of its motives, to look over into 'the abyss of nothingness'. The major part of these programmes might be given over to manifestos which the Dadas had to bellow to be heard over the hubbub of the infuriated audience. The nihilism of these statements was unparalleled:

'Dada itself feels nothing, it is nothing, nothing, nothing
It is like your hopes, nothing
Like your heaven, nothing
Like your idols, nothing
Like your politicians, nothing
Like your heroes, nothing
Like your artists, nothing
Like your religions, nothing.'[12]

Once the initial shock was over, Paris loved Dada and, by its welcome, gave Dada there a resonance lacking elsewhere. In addition to the Dadas' own flysheets and reviews – *391, Dada, Cannibale, Littérature, Dadaphone, Proverbe, Z, Projecteur,* to name but some – the entire metropolitan press showed itself eager to publicize Dada's eminently newsworthy activities and to collude in the blatant self-advertising which was one of Dada's principal *raisons d'être*. Dada's antics provoked a titillated frisson rather than real anxiety. Erupting well over a year after the Armistice, much later than in its other capitals, Paris Dada was a phenomenon of peace and restoration. Dada provided the funnel through which a great force of youthful high spirits, bottled up for four years by military discipline and censorship, burst out in a fount of extravagant exhibitionism. After military victory, the collapse of a wave of strikes and the election of a strongly conservative government, the Third Republic could afford to tolerate the noisy onslaughts of Dada and rightly suspected that the virus was likely to be as short-lived as it was initially infectious. Thus, Paris was Dada's most effective

52. Francis Picabia, The cover of *391*. New York, Collection of Arthur and Elaine Cohen. Duchamp had added a beard and moustache to the Mona Lisa in his campaign to debunk the reverence bestowed on works of art. He also proposed using a Rembrandt as an ironing-board. The five-letter title, *LHOOQ,* may be read as something like, 'she has a hot bit of tail'. It is typical of Dada nonchalance that Picabia, in making a copy of Duchamp's Dada picture for his magazine cover, should have forgotten the beard.

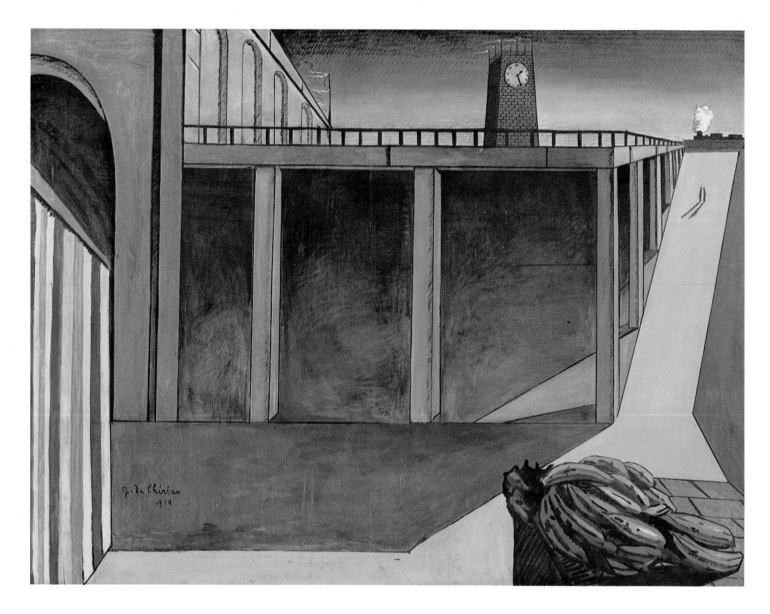

53. Giorgio De Chirico, *Gare Montparnasse
(Melancholy of Departure)*, 1914. Oil on canvas,
55 × 72½ in (139.5 × 184 cm). New York,
Museum of Modern Art (Gift of James Thrall
Soby).

54. (*Opposite*) Giorgio De Chirico,
Metaphysical interior, 1917. Oil on canvas.
Wuppertal, Von der Heydt Museum.

sounding-board, but it trivialized Dada and encouraged its already
marked tendency for empty sensationalism.

The start of Paris Dada in January 1920 was synonymous with the
arrival of Tristan Tzara from Zurich. But it had been well prepared by
the young French poets grouped since March 1919 around the review
Littérature – André Breton, Philippe Soupault, Louis Aragon, Paul
Eluard and Benjamin Péret – who awaited Tzara's coming 'a little like
the Messiah'. Unlike the Dadas of New York, Zurich and Berlin, all
these Parisians had fought in the war and had kept their feelings about it
to themselves until the end of hostilities. Their adherence to Dada was
part of a widespread protest by young French war veterans against their
exploitation by patriotic blackmail, against the nationalist sell-out by so
many intellectual 'consciences' and against the timidity and selfishness
with which the ruling class was leading the nation back to peace.
Littérature's expectations of Dada have to be understood in the light of
the hopes as well as the hatreds of the group. Breton and his friends were
attracted to Dada at a critical point on a poetic itinerary which had begun
just before the war and which, due in part to Dada's delayed arrival in
Paris, had had time to find its own orientation. This orientation was to

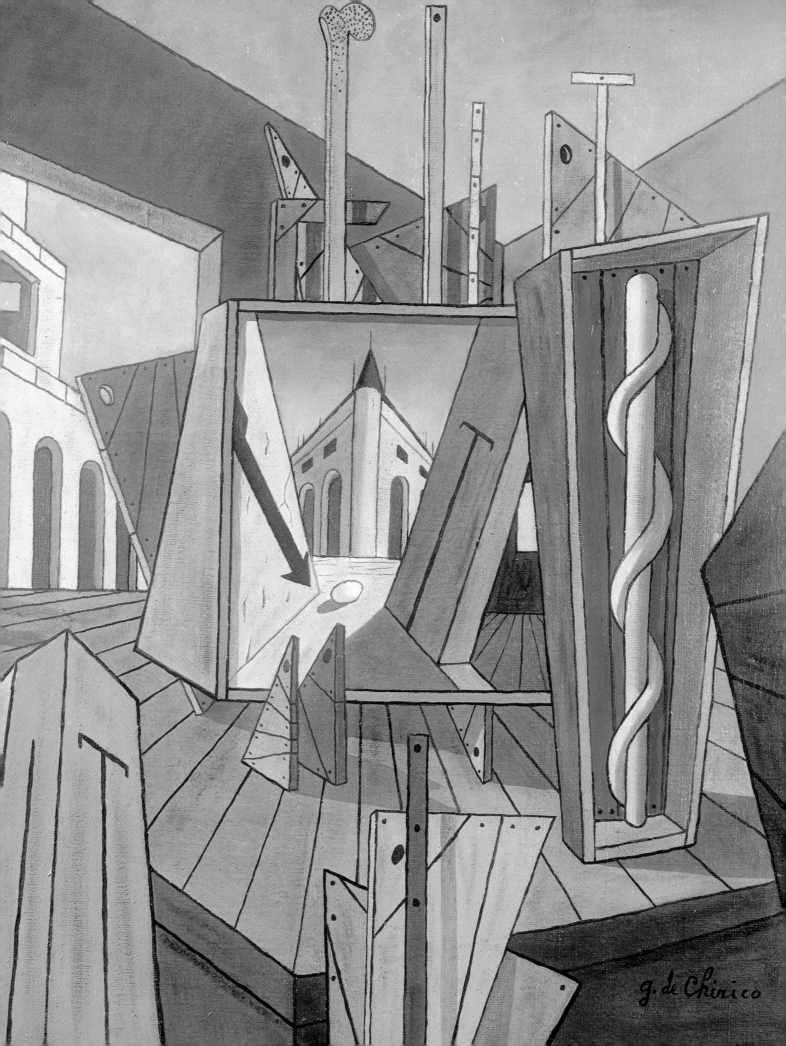

55. Georges Ribemont-Dessaignes, *God on a bicycle*, 1920. Ink, 24½ × 18½ in (62 × 47 cm). Milan, Private Collection.

lead them to Dada, but it was also to lead them beyond it. From the beginning, what united the Paris group was a shared belief in the exalted mission of the poetic imagination and a veneration for a common pantheon of French poets: Rimbaud, Lautréamont and Jarry from the recent past, and Apollinaire, Valéry and Reverdy from their immediate elders. The eclectic and uncertain tone of the first numbers of their review showed them to be struggling with a fundamental inconsistency in their own position. How could their cherished belief in the redemptive power of poetry, its capacity 'to change life', be reconciled with the demoralizing import of their immediate experience in the War? On the one hand, the near collapse of civilization seemed to make the poet's task more urgent. On the other, it cruelly exposed the impotence and corruptibility of language.

In the terms of historical circumstances and a certain indigenous poetic tradition, there was every reason why something like the Dada state of mind should emerge in France. Paris had no need to copy Dada prototypes elsewhere, any more than Duchamp and Picabia had had to in New York in 1915. There was already the homegrown personal example and wartime letters of Breton's friend, Jacques Vaché. Intuitively developing Alfred Jarry's highly idiosyncratic brand of symbolism, Vaché had carried humour to the point of demolishing conviction that anything in life, including the early literary efforts of Breton and his comrades, could be worthwhile. Refusing to grant any reality to the war, Vaché had 'deserted' into himself in much the same way as the German Dadas deserted to Zurich. The *Littérature* group evidently understood Dada to be an enterprise that would force the public at large to undergo the moral shock-treatment of Vaché's 'humour': a sharp and salutary cauterizing operation after which a fresh start could be made. Vaché died of a drug overdose in mysterious circumstances in January 1919.

Catching the *Littérature* group on the rebound from the sudden deaths of Apollinaire and Vaché, Tzara's *Dada Manifesto* of 1918 was bound to strike a responsive chord. Dada promised to rescue these poets, at least temporarily, from their anxieties about the justification for continuing to write. It made writing into a programme of action which permitted poets to jettison self-doubt and to counter-attack. It offered an escape from solitude and incipient boredom and an opportunity for camaraderie in a rash collective adventure. With its dubious foreign reputation and associations with war-time neutralism, it was a red rag to patriots and *bien-pensants*, to the old men who horrified the young poets. As Soupault said, 'Perhaps no one knew what it represented. Its feathers were never fixed. We were passionately committed to making scandals. It was a reason to live.'[13]

But, even before Dada took Paris by storm with its campaign of spring 1920, there were advance warnings in the correspondence exchanged the year before between Breton and Tzara of most of the disagreements which were soon to cause the proto-Surrealists to break with Dada. In the first place, these letters show that Breton still placed

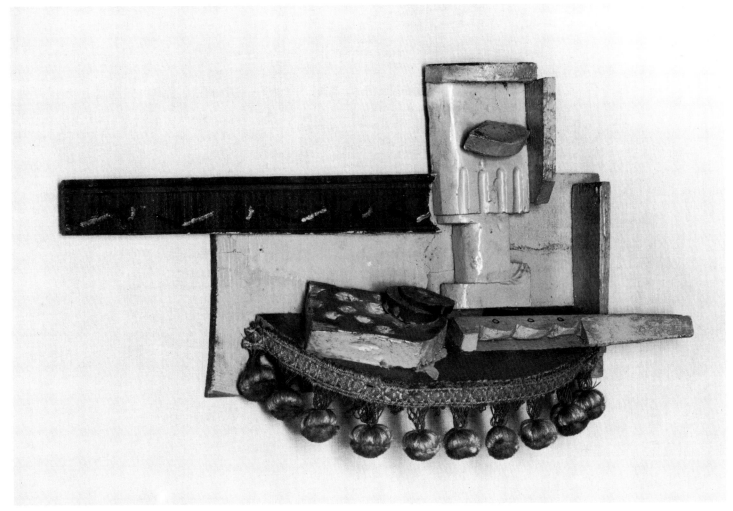

hope in many persons and resources that Tzara had consigned to oblivion in his *Dada Manifesto*. Several times Breton asked Tzara his views about Freud and Jung, even though Tzara had condemned psycho-analysis as an instrument of mystification, as 'a dangerous illness' which 'puts the anti-real tendencies of man to sleep and shores up a declining bourgeoisie'. While Breton and his friends may have distrusted Freud as the doctor who sought to re-integrate the ill-adapted and the dissident into a society which was itself sick, they revered him for his research into the unconscious which, interpreted with different ends in mind, could be seen to contain startling revolutionary possibilities.

Again despite the nihilistic laughter of Vaché, Breton had not really relinquished his belief that the path of liberation had already been marked out by an identifiable band of poets, heretics and dissident moralists. They themselves might be long dead, but their work was still valid. Breton was ready to defend the integrity of this heritage of protest against Tzara's call to abolish all traditions. Breton regretted that his correspondence with Tzara was so literary and said that he would like to know Tzara's feelings about love, for instance. But love, of course, for

56. Pablo Picasso, *Assemblage*, 1914. Painted wood with upholstery fringe, 10 × 19 in (25.5 × 48 cm). London, Tate Gallery. Picasso's role in the Cubist liberation of art from the 'exterior model' earned him the undying admiration of Breton. In 1925 Breton wrote: 'If Surrealism is to set itself any particular line to follow, then it must go where Picasso has gone and will go.'

57. (*Overleaf left above*) Robert Desnos, *Untitled automatic watercolour*, 1924. Watercolour, 16½ × 22 in (42 × 55 cm). Paris, Collection Alain Brieux.

58. (*Overleaf left below*) André Masson, *Enlèvement (Rape)*, 1932. Oil on canvas. Paris, Musée National d'Art Moderne.

59. (*Overleaf right*) Max Ernst, *Pieta or the revolution of the night*, 1923. Oil on canvas. Private Collection.

62

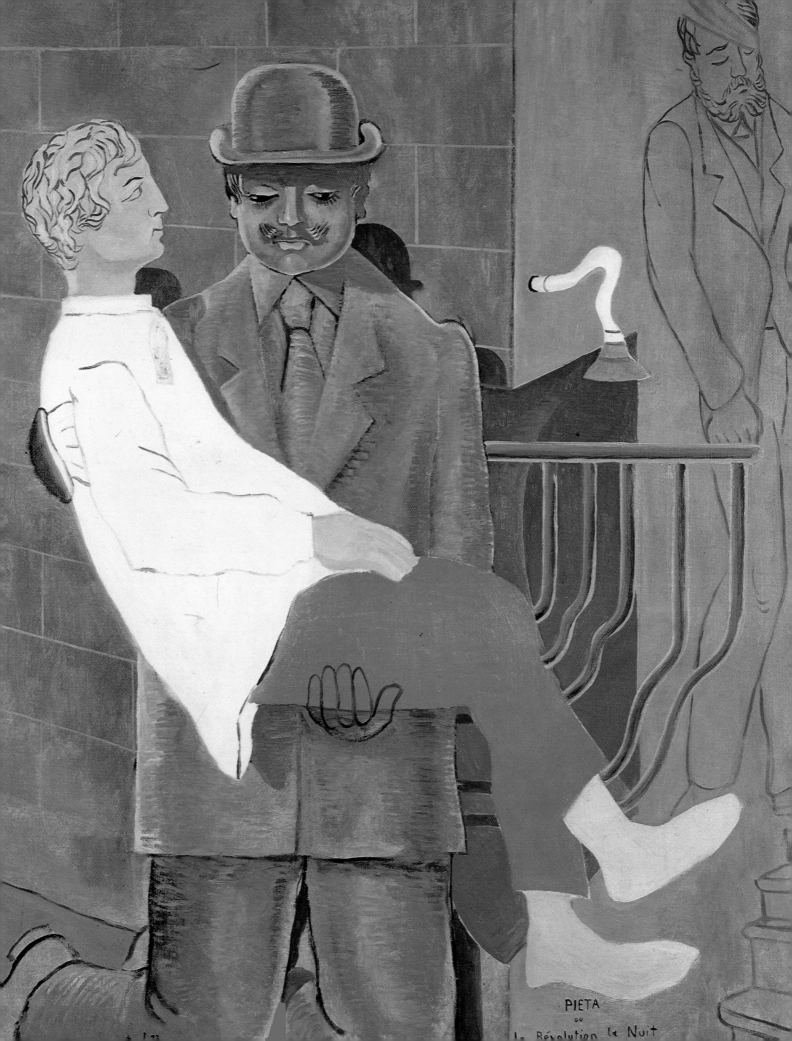

PIETA
ou
la Révolution la Nuit

64

Tzara, was just another shibboleth. Breton expressed doubts whether the shock tactics which Tzara had employed at Dada's last Zurich programme could be successful more than once. His own war experience led him to believe that insubordination should be more surreptitious. In the same context, Breton hinted darkly to Tzara in a letter dated 20 April 1919 that he and his friends were currently 'nursing a project which ought to overthrow one or two worlds', but the preparation of which would take several years. He was undoubtedly referring to the experiments with automatic writing which he and Soupault were conducting that spring. His message was advance notice, however imprecise as yet, of the following five years of creative activity and enquiry which was to continue in the midst of and often against the spirit of Paris Dada, the culmination of which would come in December

60. (*Opposite above*) Max Klinger, *Die Entführung*, plate 9 from *Paraphrase über den Fund eines Handshuhs*, 1881. Etching and aquatint, 4¾ × 6¾ in (11.9 × 16.9 cm). Munich, Staatliche Graphische Sammlung.
The series of engravings telling the story of a lovesick young man and a fetishistic glove executed in 1878 by the German symbolist, Max Klinger, not only made a big impression on De Chirico, but anticipated the mood of troubling eroticism that is so prevalent in Surrealist art.

61. (*Opposite below left*) Arcimboldo, *Water*, late sixteenth century. Oil on canvas, 25 × 20 in (64 × 50.5 cm). Paris, Collection Jean-Jacques Lebel.
Like the visual puns and double images of *fin-de-siècle* postcards, the composite heads by the sixteenth-century Hapsburg court painter, Arcimboldo, prefigured the 'paranoiac-critical method' of Salvador Dali.

62. (*Opposite below right*) Male figure from the Ramu Delta in New Guinea. Wood, 27 in (68.5 cm) high. London, British Museum.
The Surrealists were avid collectors of primitive art, filling their studios with Hopi dolls, masks and figurines from all over the world. They exhibited these side by side with their own work so as to suggest the identity of preoccupations which lay behind them. Unlike the Cubists, who had been most excited by African art, the Surrealists preferred the artifacts of Oceanic cultures for their unmatched freedom of invention.

63. (*Left*) Henri Rousseau, *L'Octroi*, c. 1900. Oil on canvas, 15 × 14 in (37.5 × 32.5 cm). London, Courtauld Institute Galleries.
The 'Douanier's' innocent eye and his ability to find the exotic in the humdrum everyday world made him an important precursor of Surrealist pictorial lyricism.

64. Jean Scutenaire, *From Marat to the Bonnot Gang – the Surrealist Pantheon*, from the Belgian Surrealist review, *Documents 34*, 1934.
The Surrealists were always more ready than the Dadas to acknowledge a line of spiritual ancestors. Among the forebears who could be claimed to have prefigured Surrealism and who are portrayed here are Sade, Hegel, Marx, Lautréamont, Rimbaud, Jarry, Lenin, Freud and Vaché.

65. (*Opposite*) André Masson, *Automatic drawing*, 1924. Ink, 12 × 9 in (30.5 × 23.5 cm). Collection Rose and André Masson.

1924 with Surrealism's declaration of the rights of man through the liberation of the unconscious activity of the mind.

It is hardly an exaggeration to say that all the main differences between Dada and Surrealism crystallized around the significance to be attributed to automatism. The sibylline utterances derived from Breton's and Soupault's exercises in the Freudian technique of free association, carried out in 1919 and published later the same year in *Littérature* under the title, *Les Champs Magnétiques* (Magnetic Fields), reveal all that distinguishes the Dada of Tzara and Picabia from Surrealism. In the first place, these experiments were not inspired by Dada but by the readings in psychiatry which Breton had undertaken as a medical student and as an assistant at the neuro-psychiatric centre of Saint-Dizier in 1916. He already knew of Freud and, in letters to a friend, was using some of the precise phrases – referring to the subject as 'a simple recording machine' of the unconscious murmur, for example – that he was later to employ when describing the automatic method in his 1924 *Manifesto*.

It is evident that Breton's preoccupation with these phenomena in 1916 already stemmed from a concern to elucidate the nature of poetic speech and to identify the source and mechanism of irrational images. Psychic automatism was understood to express the voice of the mind freed from the conventions and limitations of conscious expression. It

andré masson
1924.

was on account of the influence of Freud that Breton and Soupault accorded their 1919 experiments scientific status, varying the speed of their pens and recording the different effects. The results were totally different from the texts supposedly produced 'automatically' by Dadas elsewhere. In Tzara's poetry, for example, the syntax was regularly disrupted, the single word was often the largest poetic unit, potential images were broken off before they were fully formed and recognizable words often gave way to onomatopoeia or simulated African speech. *Les Champs Magnétiques*, by contrast, abounds with fresh and astonishing analogies such as 'our skeletons show through like a tree through the successive dawns of flesh in which the desires of children sleep soundly', and 'the beaches full of those eyes without bodies one meets near dunes and distant meadows, red with the blood of flocks in blossom'.[14] If *Les Champs Magnétiques* followed any models, then these were much more arguably Lautréamont's *Les Chants de Maldoror* (to which the title punningly pays tribute) and Rimbaud's *Les Illuminations*. In practising automatism, Breton and Soupault thought that they had identified the psychic sources of what had hitherto been known as the muse of imaginative inspiration. No wonder that they were, as Soupault recalls, 'transported': 'These experiments led us to consider poetry as a liberation, as the possibility, perhaps the only one, of according the mind the liberty that we had known only in our dreams and of delivering us from all logical apparatus.'[15]

The disagreements between Dadas such as Picabia and Tzara, and the proto-Surrealists who were merely passing through Dada, about the meaning and lessons of automatism had existential ramifications which demonstrate the basic differences between the two movements. For the Surrealists, automatism allowed a speech to be heard which was exempt from the corrupting effect of culture – a voice which expressed, as Breton put it in the 1924 *Manifesto*, 'the real functioning of the mind', and was 'a true photography of thought'. They believed that all men enjoyed equality at this level of mental activity and hence that it provided a common basis for a new mentality. Nothing could have been further from Tzara's ideas; in the *Dada Manifesto* of 1918, he had denounced the notion of a 'common psychic base' as a myth. Dada automatism did not issue from a specific, privileged foyer in the mind, filled with lost or hidden knowledge; it was a cry from the bowels. For Tzara, automatism was a visceral spasm, an explosion of the senses and the instinct which expressed the primitive and chaotic intensity in man and Nature. Where Surrealist automatism was introverted and sought to reveal patterns in the human unconscious, Dada art mimicked an objective chaos. For Arp, as for the Dadas, both chance and the unconscious were impersonal forces, while for Breton they were the key to the exploration of subjectivity. Tzara's Dada, like the machine metaphors of Duchamp and Picabia, implied a tendency towards passivity and resignation. According to the Dada understanding of automatism, as Anna Balakian has so aptly put it: 'the language itself is irrational in structure and content and is offered as symptomatic of man's abject

66. Gustav Moreau, *Salome dancing*, 1876. Oil on canvas, 12½ × 10 in (32 × 25 cm). Paris, Musée Gustave Moreau.
Breton venerated the secluded and little-visited Moreau Museum in the rue de La Rochefoucauld as a temple. Of Moreau's nudes he wrote: 'The particular "type" of these women plunged me into a state of complete enchantment and probably prevented me from recognizing any other type.'

67. André Breton, *Self-portrait: automatic writing*, 1938. Photomontage, 7½ × 4 in (19.2 × 10 cm). Milan, Private Collection. In this relaxed and appealing portrait of the normally imperious Breton, wild horses are shown running out from the plate beneath the poet's microscope. In the background, a girl from a Hollywood musical comedy is struggling to break in.

68. (*Opposite*) Germaine Berton surrounded by portraits of the Surrealist group in 1924, from *La Révolution surréaliste* No. 1, December 1924.
The previous year, this anarchist girl had assassinated one of the leaders of the right-wing league, *Action Française*. The Surrealists were particularly sympathetic to those who stepped outside the law for idealistic and passionate reasons, especially when they were women, such as Berton, the Papin sisters or Violette Nozière.

condition as an automaton deprived of his freedom in a world reduced to automation'.[16] Refusing to give way to Dada's all-pervasive irony which did not spare the Dada himself, the Surrealists would not renounce their vision of freedom even if this required an unremitting quest for the impossible. They saw Surrealism as an attempt to recover control over man's destiny.

Surrealism was to cultivate every experience which permitted the imagination to challenge immediate circumstance and received wisdom or to liberate desire. Like the Romantics before them, they credited language with the power to change life, believing the quality of what we recognize as reality to be a function of our expressive, linguistic structures. They posited an intimate relation between the corruption of the European order and the obsolescence of its forms of expression. While the mental discourse opened up by automatic methods was free

La femme est l'être qui
projette la plus grande
ombre ou la plus grande
lumière dans nos rêves.

Ch. B.

71

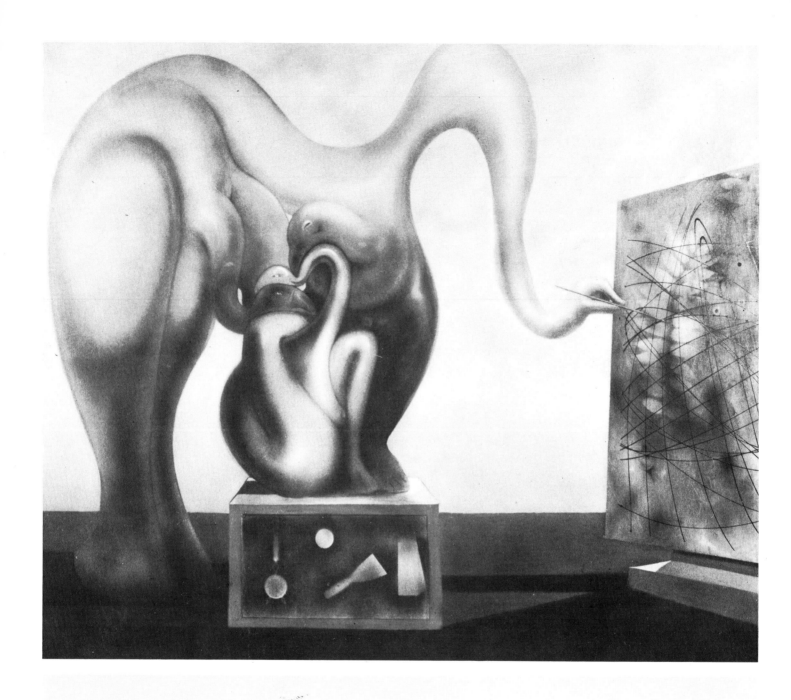

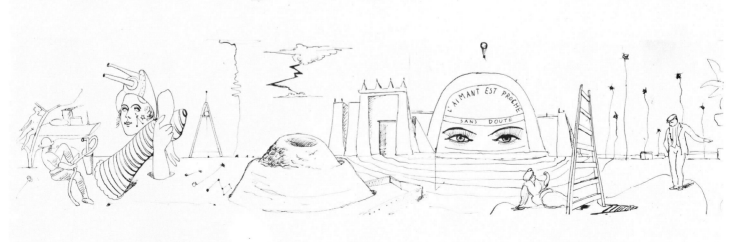

from contamination by an unacceptable culture, it was not arbitrary. It had its roots in an alternative order. It was a natural speech whose authenticity was guaranteed by a Nature that was not yet fully understood and, as far as humanity was concerned, utterly at odds with prevailing systems of knowledge and social organization. The automatic sign was tied to a significance that was latent. As Breton later said: 'The imaginary is what tends to become real'.[17] The automatic exercises of the Dada period were the first indications to the Surrealists that poetry need not be simply a formal exercise, a decorative façade with nothing behind it. Thenceforth, they concentrated on the authentic mental substance and ignored the aesthetics of appearance, which is why so many of the main formal preoccupations of Dada – the mixing of art genres, phonetic poetry, typographic experimentation, abstraction – are absent from Surrealism and why the latter's reviews were always classically sober in presentation. In the end, the results of the automatic writing which had given Surrealism its initial impetus, were rather disappointing. But by then, the movement had developed its own momentum. The Surrealist imagination had acquired a whole armoury of weapons – dream, love, objective chance, the marvellous, black humour and social revolution – with which to smash one 'reality' and build another where man's fate would at last be in harmony with his desires.

It may well be that the clash between emergent Surrealism and Dada could have been avoided, or at least rendered much less dramatic, if Breton's circle had come into contact with the Zurich movement in its inchoate and tentative early days when the more affirmative and even mystically-minded Dadas such as Hugo Ball and Hans Arp were to the fore. On the face of it there could have been much in common between the Surrealists' nascent project and Ball's attempts 'to seize the magical elements of his unconscious', 'to retreat into the secret alchemy of the word', and Arp's use of chance to reveal the elementary forms of Nature. As it was, the picture of Dada which first communicated itself to the Paris poets in 1919 was the already schematized and radicalized Dada of Tzara's *Manifesto*. It was Dada without its 'martyrs and believers' and its 'great dreamers and recluses'. It was also a Dada without most of its painters, since Tzara had quarrelled with the Zurich painters, except Picabia, in the spring of 1919. In the event, Dada came to Paris as the exterminating angel and therefore the scenario of Zurich Dada had to repeat itself there as soon as the questing spirits among the new Dada converts began to tire of the cult of negation upheld by Tzara and broke away to explore more creative perspectives.

The very real bridgehead between the two movements represented by the Cologne work of Max Ernst was not recognized as such. This was partly because the main preoccupations of Paris Dada were literary and 'theatrical' rather than artistic, and partly because Ernst's work did not become known in Paris until May 1921 by which time the break between Breton's and Tzara's factions was well in the making. When Breton and Soupault first saw Ernst's Cologne collages as they were

69. Max Ernst, *Surrealism and Painting*, 1942. Oil on canvas, 77½ × 92½ in (195 × 233 cm). New York, William N. Copley Collection.

70. Max Ernst, *Lesson in automatic writing*, 1924. Detail. Paris, Galerie A. F. Petit.

71. Max Ernst, *The voice of God the Father*, 1930. Collage, 6 × 6¾ in (15 × 17 cm). New York, Collection Rosamund Bernier.

unpacked in Picabia's apartment prior to the Sans Pareil Gallery exhibition, the authors of *Les Champs Magnétiques* were struck with the force of a revelation. In the catalogue introduction for the show which Breton then wrote, he still attributed the impact of the work to its Dada spirit but he defined this spirit in unmistakably Surrealist terms. The incongruous combinations and juxtapositions in these collages undoubtedly reminded Breton of Lautréamont's phrase, – 'as beautiful as the chance encounter on a dissecting table of a sewing-machine and an umbrella' – which was to become a touchstone of the Surrealist conception of beauty. Later, Breton was to write: '. . . we can easily see now that Surrealism was already in full force in the work of Max Ernst. Indeed Surrealism at once found itself in his 1920 collages.'[18] For his part, Max Ernst some time later described his awakening to the possibilities of the collage principle in terms which are very reminiscent of Breton's

72. Max Ernst, *The elephant Célèbes*, 1921. Oil on canvas, 49¼ × 42 in (125 × 107 cm). London, Tate Gallery.
With its proliferation of inanimate phallic objects, its delineation of subjective space, its sombre colours and atmosphere of incipient menace, *The elephant Célèbes*, owes much to De Chirico like all Ernst's proto-surrealist canvases. The title, according to Roland Penrose, who bought the painting from its original owner, Paul Eluard, derives from a scatological German schoolboy couplet.

73. Max Ernst, *Saint Cecilia*, 1923. Oil on canvas, 39¾ × 32¼ in (101 × 82 cm). Stuttgart, Staatsgalerie.
The patron saint of music – her name in French suggests blindness – is presented as a stone colossus whose many eyes stare out of the masonry blocks which, in the manner of Michaelangelo's *Captives*, simultaneously compose her and incarcerate her. One of Ernst's emblematic birds rises towards a 'chord' hanging in the sky while the Saint's hands, as in the children's parlour-game, cast the shadow of a bird's head.

account in the first *Manifesto* of his own dream call to automatism in that same seminal year:

'One rainy day in 1919, finding myself in a village on the Rhine, I was struck by the obsession which held under my gaze the pages of an illustrated catalogue showing objects designed for anthropologic, microscopic, psychologic, mineralogic and paleontologic demonstration. There I found brought together elements of figuration so remote that the sheer absurdity of that collection provoked a sudden intensification of the visionary faculties in me and brought forth an illusive succession of contradictory images, double, triple and multiple images, piling up on each other with the persistence and rapidity which are peculiar to love memories and vision of half-sleep.'[19]

Unlike the Cubists, Ernst chose the elements of his collages not for their material but for their representational qualities. Collage, for Ernst, was a poetic procedure; 'What was only a revolution in plastic art became, thanks to Max Ernst, mental subversion', wrote E. L. T. Mesens. Ernst's use of collage differed not only from that of the Zurich Dadas who pushed further in the formalist, abstract direction of Cubism, but also from that of the Berlin photomontagists for whom the representa-

tional message was much more important than in Zurich. The contrast can be seen even when, as in Hausmann's *Tatlin at home*, the Berliner resorted to the steeply receding perspectives and scattered dreamlike elements which both he and Ernst had found in De Chirico. In the work of the Berlin Dadas, we are primarily aware of the fact of disruption of an original normality; in the work of Ernst we are primarily aware of the magic of a new formation. Ernst presents the most eccentric images as if they were normal and expected. He uses the collage not merely to debunk men and machines but to convey a sense of the marvellous through images which are consistent in their fantasy, narrative in their content and which achieve a convincing dream-like realism. Between 1921 and 1924, Ernst carried over the collage method into monumental oil paintings which employ illusionistic form and space. In *Pietà* (plate 59) and *Of this men shall know nothing* (plate 1), for example, he elaborates a bizarre personal mythology incorporating childhood memories. It is as if Freud has been passed through the distorting mirrors of collage and poetry. And as so often with Surrealism, distinguishing it definitively from Dada, there is the sense of exploration and enquiry behind the fantasy, the presence of 'a critical conscience that sees the need to control and comprehend the meaning of every step in this disturbing experience'.[20]

74. Giorgio De Chirico, *The poet and the philosopher*. Pencil on paper. Private Collection.

The model and point of departure for the early work of Max Ernst, as it was to be also for Magritte, Tanguy, Dali and Delvaux among later Surrealist painters, was the extraordinary series of paintings executed by the Italian Giorgio De Chirico between 1911 and 1919. Breton and Eluard already owned major canvases by De Chirico during the Dada years. Breton stressed his importance in the awakening of Surrealist self-consciousness when he wrote seven years later in *Surrealism and Painting*: 'In times of great uncertainty about our mission, we often looked at the fixed points of Lautréamont and De Chirico, which sufficed to determine our straight line.'[21] De Chirico's art is a naturalism of the inner mind. His deserted townscapes of arcades, mournful piazzas, peopled with statues on their low plinths, represented the psyche as architectural space, or spatial theatre, a conception of fundamental importance for Surrealism thereafter. Everything in the inner space of De Chirico's world is man-made or manufactured; nature is only shown in the form of foodstuffs such as plucked fruit and vegetables. Yet, as Marcel Jean has noted, these products of latterday civilization have become as surprising as ghosts.[22] De Chirico takes perspective, one of the guarantees of the anthropocentric, Renaissance world-view, and so exaggerates and distorts it that it loses any relation with the physical world of time and three dimensions. The density and consistency of De Chirico's images and their opaque tones, emphasize the tangibility of the bizarre repertoire of objects represented. At the same time the unreal light, and the multiple vanishing points with their hints of the infinite, just as emphatically deny it.

The Surrealists immediately recognized the unconscious sexual iconography in De Chirico's paintings. They saw in the obsessive lines

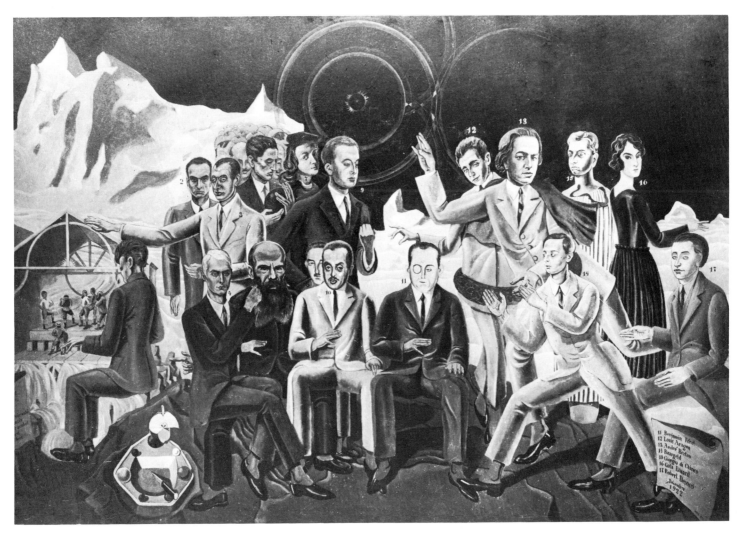

of dark arcades the presence of his dominant mother in whose eyes he was always at fault. And in the statues and the locomotives puffing in the background, they saw allusions to his father, the railway engineer who had died when the artist was sixteen years old. The sense of stillness conveyed by De Chirico's mental landscapes is mixed with anticipation or foreboding. In this disquieting atmosphere of peace, the Surrealists saw nostalgia for pre-natal life or for death, and in the sudden arrivals and departures, reference to the traumas of birth.

The contrast between, on the one hand, the perspectives opened up by the automatic method in poetry and by De Chirico's and Max Ernst's example in painting, and, on the other, the repetitive theatricals of Paris Dada, grew steadily more striking. The concerns of the *Littérature* group from 1920 to 1922 became increasingly lyrical and oriented towards a beckoning future, while Picabia, Tzara and Ribemont-Dessaignes remained exclusively concerned with the here and now. In May 1921, the mock-trial of the nationalist writer Maurice Barrès, staged by Breton, showed that the differences between the two groups were extending from the plane of imaginative expression to that of social commitment. More and more frequently, Breton's circle were applying the word 'Surrealist' – first coined by their mentor Apollinaire to describe his absurdist play *Les mamelles de Tirésias* performed in 1917 – to automatic writing and other new-found methods of exploring the unconscious, for which the term 'Dadaist' was not found appropriate.

76. Max Ernst, *At the Rendez-vous of friends*, 1922. Hamburg, Collection Dr Lydia Ban. 1. René Crevel; 2. Philippe Soupault; 3. Jean Arp; 4. Max Ernst; 5. Max Morise; 6. Dostoievsky; 7. Raphael; 8. Theodore Fraenkel; 9. Paul Eluard; 10. Jean Paulhan; 11. Benjamin Péret; 12. Louis Aragon; 13. André Breton; 14. Baargeld; 15. Giorgio De Chirico; 16. Gala Eluard; 17. Robert Desnos.

75. (*Opposite*) Giorgio De Chirico, *Two Heads*. Oil on canvas. Private Collection.

77. Max Ernst, *The forest*, 1925. Oil on canvas, 45½ × 29 in (115.5 × 73.5 cm). Brussels, Galerie Isy Brachot.
Ernst was haunted from childhood by a feeling of panic and enchantment induced by the all-enveloping atmosphere of the forests near which he was born. Following the discovery of the frottage technique in 1925, he painted many canvases in which he explored these hallucinations.

From the start, Breton's Dada Manifestos had struck a characteristic note. They tended to be proud rather than aggressive, hinting at enticing secrets soon to be revealed, at the possibility of revising life and not merely deprecating it for what it happened to be there and then. He concluded his essay of June 1920 on *Les Chants de Maldoror*, 'Now we know that poetry must lead somewhere.'[23]

Despite the dogged persistence of Tristan Tzara who had invested so much creative capital in Dada, its life-span in Paris, as elsewhere, was bound to be brief. The very energy with which Dada proclaimed its nihilism involved a contradiction which could only be sustained for a short while. Dada lived off acts from which it had to detach itself at the moment it committed them. It swung without respite between formal liberty and living spontaneity, only miming the latter. It being beyond the wit even of Dadaists continuously to reinvent the present, Dada became a stereotype. Its shocks became mere ticks. And nothing could be less Dada than the effort to prolong an activity that had become sterile and repetitive. The impasse precipitated a series of prolonged and acrimonious quarrels within the Dada ranks which soon became more newsworthy than their public provocations. The *Littérature* group tried for a year to bend Dada to accommodate their own embryonic enterprise, but when they met with the resistance of Picabia and Tzara, they had no qualms about dropping the label.

The story of Paris Dada was a tragi-comedy of mistaken identities. It was an unsuccessful attempt to graft a well-rehearsed campaign of radical doubt on to what was already a healthy native growth with its roots in Romanticism. The two movements drew different lessons from similar experience. Tzara's Dada stopped short at parody and mockery; the Surrealists wished to attend to the privileged moments of imaginative life. On the things which Dada opposed, there was general agreement; but on the things which might be loved, there was almost none. Certainly, the moment of Dada was an important stage in the development of Surrealism. Dada made a *tabula rasa* of Symbolist paraphernalia and gave the Paris poets the opportunity to sort out the items of their inheritance which still had worth. Dada was also exemplary as a cultural movement which made a moral and intellectual revolt into a public campaign and it was important as a rallying-point of like-minded individuals. But Dada, in the form it came to Paris, was no longer the open door that it had been in Zurich and Cologne. Indeed the *Littérature* group soon found it to be a corridor that led nowhere.

With Tzara in eclipse, there followed an uncertain period, appropriately called by Aragon '*le mouvement flou*', in which the Surrealist position gradually defined itself by reference to a discarded Dada. This included the 'period of sleeping-fits', seances with hypnosis, journeys without destination across Paris and the recording of dreams. Finally in 1924, the Surrealist *Manifesto* gave full and coherent expression to all that had been obscurely felt since the evening five years before when Breton was troubled by that first insistent phrase from the subliminal world: 'There is a man cut in two by the window'.[24]

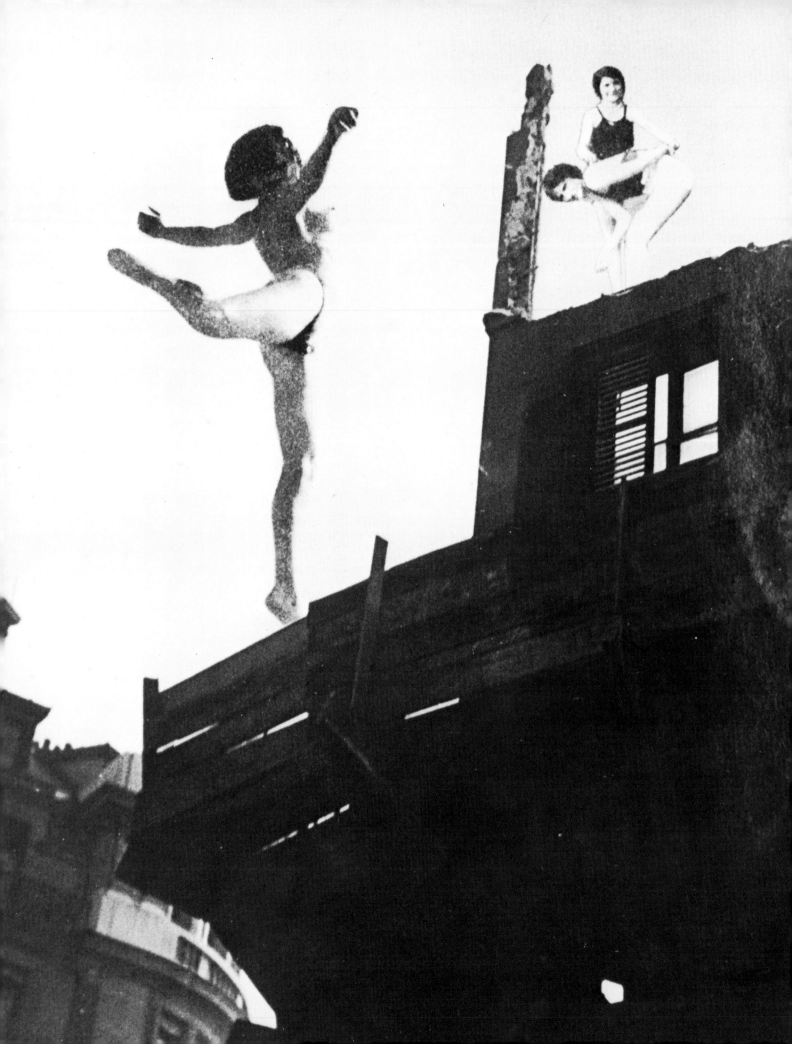

3
The imagery of Surrealism

'Beauty will be CONVULSIVE or will not be at all' (André Breton, *Nadja*, 1928)

'Convulsive beauty will be erotic-veiled, explosive-fixed, magic-circumstantial or will not be at all' (André Breton, *L'Amour fou*, 1937)

Explosive-fixed

As its 'intuitive period' gave way to its 'heroic period' in 1924, the Surrealist revolution burst upon the world with a limitless and desperate confidence in its power to 'change life' by opening up the gates of the marvellous. Like Dada, Surrealism was not a gathering of artists who practised a certain common style but a collective adventure of the mind. Unlike most of Dada, it tried to do much more than merely awaken men to the fact of their alienation. Surrealism proposed that the derisory existence that was the common lot of men was no immutable destiny but rather a remediable, contingent, cultural condition. For Surrealism, the eruption of the irrational and the unconscious into everyday reality was at one with a campaign for untrammelled liberty. The apparently negative operation of 'de-realizing' the real was inseparably linked to the 'de-alienating' of man. If the stability of the anthropocentric world was an illusion, as Dada had shown, then that left the imagination all the freer to accord a new, more generous and open meaning to things and one which took full account of human faculties that were ignored by the utilitarian outlook. As the straitjacket of rationalism fell away in tatters, so those forces of desire within the psyche which rationalism repressed could reassert themselves. Surrealism was to prospect and exploit a vast substratum of mental resources which the Western cultural and economic tradition had deliberately tried to seal off. In place of science and reason, Surrealism was to cultivate the image and the analogy. In its efforts to restimulate the associative faculties of the mind, it turned its attention with respect and enthusiasm towards the thought processes of children and primitive peoples, towards the lyrical manifestations of lunacy and the synthesizing notions of occultism. The Surrealist revolution meant breaking down the barriers which led to fragmented consciousness and to the endless frustration of desire. It would show that phenomena commonly believed to be hopelessly at odds – dream and waking life, conscious and unconscious, the subjective and objective worlds, mental representation

78. Georges Hugnet, *Photocollage*, 1933. 5 × 6¾ in (13 × 17 cm). Paris, Collection Jean Armbruster.

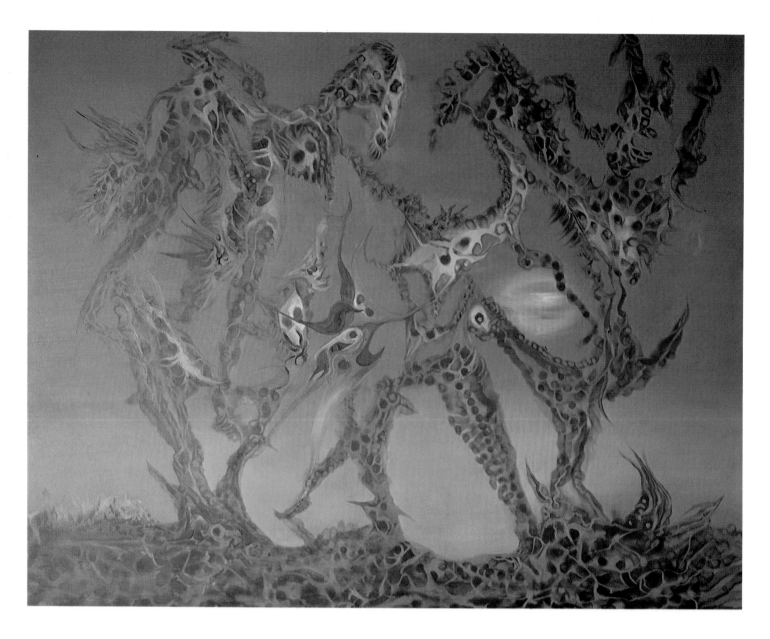

79. Wolfgang Paalen, *Land of Medusa*, 1937.
Oil on canvas, 51¼ × 62½ in (130 × 162 cm).
Paris, Galerie Lefebvre-Foinet.

and physical perception – were, in fact, susceptible of a synthesis which would in turn bring a liberation encompassing the whole human condition.

It might seem far-fetched in the extreme that a movement which began as a series of experiments in language and the visual arts should so promptly set itself up as the harbinger of revolution. But the leap was an easy and natural one for the Surrealists because they believed that the mind's imaginative powers were fuelled directly by desire. There was thus for them little or no hiatus between a changed perception of the world and the actual, objective changing of the world. As the free expression of the imagination, art became an adventure into life itself. Such art was no longer a luxury commodity produced by specialists for the enjoyment of an elite. It was not a diversion but a challenge to the *status quo*. The 'seriousness' of the Surrealists when compared with the Dadas is a measure of the intimacy of the relation that they posited between our powers of expression and the quality of our universe, an intimacy which placed a heavy burden of moral responsibility on the artist. For as he revealed the world that might be, so men would

80. (*Opposite*) Yves Tanguy, *Shadow country*,
1927. Oil on canvas, 39 × 31½ in
(99 × 80.5 cm). Detroit, Detroit Institute of
Arts (Gift of Mrs Lydia Winston Malbin).

84

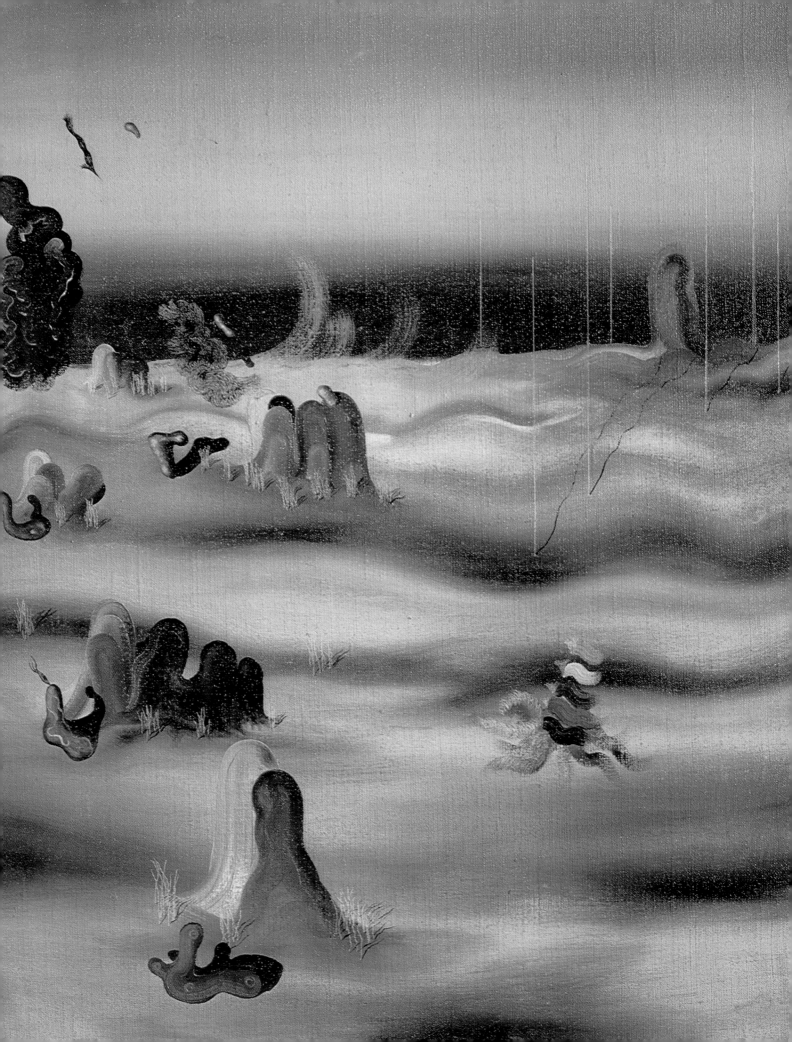

endeavour to convert the potential into the real. The artist was thus leading the struggle to raise reality to the level of man's dreams.

The instrument of this changed consciousness was nothing other than the prime matter of art and poetry itself – the image. So imperious was the authority of images welling up from the unconscious – 'your tongue, the goldfish in the bowl of your voice' (Aragon); 'laughter of a hidden pool where absent-minded prophets go to drown (Péret); 'my wife with eyes of water to drink in prison' (Breton) – that these imaginings, these 'as if's, assumed a reality which ranked alongside the perceptible, tangible phenomena of the exterior world. They were not artificial but part of 'natural history', claimed Max Ernst and René Crevel. Omitting the mediating and distancing 'like' and 'as' of the customary poetic simile, the Surrealist image attained a startling new directness. In free association, as in the dream, the identities which the waking intelligence imposes were dissolved: a coffin could become a womb; a room, a woman; a necktie, the male organ. The Surrealist image brought the fact of interchangeability out of the dream and projected it on to reality. And the image could assume either a verbal or a pictorial form. The medium was a matter of indifference because, as Tristan Tzara was later to put it, poetry (Surrealism) was not a means of expression but an activity of mind. So Dali rehearsed his truculent parade of erotic fantasies in both paint and words. Picasso experimented with automatic writing. Desnos engaged in drawing and nearly all the writers produced collages, poem-objects and other objects. The choice of means was not itself significant because the image bodied forth did not represent anything already given in the world outside but rather a unique thought which had yet to find its form: the image within the mind.

Whether verbal or visual, the Surrealist image performed a three-fold function. First, by juxtaposing elements which reason would deem to be irreconcilable, it disrupted conventional expectations and sabotaged the passive enjoyment of the world. The Surrealists frequently found that the power of an image was in direct proportion to the incongruity of the entities which it brought together.

Secondly, it marked the beginning of an exploration into the un-known and was not, as in traditional art, the end product of the aesthetic imagination which tried to create a thing of beauty or to illustrate a thought or a perception. It was a record of a journey into the interior, to the no-man's land beyond the frontiers of the familiar and of common-sense. The Surrealists' art is often obscure because they refused to sacrifice fidelity to the 'interior model' for the sake of ready accessibility. Instant comprehension indicated a traffic in a false expressive currency which was tied to the contingent, unacceptable *status quo*. The Surrealists believed that the word and the plastic image, when stripped of con-ventional deforming accretions, would gradually come to be under-stood by virtue of the authenticity of the psychic matter in which they were rooted. To paraphrase Wolfgang Paalen, the value of an image did not depend on the accuracy of its representation but on its capacity to

82. Mimi Parent, *The age of reason*, from *La Brèche: action surréaliste*, 1961.
In 1960 Mimi Parent suggested that portrait photographs be taken of members of the Surrealist group which would present them in the costume and décor that, as children, they had dreamed of inhabiting. An accident during the processing contributed to this striking example of 'convulsive beauty'.

81. (*Opposite*) Jindrich Styrsky, *The Statue of Liberty*, 1937. Collage, 12½ × 9 in (32 × 23 cm). Paris, Collection Jean-Jacques Lebel.

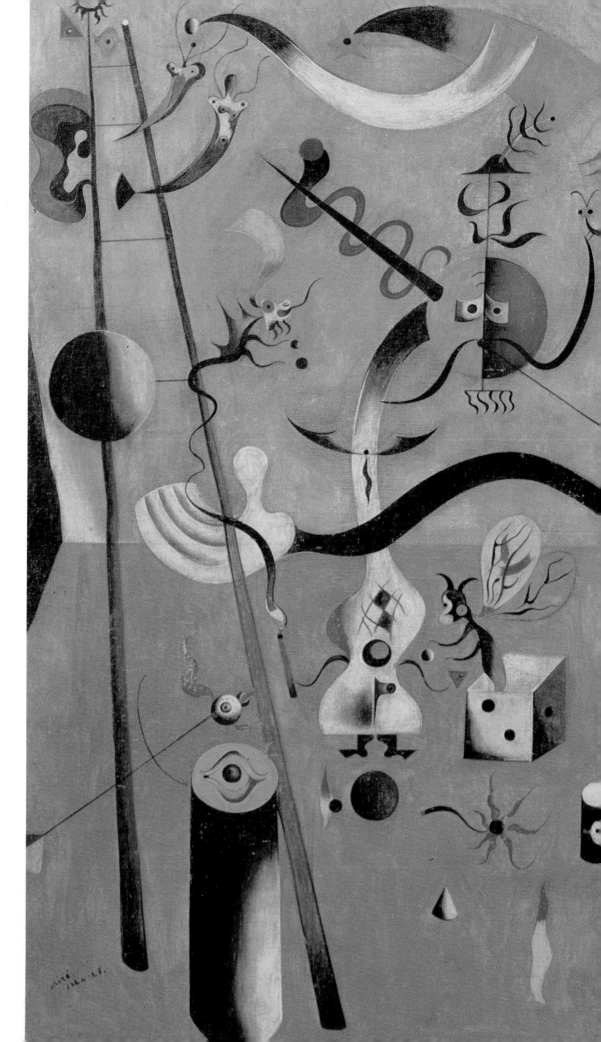

83. Joan Miró, *Harlequin's carnival*, 1924–25. Oil on canvas, 25 × 36 in (64 × 91 cm). Buffalo, Albright-Knox Art Gallery (Room of Contemporary Art Fund).

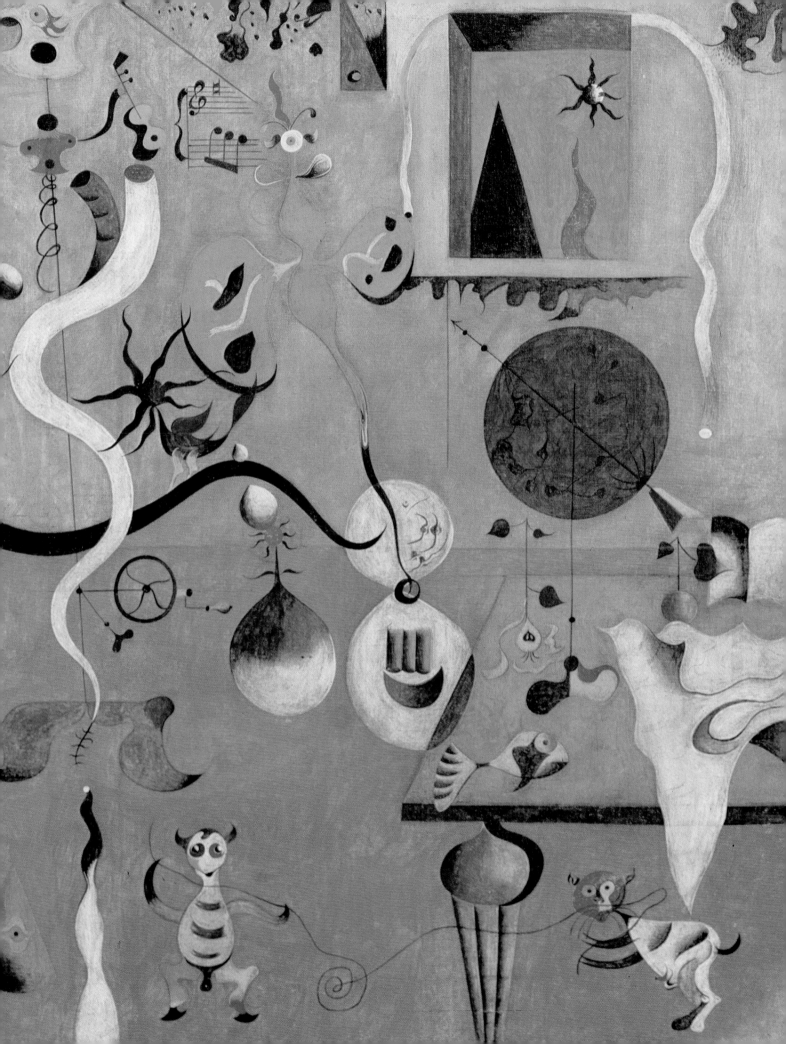

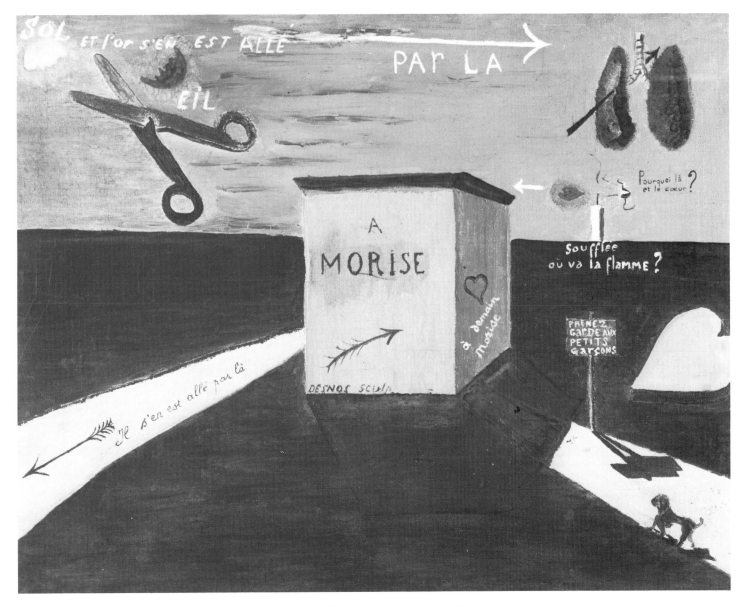

prefigure, to express a new and latent order of things. Finally, and of this more will be said later, the Surrealist image was a revelation of the subtle net of correspondences which linked the individual psyche to forces operating in the external world.

When they wanted to evoke the quality of an image in a painting or a poem, the Surrealists frequently referred to its 'brightness' or 'intensity'. Similarly when Breton wished to verify the aptness of certain analogies – in whose free and limitless play, he claimed, lay 'the key to our mental prison' – he used criteria such as 'disturbance', 'disorientation', 'spark', 'affinity' and 'attraction'. These terms illustrate how the Surrealists judged the effectiveness of imaginative expression not by the conviction it carried in the mind alone but by the 'shock' it caused to the whole sensibility. The Surrealist experience of beauty involved a psychic disturbance which affected both mind and the senses, negating the

84. (*Opposite*) Paul Eluard, *To each his own anger*, 1938. Collage, 12 × 10 in (30 × 26 cm). Private Collection.

85. (*Above*) Robert Desnos, *The death of Morise*, 1922. Oil on canvas, 21½ × 25½ in (55 × 65 cm). Paris, Private Collection.

86. (*Overleaf left*) Yves Tanguy, *This morning*, 1951. Oil on canvas, 36 × 21 in (91 × 53 cm). Collection Selma and Nesuhi Ertegun.

87. (*Overleaf right*) Yves Tanguy, *Through Birds, through fire, but not through glass*, 1943. Oil on canvas, 40 × 35 in (102 × 89 cm). Minneapolis, Minneapolis Institute of Arts (given in tribute to Richard S. Davis by Mr and Mrs Donald Winston).

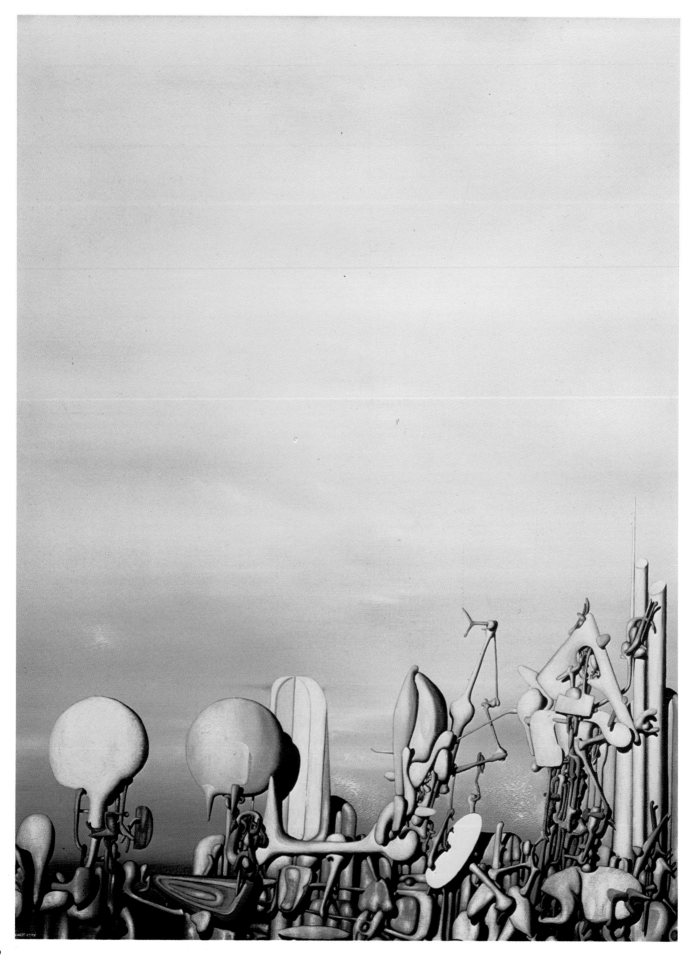

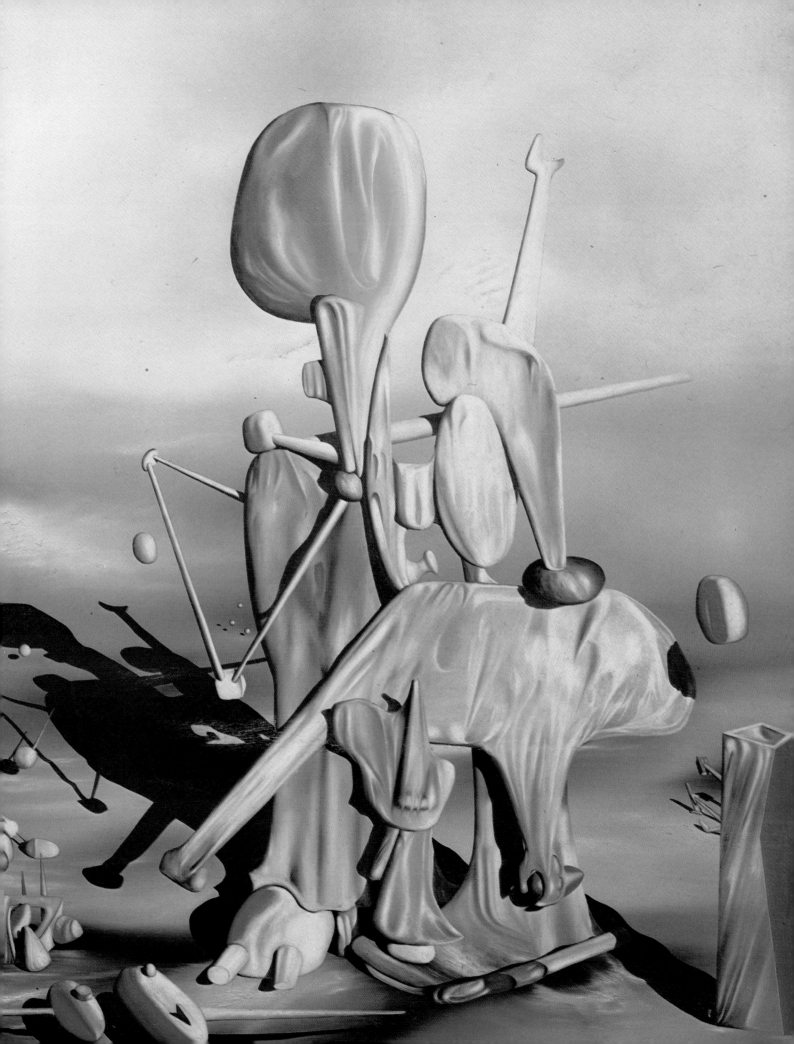

88. Max Ernst, *The woman with an hundred heads opens her august sleeve*, 1929. Collage on paper, 12 × 5½ in (30.5 × 14 cm). Collection D. and J. de Menil.

89. (*Opposite*) Max Ernst, a collage from *A week of happiness*, 1934.
In a similar spirit to Buñuel's and Dali's film *L'Age d'Or*, which dates from the same period, Ernst's collage 'novels' of which this was the last, delight in exposing the frenzy that often underlies outwardly respectable behaviour. Quite simple additions to anodine illustrations in nineteenth-century popular literature, such as the animal heads given to figures in the 'Lion of Belfort' section of *A week of happiness*, sufficed to convert them into savagely ironical homilies on the vagaries of modern man.

distinction between thinking and feeling. In this, of course, they were entirely consistent because the unconscious which they had set out to rehabilitate was the seat of the libido, of pre-conscious desire, as well as being the source of imaginative inspiration. The Surrealist aesthetic was thus defined in terms of desire. Beauty caused a 'frisson' which Breton likened to 'a great rustling of leaves surging through the poplars of my blood' and to 'a plume of wind at the temples'.[25] In place of the traditional aesthetic of imitation, the Surrealists took literally Diaghilev's watchword 'Astonish me' and proposed an aesthetic of absolute originality. For the traditional aesthetic founded on the idea of the aptness of the relations between an idea and its expression, between subject and context, the Surrealists substituted an idea of beauty based on noncoincidence and unlikelihood. The 'convulsive beauty' aspired to by Surrealism is troubling, effervescent and incomplete; it does not permit of quiet contemplation. It delights in the precarious tension generated by combining opposites such as the static and the dynamic, the banale and the baroque, the ideal and the obscene. Once recognized, this convulsive quality emerges as the most distinctive trait by which to identify the Surrealist presence not merely in an image but in lived experience also. It encompasses the unexplained enigma, the short-circuited metaphor, the overheard remark, the fetish, the fortuitous meeting which jolts the motor of consciousness into higher gear, the black humour of the condemned man who is able to laugh even at the foot of the scaffold, the street-sign which beckons with the promise of some unspecified revelation. . . .

The Surrealists resorted to painting because, 'lamentable expedient' though it was, it remained the best way of recording the inner life, of

90. Joan Miró, *The cry*, 1925. Oil on canvas, 35 × 46 in (89 × 116 cm). Private Collection.

endowing subjective imaginings with the forms of reality, of projecting desire and of making men see. And they were always more interested in the spirit that informed a painting than in its formal qualities. Art, whether of the word or the plastic image, was only one of the manifestations of a movement with its own metaphysic, ethic and sensibility. Several active Surrealists in Breton's circle produced neither art, literature, objects nor films. Art works were so many traces left behind in the course of a spiritual quest. They were evidence of an adventure but hardly the purpose of it. They were expressions of a theory which demanded not just illustrations but also action. So although we may look for the distinctive 'convulsive' quality, it is a waste of time hoping to find a common style or technique in all the works which the Surrealists claimed as their own, even those by the artists named by Breton in his *Surrealism and Painting* in 1928. Part of the answer to the problem of the identity of Surrealist art is provided by the shock-phrase with which the book opens – 'the eye exists in a savage state' – which, like Marx's and Engels's 'A spectre is haunting Europe . . .' was not so much a statement of fact as a programme. All the artists discussed by Breton nurtured an eye which was undistorted by conventional perceptions of the world, an eye whose untamed vision shared the same freedom that automatism

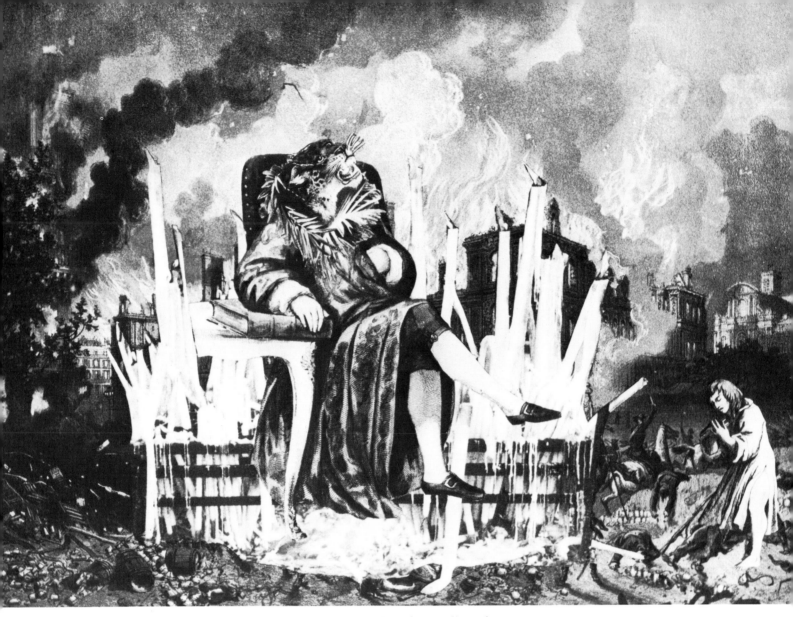

91. Jacques Prévert, *Puss in boots*, 1951.
Collage, 10 × 14 in (25 × 36 cm). Milan,
Private Collection.

had won for the poet. Surrealist painters referred only to 'interior models': wild landscapes of the unconscious which were the hunting grounds of the 'savage eye'. For Breton, the Surrealist painter was first and foremost a 'seer' whose Surrealism lay not in the operation of his hand but in that of his 'inner eye'. Thus Surrealism in painting embraced styles as different as the illusionistic 'magic mirrors' of De Chirico or Dali, and the rhythmic automatism of Miró or Masson. It was immaterial whether the painter painted a dream or as if in a dream. What counted was something which was, to use Max Ernst's phrase, 'beyond painting'; it was the artist's drive for spiritual emancipation.

Given the eventual success of the international language of its painting in communicating the Surrealist vision, it is surprising that, as late as the spring of 1925, members of Breton's group were still arguing whether painting could ever be Surrealist. Pierre Naville, the co-editor of the first numbers of *La Révolution surréaliste*, argued that, outside the hands of mediums, painting and sculpture would never be able to attain the fidelity to the subconscious message which was reached through words. Even if the artist did not preconceive his painting in its final form, there was bound to be re-touching. Naville and others could take this intransigent line because Surrealism in its formative years had

97

92. Max Ernst, *She keeps her secret*, 1925. Pencil and gouache on paper, 17 × 10¼ in (43 × 26 cm). Private Collection.

93. (*Opposite*) Max Ernst, *A flanc d'abine*. Pencil and gouache on paper. Private Collection.

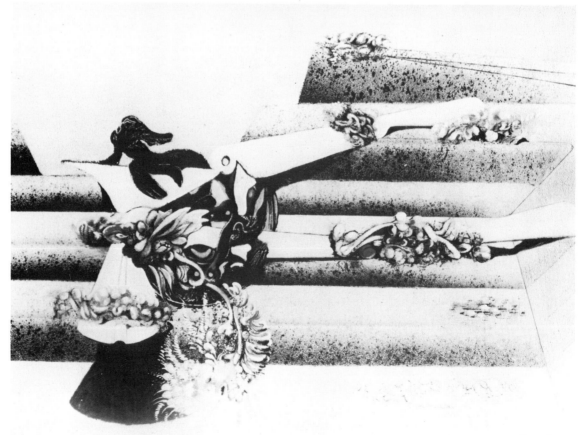

distinguished itself from Dada and other avant-garde movements precisely by its cultivation of automatism. Thus, although the paintings of Ernst and De Chirico drew on the hallucinatory material of the preconscious, the fact that they were not automatically executed disqualified them at this stage. Breton himself was hesitant and, despite the enthusiasm he showed in *Les Pas perdus* (1924) for all radical manifestations of the *ésprit nouveau* in painting since Cubism, relegated the subject to a footnote in the first *Manifesto*. His 'encyclopaedia definition' of Surrealism, however, prudently opened the way to a wide range of possible means of expression:

'Surrealism, n. Masc. Psychic automatism in its pure state by which one proposes to express – verbally, by means of the written word, *or in any other manner* – the actual functioning of thought.'[26]

No sooner said, than the sheer proliferating abundance of indisputably Surrealist art settled the issue and the first group exhibition was held at the Galerie Pierre in November 1925, bringing together work by Arp, De Chirico, Ernst, Klee, Masson, Miró, Picasso, Man Ray and Pierre Roy.

Painters such as Masson and Ernst were prompt to discover methods which were the pictorial equivalents of automatic writing. Masson would let his pen move over the paper according to its own 'inner rhythm', the wandering line spinning an elusive, intuitive, symbolic imagery of fruit, birds, fish, women's breasts, and open hands. In 1927, he moved on to automatic painting in which he scattered sand onto pools of glue on the canvas, building up successive layers on which he drew rapid lines and added a few traces of colour. Meanwhile, Max Ernst was looking for ways of 'irritating his perception', of provoking utterly original visions in his receptive mind with the help of chance. As a child he had unwittingly followed Leonardo da Vinci's advice to his pupils to stare at old walls on which the plaster was cracked and stained, to discern in the suggestive visual confusion, hidden faces, horsemen and dancers. In August 1925 this kind of exercise led Ernst, who had already invented the Surrealist collage, to make his second great contribution to pictorial Surrealism: the 'frottage', literally rubbings taken from all kinds of everyday materials such as planks of wood, leaves, sackcloth, brush marks on paintings and unravelled thread. After travelling through 'a field of vision limited only by the capacity of irritability of the mind's power', the direct impressions of the rubbings were transformed – wood grain into lofty slatted walls, wafer into the surface of the sea, leaves into moth's wings – to become faithful images, not of anything in external reality, but of the artist's own hallucinations. Combined with collage, scraping and combing and other means, a modified 'frottage' technique permitting the interaction of technical stimulation and intellectual control was to contribute to many of Max Ernst's most stupendous canvases in the following years (e.g. plates 117 and 121).

'Frottage' exemplified an appealing paradox: the more 'objective' the technique, the more enriching was its potential as vehicle for

94. Max Ernst, *The horde*, 1927. Oil on canvas, 45 × 57½ in (115 × 146 cm). Amsterdam, Stedelijk Museum.

95. Max Ernst, *Jardin Gobe-avions (Garden aeroplane trap)*, 1934. Oil on canvas, 16 × 24 in (46 × 61 cm). Switzerland, Private Collection. The black humour of a certain 'autumnal cannibalism' flickers in this series of pictures which Ernst described in *Beyond Painting* as 'voracious gardens in turn devoured by a vegetation springing from the debris of trapped aeroplanes'.

101

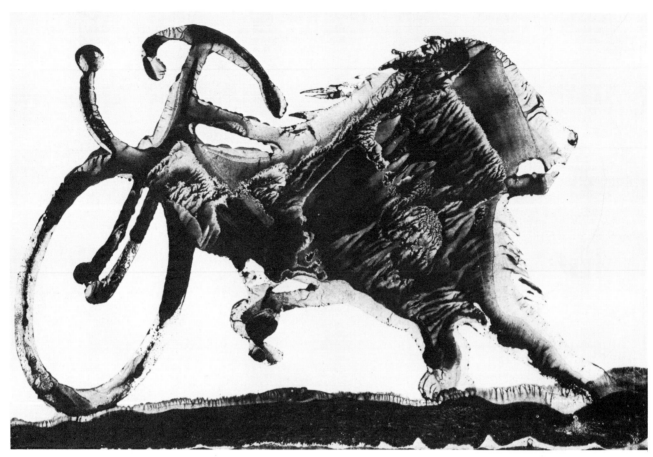

98. (*Above*) André Masson, *Massacre*, 1931.
Oil on canvas, 47¼ × 62½ in (120 × 160 cm).
Paris, Private Collection.

99. (*Left*) Joan Miro, *Photo, Ceci est la couleur de
ma rêves (Photo: this is the colour of my dreams)*,
1925. Oil on canvas, 38 × 51 in
(96.5 × 129.5). Private Collection.

96. (*Opposite above*) Oscar Dominguez,
Untitled, 1936. Decalcomania, 6 × 8½ in
(15.5 × 22 cm). New York, Museum of
Modern Art.

97. (*Opposite below*) Georges Hugnet, *Untitled
decalcomania and collage.* 12½ × 15½ in
(31.5 × 39.5 cm). Paris, Jean Armbruster.

100. Alberto Giacometti, *The palace at 4 a.m.*,
1932–33. Pen and ink, 7½ × 9½ in
(19 × 24.5 cm). Basle, Kunstmuseum.

expressing the artist's subjectivity. The Surrealists were to invent or
exploit a whole repertoire of devices for provoking inspiration and for
checking interference by the censors of the conscious mind. In 1935,
Oscar Dominguez began making his 'decalcomanias without any
preconceived aim'. This meant applying paint at random to a smooth
surface, pressing a second sheet upon it and then peeling it off. As with
frottage, the product could become the starting-point for a new inter-
pretation or it could be left as it was. In the same year, Wolfgang Paalen
started using a method called 'fumage' which involved working from
the smokey traces left on a surface by a candle-flame. Man Ray devised
equivalent processes for photography such as his 'Rayograms' and
'solarizations'. Quite often, as with the verbal or drawn version of the
'*Cadavre exquis*' (Exquisite corpse) which was based on 'Consequences',
these procedures were appropriated from age-old children's games and
pastimes adapted to serve Surrealist ends.

The purity of the automatism at work in Jean Miró's paintings from
1924 backed by his declared intention to 'murder painting . . . and to go
beyond the plastic fact to attain poetry' led Breton to acknowledge that

101. (*Opposite*) Man Ray, *Erotic-veiled*.
Photograph. Private Collection.

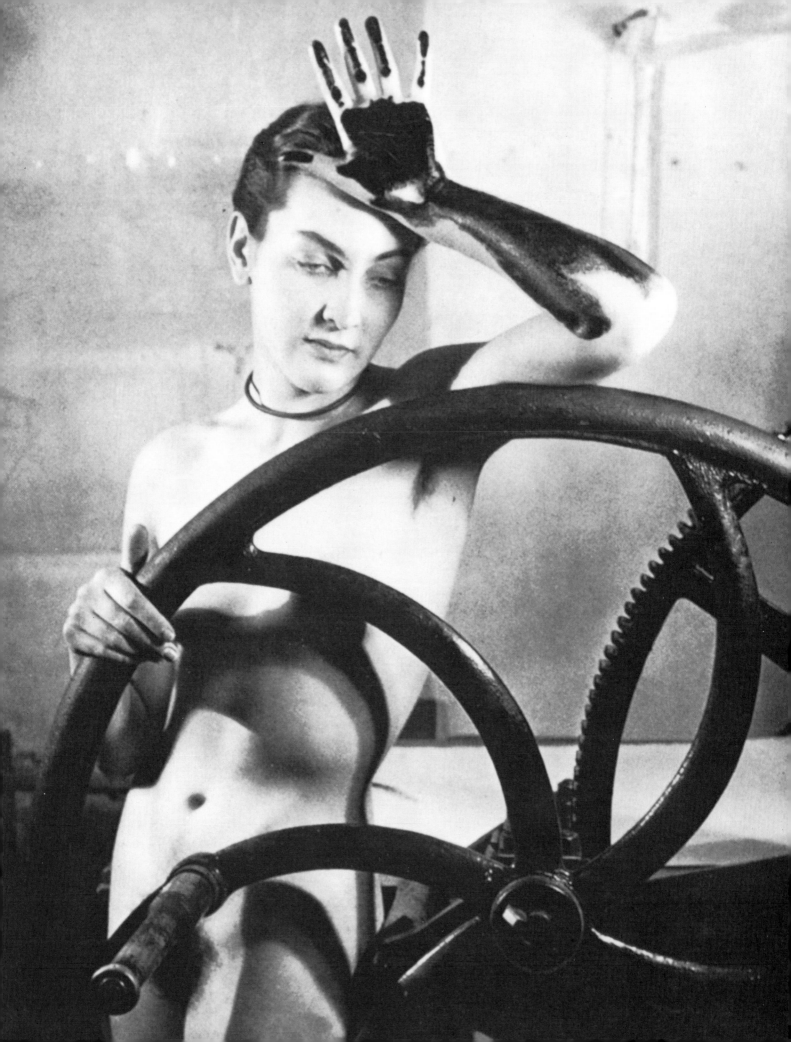

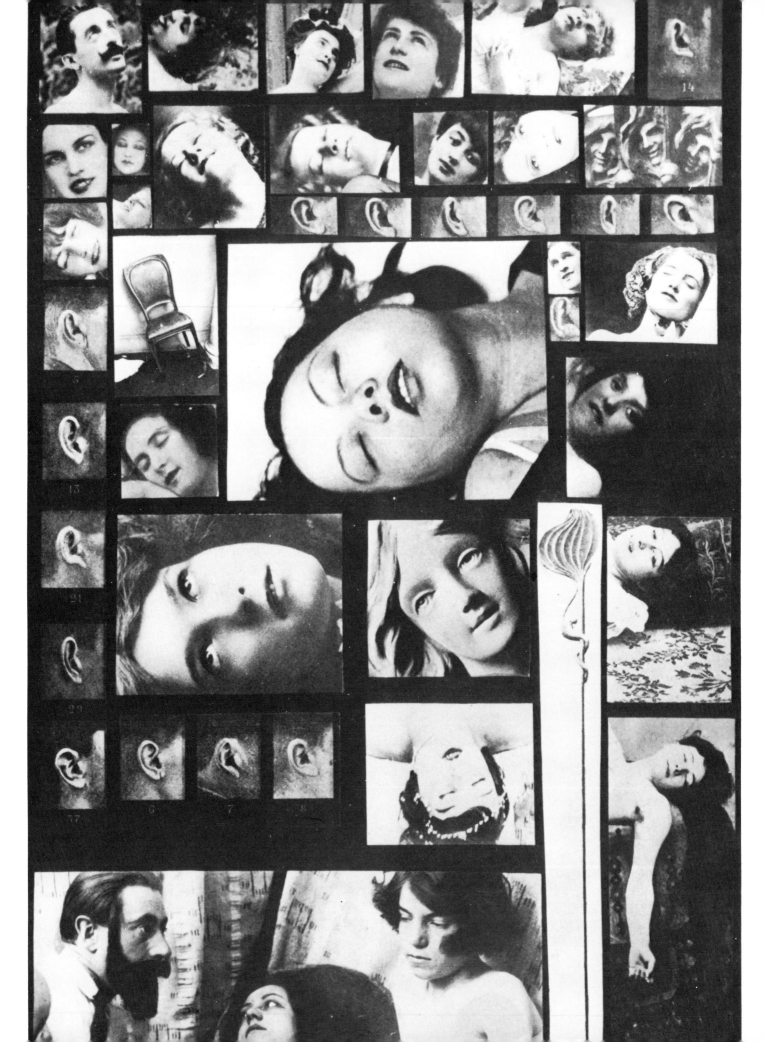

Miró could pass for being the most 'Surrealist of us all'. Christian Zervos was later to describe Miró's 'rhythmic automatism':

> 'Miró no longer prepares his paintings; he gives them not the slightest thought in the world before taking brush or pencil in hand . . . The forms install themselves on the canvas without a preconceived idea. He begins them by spilling a little colour on the surface and then circulates a dipped brush around the canvas. As his hand moves the obscure vision becomes more precise.'[27]

Miró drew from the hallucinations induced by the hunger of his impoverished early days in Paris. His imagery recalls a child's disinterested search for certain elemental features of the existence of organic beings: simple cells, rudimentary foetal figures, the circle of the breast, moons, shapeless protozoan lumps, corded placentas – a spontaneously generated biomorphic universe in an apparent disorder which gradually reveals its own logic and harmonious structure. Miró's work embraces a great variety of moods from the whimsical and hugely animated canvases of the twenties to works full of sombre foreboding and feverish colour like his premonition of the civil war in *Still life with old shoe* (plate 112). His pictorial language was composed of the simplest shapes but, as is true of all Surrealist art, these remained figurative: 'For me a form is never something abstract; it is always a sign of something. It is always a man, a bird or something else. For me, a painting is never form for form's sake.'[28] Miró's pictures often resemble calligraphy or hieroglyphics. In several of the great, airy canvases from the twenties, words and letters are the main features of the composition. Breton was to suggest the world itself should be interpreted like a cryptogram; Miró's paintings can be read as so many keys to the deciphering of that 'forest of symbols'.

The Surrealists did not delude themselves that artists as accomplished as Miró painted entirely at the dictates of their unconscious. If Ernst was a 'blind swimmer' at the first stages of a frottage, the moment eventually came for careful calculation. By 1933, Breton had modified his position on automatism, which he now regarded as an ideal of pure inspiration to be aimed at rather than as the only source of authentic Surrealism. It was acknowledged that Surrealists would combine automatism with premeditated intentions, but Breton added the proviso that 'one runs a great risk of moving away from Surrealism if automatism stops making its way, at least as an undercurrent.'[29] At the same time, Surrealism recognized as its own a type of painting which, rather than evolving from the unconscious process itself, consciously and realistically recorded a prior experience from the unconscious. In the footsteps of De Chirico, many Surrealists were reproducing in a state of lucidity images which had already been registered by the conscious mind and owed only their origin to dream. Painters such as Dali, Magritte and Delvaux applied a meticulously realistic technique to fantastic subject matter or to familiar objects which they placed in surroundings so unusual that they become fantastically disorientated. The same was true for the sculptor Giacometti whose *Palace at 4 a.m.*

102. Salvador Dali, *The phenomenon of ecstasy*, 1933. Composite photograph.

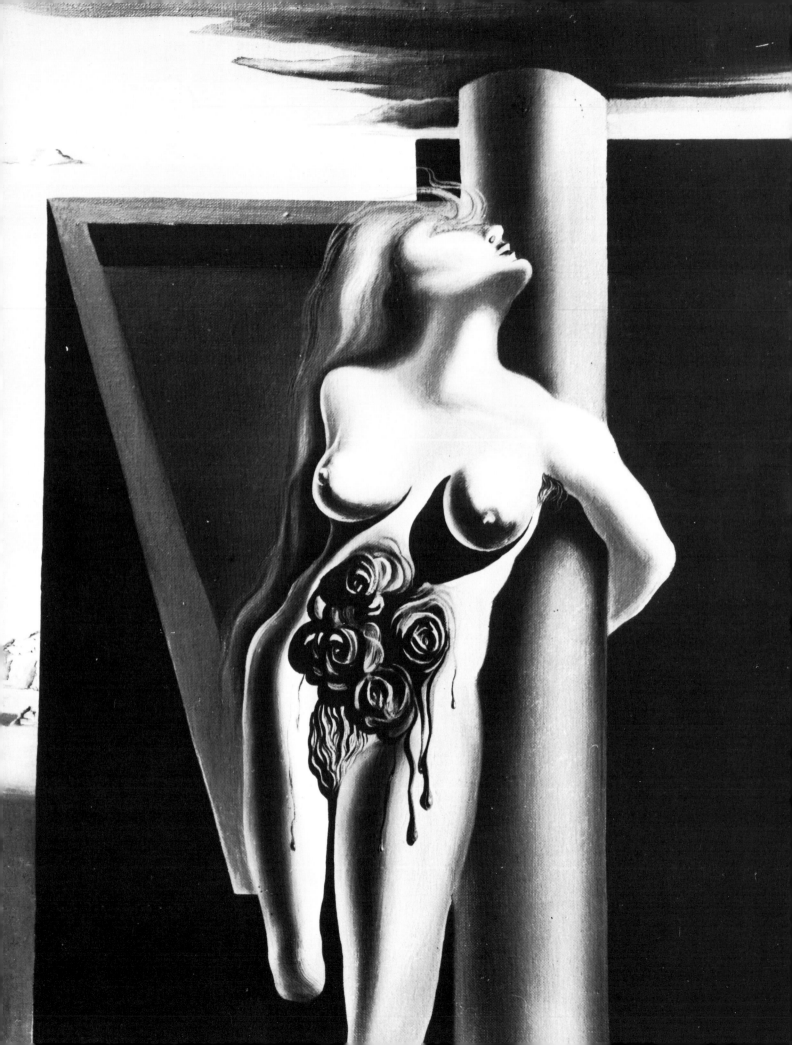

104. Salvador Dali, *Drawing for 'Nuits partagés' by Paul Eluard*, 1935. Courtesy of Robert D. Valette.
A striking example of Dali's 'paranoiac-critical' method. The distant belfry echoes the archway with the skipping girl in the foreground.

slowly took shape in his mind in 1932 and was executed in little more than a day: 'For some years now', he wrote in 1934, 'I have made only sculptures which offered themselves already completed to my imagination: I have limited myself to reproducing them in space without changing anything.'[30]

A painter who succeeded in treading the paths of both illusionistic automatism and rhythmic automatism was Yves Tanguy. The biomorphic and organic forms which crowd his milky landscapes admirably express psychic and physiological inwardness. Although it was seeing a De Chirico that made up Tanguy's mind to become a painter, and although his own pictures also often resemble inhabitable dreams, Tanguy always insisted on the role played by automatism in their creation. He said, for instance, 'I found that if I planned a picture beforehand, it never surprised me, and surprises are my pleasure in

103. (*Opposite*) Salvador Dali, *The roses bleed*, 1930. Oil on canvas, 23½ × 19½ in (60 × 50 cm). Brussels, Collection J. Bourjou.

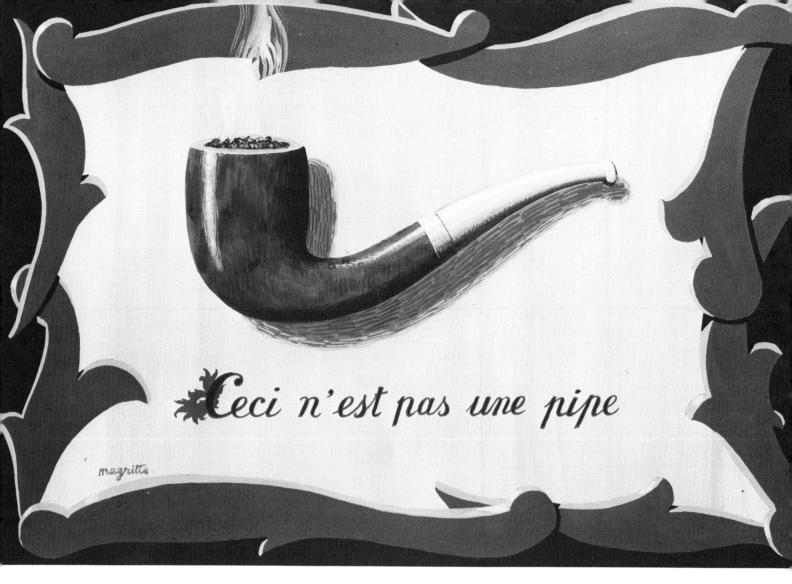

105. René Magritte, *Ceci n'est pas une pipe* (*This is not a pipe*). Oil on canvas.

painting', and 'I expect nothing of my reflections but I am sure of my reflexes.'[31] In Tanguy's projections of the inner landscape, the dichotomies of exterior reality no longer apply. We cannot distinguish the organic and the inorganic, the sky and the horizon, light and shadow, the heavy and the weightless, the wet and the dry, the hard and the soft. The world of matter appears to have become assimilable, like food. André Breton insisted on the literalness of Tanguy's dreamscapes saying, 'We are not in the abstract here – but in the very heart of the concrete'. After describing the onlooker's reading of these pictures, Breton went on to comment on the inadequacy of our normal verbs of perception such as 'seeing'. He suggested that more active verbs, such as 'recognizing', were needed in order to emphasize the role of imaginative participation and of the analogy-seeking mechanism in the act of seeing.

It was thanks to the contribution of Salvador Dali that pictorial Surrealism moved decisively beyond the passive conception of Surrealist mental activity as the recording of the interior message to the dynamic reinterpretation of the world in the act of perception itself. Starting from Kraepelin's and Bleuler's definition of paranoia which 'lends itself to the coherent development of certain errors to which the subject shows a passionate attachment', Dali, from 1929 onwards, developed his own 'paranoiac-critical method'. This meant giving systematic encouragement to the mind's power to look at one thing and to see another. It was

a matter of willing alternative readings on to the world outside, the only determinant of the content of these readings being psychic desire. Rimbaud had been practising such a deliberate derangement of the senses when he saw a salon at the bottom of a lake or a mosque where there were factory chimneys. When Dali himself, as an art student, had been asked to draw the Virgin Mary, he had handed in a sketch of a pair of scales. In his habitually explosive manner, Dali claimed that his paranoiac-critical method was capable of 'systematizing confusion and contributing to the total discredit of the world of reality'.[32]

He adopted a deliberately retrograde technique of photographic realism, reminiscent of the nineteenth-century academic painter Meissonier, in order to assert the equality of status between his private

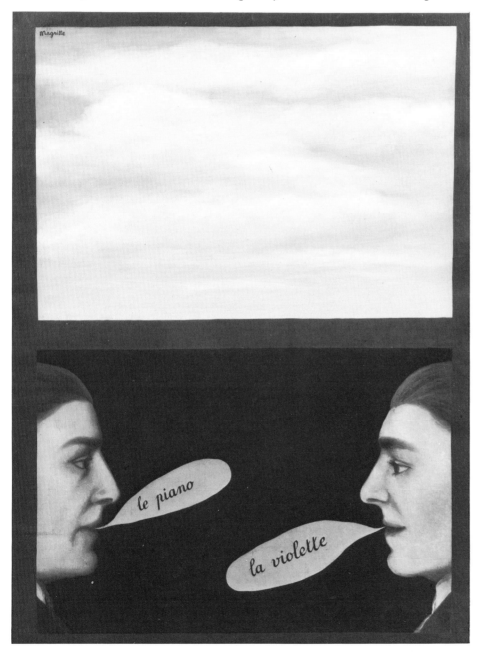

106. René Magritte, *The use of speech*, 1928.
Oil on canvas, 28¾ × 21¼ in (73 × 54 cm).
Private Collection.

111

107. (*Opposite*) Joan Miró, *Woman, bird by moonlight*, 1949. Oil on canvas, 32 × 26 in (81.5 × 66 cm). London, Tate Gallery.

108. (*Overleaf left*) René Magritte, *The human condition*, 1933. Oil on canvas, 39½ × 32 in (100.5 × 81.5 cm). Private Collection. Describing the way he and the artist chose titles for Magritte's pictures in order to emphasize the gap they felt to exist between words and what they describe, Magritte's friend, Paul Nougé explained: 'The title of a picture, if it is effectual, does not fit in with the painting after the manner of a more or less subtle and adequate commentary. But, by the help of the picture, the title is born of an illumination analogous to the one which determines what it names.'

109. (*Overleaf right*) René Magritte, *The pleasant truth*, 1966. Oil on canvas, 35 × 51¼ in (89 × 130 cm). U.S.A., Private Collection.

visions and the objects in the everyday world. His aim, as he put it, was 'to materialize the images of concrete irrationality with the most imperialist fury of precision, in order that the world of the imagination . . . may have the same objective evidence, the same consistency, the same persuasive, cognoscitive and communicable thickness as the exterior world of phenomenal reality'.[33] Dali made good the promise of this rhetoric with his breath-taking iconography of the early thirties – a knowing Freudian casebook crowded with visual puns and all manner of projected obsessions and childhood memories: cannibalism (lovers, architecture, even the earth itself become soft comestibles); masturbation guilts and castration fears; and fetishes – grasshoppers, crutches, wheelbarrows.

A challenge to the reality of real phenomena of a very different but equally persuasive kind came from the Belgian painter, René Magritte. No Surrealist has shown more convincingly how little we are at home in the world. And he has done this not by uncorking monsters and other irrational extravagances but through the patient interrogation of objects with which we are apparently most familiar. Magritte's Surrealism derives not from 'the sleep of reason' but from his unique brand of non-utilitarian lateral thinking. According to André Breton:

'Magritte's approach which, far from being automatic was, on the contrary, perfectly deliberate, offered support to Surrealism from an entirely different direction. Alone in adopting this particular method, Magritte approached painting as if it consisted of 'object-lessons', and from this point of departure he has proceeded to put the visual image systematically on trial, taking pleasure in stressing its lapses and in demonstrating the extent to which it depends upon figures of language and thought.'[34]

Representing the world of objects with scrupulous, dead-pan care, Magritte undermines our confidence in the stability of visible forms by means of a repertoire of disruptive devices, such as bizarre juxtapositions, enlargement of details and arbitrary changes of scale, the association of complementaries, the animation of the inanimate.

Magritte is no less a Surrealist because his pictures are absurd rather than fabulous and because they illustrate epistemological riddles rather than 'accommodations of desire'. The problem of the relation between physical perception and mental representation in *Perpetual Motion* (plate 137), for instance, is central to Surrealism's preoccupations. One sphere of the strong man's dumb-bells is also his head. Magritte is asking: in the relation of the mind to the world, which is the extension of the other? Do we see what we think or do we think what we see? And if his work served as an autocritique of Surrealism's tendency towards unbridled lyricism, a new poetry giving expression to the latent neglected life and misunderstood virtues of ordinary objects nevertheless shines through after Magritte has gratified our initial anarchic glee at seeing the given world overturned.

The example of this handful of artists, who have been chosen not because they have won honoured places on the walls of the world's

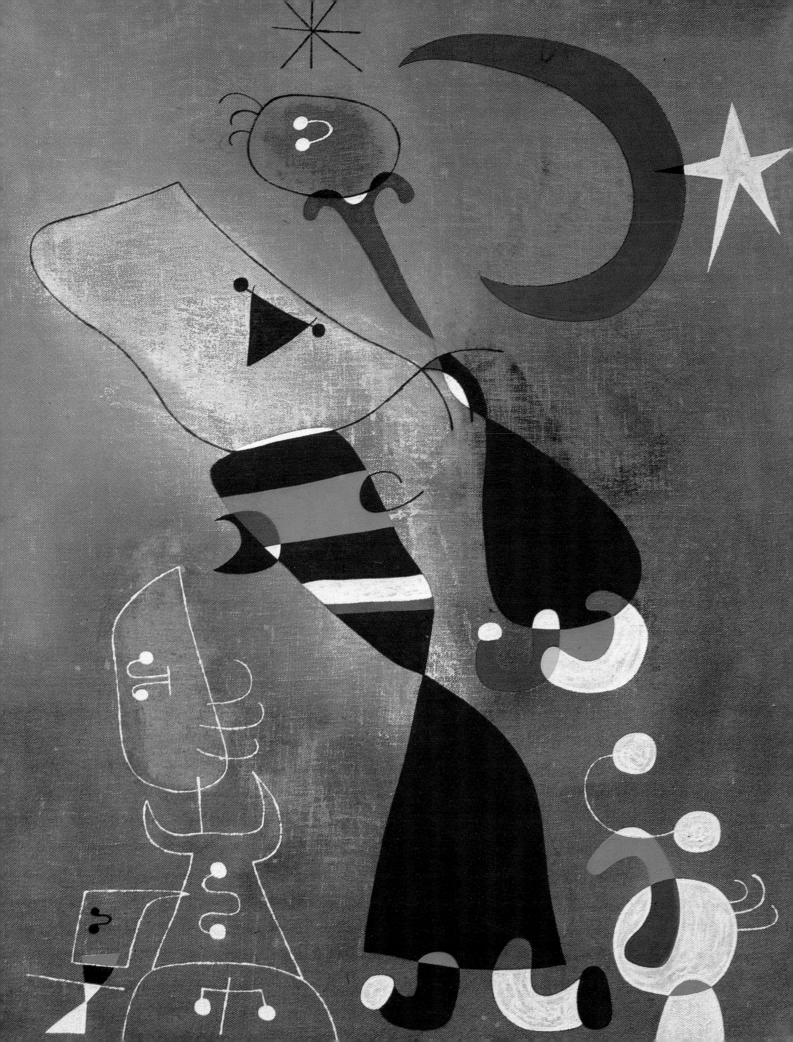

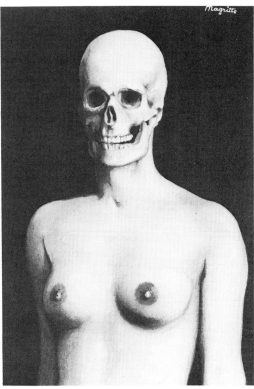

110. (*Far left*) René Magritte, *The heart of the matter*, 1928. Oil on canvas, 44 × 32 in (116 × 81 cm). Rhode St Genèse, Marcel Mabille. The human figure occurs frequently in Magritte's work but it is invariably depersonalized. Humans may be reduced to standardized objects such as skittles or rendered anonymous as with his bowler–hatted men. Others wear masks or stand with their backs to the onlooker. Here the head is covered with a cloth – a frequent motif which may recall the death of Magritte's mother who drowned herself and whose body was found with the nightdress over the face.

111. (*Left*) René Magritte, *The spoiler*, 1935. Gouache, 7½ × 5¼ in (19 × 13.4 cm). London, Collection George Melly.
Here, as in *The Rape*, Magritte has substituted another image for the expected face.

112. Joan Miró, *Still life with shoe*, 1937.
Oil on canvas, 31½ × 45½ in (79.5 × 116 cm).
New York, Museum of Modern Art (Gift of
James Thrall Soby).

museums but because they invented the principal means and defined the scope of pictorial Surrealism, shows how heavily the vitalism of Surrealism, like that of Dada, drew on the powerful stimulus of violence. The first of the twin moments of the dialectic of 'convulsive beauty' was disruption and disorientation. Surrealists welcomed the sensation of physical and mental vertigo which came from systematic demoralization, from affirming the lasting value of the ephemeral and blaspheming against the vauntedly eternal. Dali devoted a book and many paintings to exposing the wealth of perverse, sexual symbolism that lay hidden within Millet's *Angelus*, so accounting for the immense popularity of this work, which was ostensibly a sentimental image of a peasant couple standing in a field with their heads bent in pious devotion. Surrealism stood for revolt against reason and, by the same token, for the celebration of 'error', hallucination, perversion, and 'delinquency'.

But negation is only one moment of the flickering Surrealist synthesis. Surrealism is a commitment to being continually on the move. Its impulse to life feeds its impulse to art at the same time as it clashes with it. Animatedly suspended between the poles of reification and the void, the Surrealist phenomenon has its being against all the odds, as impossible and yet as disconcertingly evident as that 'soluble fish' which gave its title to an early collection of Breton's automatic texts. And Surrealism is a quest for beauty, that beauty which according

113. (*Above*) Arshile Gorky, *The sun, the dervish and the tree*, 1944. Oil on canvas, 36 × 47¼ in (97 × 120 cm). Private Collection.

114. Matta Echaurren, *Years of fear*, 1942. Oil on canvas, 44 × 55¼ in (112 × 142 cm). New York, Solomon R. Guggenheim Museum.

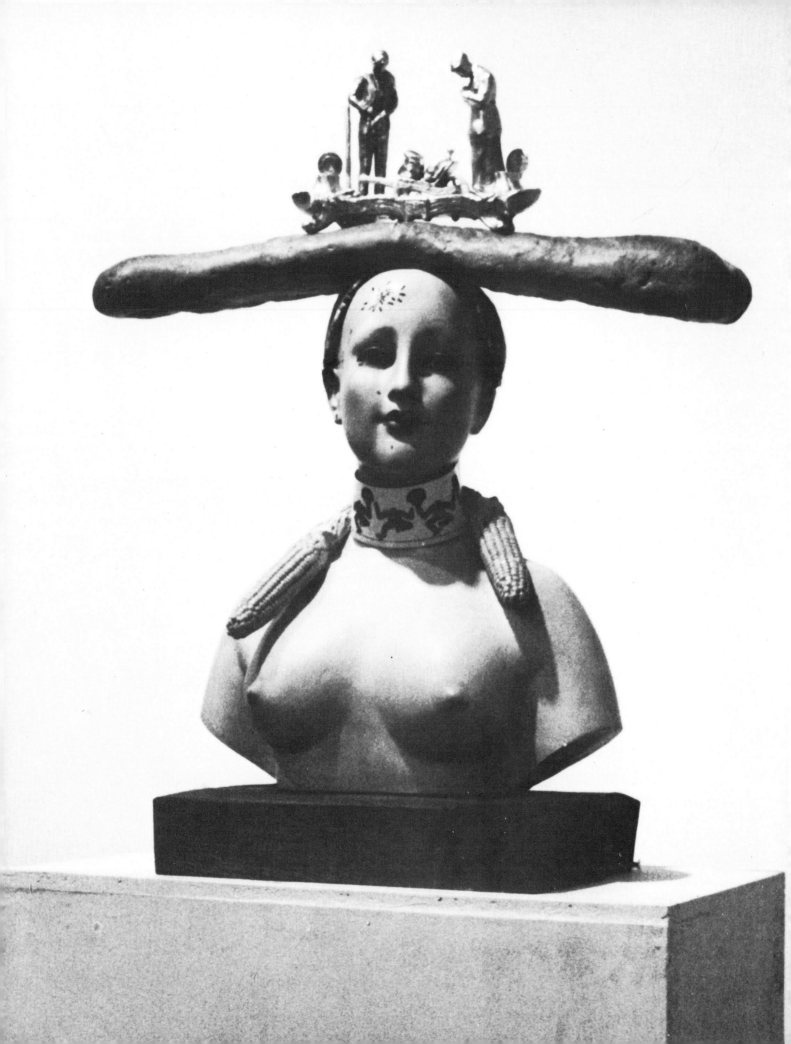

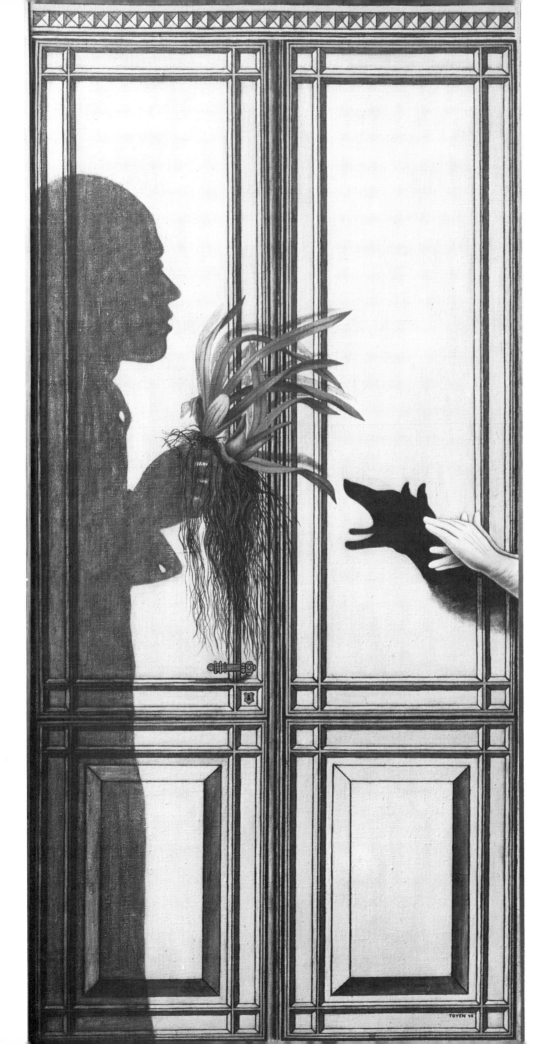

115. (*Opposite*) Salvador Dali,
Retrospective bust of a woman, 1933.
28½ × 26 × 9½ in (72 × 67 × 24 cm).
Paris, Galerie du Dragon.

116. (*Left*) Marie Cernisova Toyen,
Myth of light, 1946. Oil on canvas,
62½ × 29½ in (160 × 75 cm).
The ambiguous relations between
substance and its shadow, the shell and
its contents, the mask and what it
conceals, are perennial themes in
Surrealist art. Toyen was one of many
Czech poets and artists who rallied to
Surrealism in the thirties and she has
remained faithful to its tenets since she
settled in Paris in 1947. A nocturnal
melancholy pervades her beautiful and
insufficiently known work which is
peopled with equivocal children, birds,
wolves and deserted houses.

119

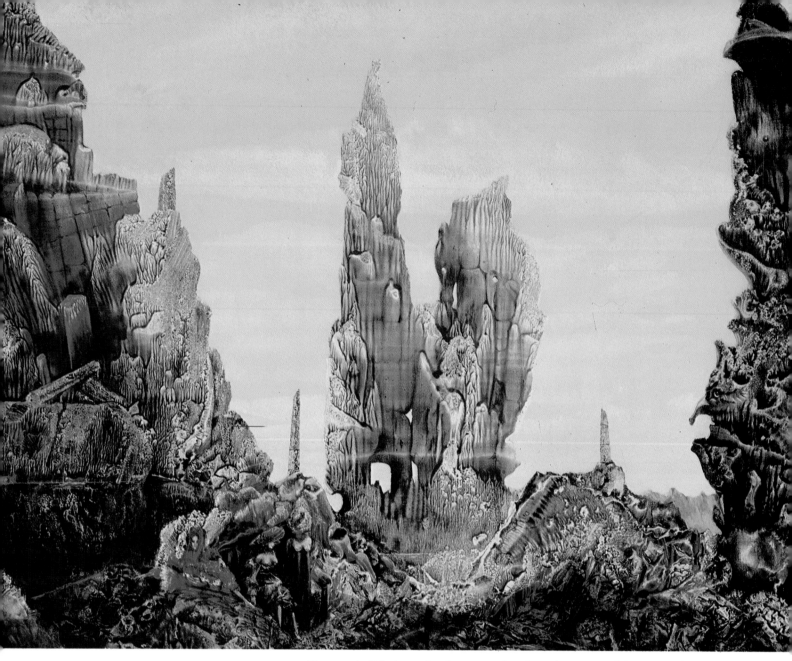

117. Max Ernst, *Europe after the rain*, 1940–42. Oil on canvas, 21½ × 60 in (54.5 × 148 cm). Hartford, Wadsworth Atheneum (the Ella Gallup Sumner and Mary Catlin Sumner Collection).

to Breton is 'like a train that ceaselessly roars out of the Gare de Lyon and which I know will never leave, which has not left. It consists of jolts and shocks, many of which do not have much importance, but which we know are destined to produce one SHOCK, which does'.[35] Surrealism is desperate but never defeatist. It 'explodes' reality not to debase it but in order to turn it into gold. The Surrealist image is always 'a sign in the ascendant'. Breton quotes the story of the two Japanese bonzes, one of whom made up the haiku: 'Take a red dragon-fly, pull off its wings and you have a pimento'; the other modified it to 'Take a pimento; add wings and you have a red dragon-fly'.[36] There could not be an instant's doubt which version stands for the Surrealist project.

Magic-circumstantial

Part at least of the appeal of Surrealism – which explains its rapid global expansion between the wars, with groups forming in Belgium, Czechoslovakia, Yugoslavia, Spain, Japan, England, South America and elsewhere – lay in its rehabilitation of subject matter and pictorial poetry at a time when modernism's main preoccupations were with the purely

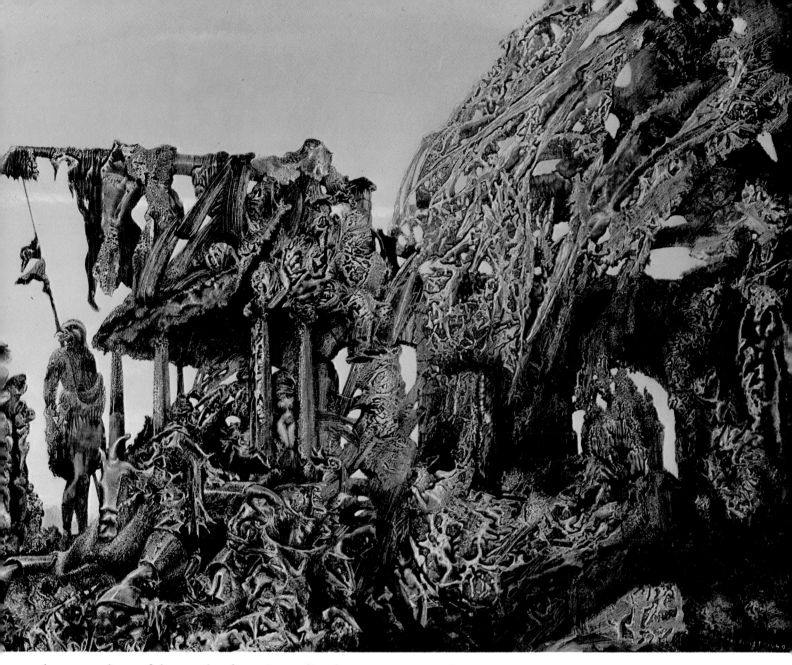

abstract values of the work of art. Surrealism's ancestors were Romanticism, Symbolism and Expressionism in that it brought back into honour both the poet as subject and the poetic subject. The dominant modes of Cubism, Constructivism and their derivatives, by contrast, had become increasingly desiccated, intellectualized and academic. Singling out Mondrian, Dali expressed Surrealism's curt dismissal of abstract art with the phrase: 'Piet, niet'.

But if, as Breton acknowledged, there was some truth in calling Surrealism 'the tale of Romanticism', then it was 'ever such a prehensile tale'. Surrealism differed from Romanticism in that it rejected the cult of inner, spiritual freedom which left the world outside intact. Only in the first days of intoxication with the image did Surrealists such as Philippe Soupault and Michel Leiris indulge a naive solipsism which supposed that reality itself would be changed simply and solely by expressing it differently. Only initially do the Surrealists seem to have believed that reality was nothing more than an internal projection and that the reinterpretation of the world in the 'magic' light of the poetic imagination would be synonymous with its transformation. After 1925, such

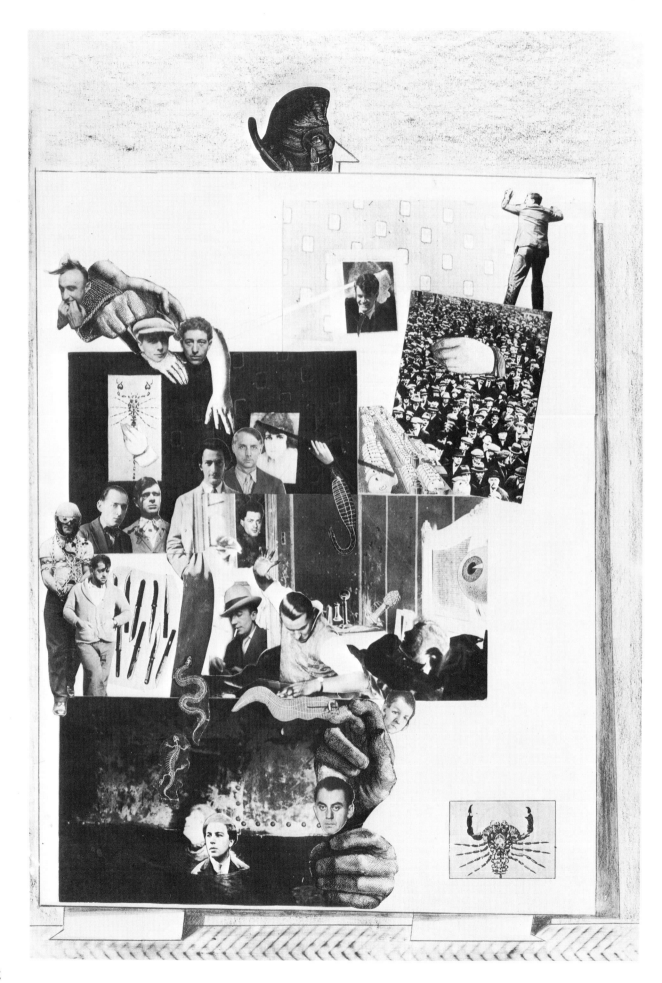

119. (*Above*) Wolfgang Paalen, *Articulated cloud*, 1938. 20 in (50 cm) high. Stockholm, Moderna Museet.

120. (*Left*) Valentine Hugo, *Constellation*, (Eluard, Breton, Tzara, Char and Péret). Oil on panel. Nice, Collection H. Matarasso.

118. (*Opposite*) Max Ernst, *Loplop introduces members of the Surrealist group*, 1931. Photographs, pencil and pencil frottage, 19¾ × 13 in (50 × 33.5 cm). New York, Museum of Modern Art.
Max Ernst identified with, and increasingly introduced into his work, the enigmatic and somewhat terrifying figure of 'Loplop', 'superior of the birds'. Here, recalling his 1922 canvas, *At the rendez-vous of friends*, Ernst celebrates the new-found unity of the group after the schism of 1929–30.

121. Max Ernst, *The entire city*, 1935–36.
Oil on canvas, 23½ × 32 in (58 × 80 cm).
Zurich, Kunsthaus.

solipsism gave way to a more dialectical position which showed much greater respect for 'circumstance' and for the contingent otherness of reality. Similarly, for all its stress on the unlimited inventiveness that lay latent within the psyche, Surrealism was no gratuitous effusion of fantasy for fantasy's sake. It never stooped to acknowledge mere whimsy or mystification. Breton specifically distinguished between 'mystery' – the deliberate concoction of riddles, resorted to by the Symbolists, for instance – and the 'marvellous' of Surrealism.

The 'marvellous' was not to be found by trying to escape reality in some romantic flight out of time but was rather, to quote René Passeron, 'an impassioned fusion of wish and reality, in a surreality where poetry and freedom were one'.[37] If Surrealism is more than 'magic without hope', it is because of its faith in such fusions. Unlike the Dadas who emphasized the vulnerability of the psyche to invasion by chaos, Breton argued that external circumstances often responded to the unspoken desires and demands of the human psyche. As much as by anything else, Surrealism distinguished itself from Dada by moving on from the idea of 'chance' to that of 'objective chance'. If Freud had shown how desire projected itself into dreams, the Surrealists found evidence that it could

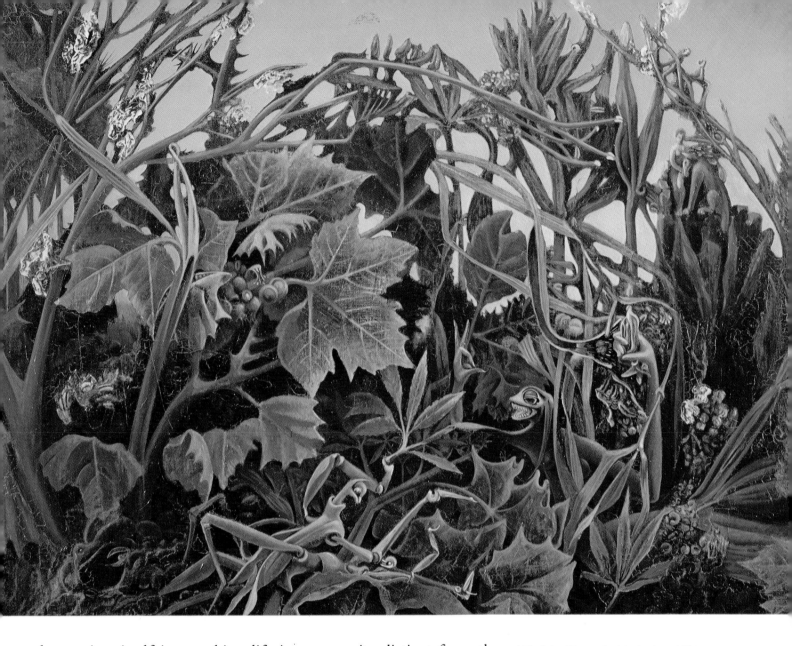

122. Max Ernst, *La joie de vivre*, 1936.
Oil on canvas, 28½ × 36 in (72 × 91 cm).
Private Collection.

also project itself into waking life in ways quite distinct from the
conscious intentions of the subject. Events which looked at first sight
like simple coincidences revealed, on further examination, signs of a
mysterious complicity between the unconscious and external pheno-
mena. The Surrealist contention, therefore, was that chance was not the
neutral agency, indifferent to human need, that science assumed it to be,
but was a distinctly positive force and one that from time to time could
be recognized as being attuned to man's subjectivity. The function of
Surrealist art was to offer evidence of such complicity and the Surrealist
goal in life was to keep as available and alert as possible to the incidence
of the marvellous, defined in this way. The whole of the Surrealist
project is summed up in this ambition. For automatism itself falls
within the sphere of objective chance. As Michel Carrouges has written:
'Automatic writing is no more than the reintroduction of objective
chance into language, whereas objective chance is the automatic writing
of fate in seemingly raw facts.'[38]

The image and the analogy were the vehicles by which the marvellous
found expression in art and thought. In conserving their evocative
charge over the years, the best products of automatism have proved that

123. (*Above*) E. L. T. Mesens, *The complete score completed*, 1945. Ink on paper and collage, 12 × 18 in (30 × 46 cm). Brussels, Musées Royaux des Beaux-Arts.
Unlike the Paris Surrealists, who dismissed music as the most incorrigibly non-Surrealist of all the arts, several of the Belgian adherents such as Mesens and Souris were accomplished musicians. Souris remained a composer but Mesens turned to poetry and paintings especially after settling in England in 1937 to run the London Gallery.

124. (*Right*) Jean Arp, *Three disagreeable objects on a face*, 1930. 14 × 10 × 7½ in (36 × 26 × 19 cm). France, Private Collection.

UN CADAVRE

Il ne faut plus que mort cet homme fasse de la poussière.

André BRETON (*Un Cadavre*, 1924.)

PAPOLOGIE D'ANDRÉ BRETON

Le deuxième manifeste du Surréalisme n'est pas une révélation, mais c'est une réussite.

On ne fait pas mieux dans le genre hypocrite, faux-frère, pelotard, sacristain, et pour tout dire : flic et curé.

Car en somme : on vous dit que l'acte surréaliste le plux simple consiste, revolvers aux poings, à descendre dans la rue et à tirer au hasard, tant qu'on peut, dans la foule.

Mais l'inspecteur Breton serait sans doute arrêté s'il n'avait pas tout de l'agent provocateur, tandis que chacun de ses petits amis se garde bien d'accomplir l'acte surréaliste le plus simple.

Cette impunité prouve également le mépris dans lequel un Etat, quel qu'il soit, tient justement les intellectuels. Principalement ceux qui, comme l'inspecteur Breton, mènent la petite vie sordide de l'intellectuel professionnel.

Les *révélations* touchant par exemple Naville ou Masson ont le caractère des chantages quotidiens exercés par les journaux vendus à la police. La méthode et le ton sont absolument les mêmes. Pour les autres appréciations sur d'anciens amis, chers parce que l'inspecteur Breton espérant qu'ignorant sa qualité ils le nommeraient président d'un Soviet local des Grands Hommes, elles ne dépassent pas les ignominies ordinaires des habitués de commissariat, ni les coups de pied en vache. A cette heure où sont maîtresses de la rue ces deux ordures : la littérature et la police, il ne faut s'étonner de rien. Aux deux extrêmes, comme Dieu et Diable, il y a Chiappe et Breton.

Que Dada ait abouti à çà, c'est une grande consolation pour l'humanité qui retourne à sa colique. Mais dira-t-on, n'avez-vous pas aimé le surréalisme ? Mais oui : amours de jeunesse, amours ancillaires. D'ailleurs une récente enquête donne aux petits jeunes gens l'autorisation d'aimer même la femme d'un gendarme.

Ou la femme d'un curé. Car on pense bien que dans l'affaire le flic rejoint le curé : le frère Breton qui fait accommoder le prêtre à la sauce moutarde ne parie plus qu'en chaire. Il est plein de mandarin curaçao, sait ce qu'on peut tirer des femmes, mais il impose

G. RIBEMONT-DESSAIGNES.
(Voir la suite page 2)

AUTO-PROPHÉTIE

Ce monde dans lequel je subis ce que je subis (n'y allez pas voir), ce monde moderne, enfin, diable ! que voulez-vous que j'y fasse ? La voix surréaliste se taira peut-être, je n'en suis plus à compter mes disparitions. Je n'entrerai plus, si peu que ce soit, dans le décompte merveilleux de mes années et de mes jours. Je serai comme Nijinsky, qu'on conduisit l'an dernier aux Ballets russes et qui ne comprit pas à quel spectacle il assistait.

ANDRÉ BRETON, *Manifeste du Surréalisme.*

MORT D'UN MONSIEUR

Hélas, je ne reverrai plus l'illustre Palotin du Monde Occidental, celui qui me faisait rire !

De son vivant, il écrivait, pour abréger le temps, disait-il, pour trouver des hommes et, lorsque par hasard il en trouvait, il avait atrocement peur et, leur faisant le coup de l'amitié bouleversante, il guettait le moment où il pourrait les salir.

Un jour il crut voir passer en rêve un Vaisseau-Fantôme et sentit les galons du capitaine Bordure lui pousser sur la tête, il se regarda sérieusement dans la glace et se trouva beau.

Ce fut la fin, il devint bègue du cœur et confondit tout, le désespoir et le mal de foie, la Bible et les chants de Maldoror, Dieu et Dieu, l'encre et le foutre, les barricades et le divan de Mme Sabatier, le marquis de Sade et Jean Lorrain, la Révolution Russe et la révolution surréaliste (1).

Pion lyrique il distribua des diplômes aux grands amoureux, des jours d'indulgences aux débutants en désespoir et se lamenta sur la grande pitié des poètes de France.

« Est-il vrai, écrivait-il, que les Patries veulent le plus tôt possible le sang de leurs grands hommes ?

Excellent musicien il joua pendant un certain temps du luth de classe sous les fenêtres du Parti communiste, reçut des briques sur la tête, et repartit déçu, aigri, maîtrechanter dans les cours d'amour.

Il ne pouvait pas jouer sans tricher, il trichait d'ailleurs très mal et cachait des billes de billard dans ses manches ; quand elles tombaient par terre avec un bruit désagréable devant ses fidèles très gênés il disait que c'était de l'humour.

C'était un grand honnête homme, il mettait parfois sa toque de juge par dessus son képi, et faisait de la Morale ou de la critique d'art, mais il cachait difficilement les cicatrices que lui avaient laissées le croc à phynances de la peinture moderne.

Un jour il criait contre les prêtres, le lendemain il se croyait évêque ou pape en Avignon, prenait un billet pour aller voir et revenait quelques jours après plus révolutionnaire que jamais et pleurait bientôt de grosses larmes de rage le 1er mai parce qu'il n'avait pas trouvé

Jacques PRÉVERT
(Voir la suite page 2)

125. *Un cadavre*, 1930. Paris, Bibliothèque Littéraire Jacques Doucet.
There was a major schism in the Surrealist group in 1930, resulting in the excommunication of a dozen members, confirmed in Breton's *Second Manifesto*. The dissidents, masterminded by Georges Bataille, retaliated with the vitriolic pamphlet *Un Cadavre* which pictured André Breton on the front as the martyred Christ. The pamphlet was ironically modelled on the Surrealist's own attack on Anatole France.

their effect did not depend simply on surprise and novelty. That large numbers of readers and onlookers have responded powerfully to such imagery also goes some way to vindicate the Surrealist claim that there are links between chance and subjectivity. And there were enough dramatic examples of precognition and clairvoyance in their art to allow the Surrealists to see them as the workings of objective chance. Apart from the astonishing conjunctions of desire and destiny which Breton records in *Nadja* and *L'Amour fou*, for instance, there are the many prophetic paintings which defy common-sense efforts to explain them away. In De Chirico's portrait of Apollinaire (plate 51), for example, a circular white line on the silhouette of the poet's profile marks the spot where the author of *Poète assassiné* was to undergo a trepanation in 1916. According to Marcel Jean, Apollinaire used to refer to the picture before he was wounded as 'my portrait as human target'[39]. Later he explained

128. (*Above*) Victor Brauner, *Memory of reflexes*, 1954. Wax on masonite, 49 × 55 in (124.5 × 138.5 cm). U.S.A., Private Collection.

126. (*Opposite above*) Wilfredo Lam, *Jungle*, 1944. Oil on cardboard, 29 × 36 in (73.5 × 92 cm). Private Collection.

127. (*Opposite below*) Victor Brauner, *Petite morphologie*, 1938, Oil on canvas, 22 × 25 in (56 × 63.5 cm). Paris, Collection F. Petit.

129. Salvador Dali, *The enigma of desire*, 1929.
Oil on canvas, 43 × 60 in (110 × 150 cm).
Zurich, Collection Oskar R. Schlag.

that the scar from the operation seemed to be on the left side (and not on the right as in reality) 'because this is not my head, but its cast shadow'.[39] Even more disturbing was the case of the clairvoyant pictures of the early thirties by the Romanian artist, Victor Brauner, which featured mutilations and other physical threats to the eye. In 1938, during a brawl at a studio party, Brauner was struck in the face by a bottle thrown by the Spanish Surrealist, Oscar Dominguez, and his left eye was put out. It was then recalled that he had prefigured the injury in his self-portrait of 1931 which showed him with one eye crushed and his cheek covered with blood. Still more strange, the eye of a figure identifiable as the artist in another picture from a year later was pierced with a sharp instrument which bore a large capital 'D' on its handle.

In its 'magic-circumstantial' quality, convulsive beauty contributed to enquiry into both the deepest intimacy of the subject and the enigmas of objective reality. As such it mediated continually between the daily life of the Surrealists and their art. It might erupt in a chance meeting on a café terrace, in the sign on a stairwell in the Passage des Panoramas, on the screens of a flea-pit cinema or in an object found on the beach or junk-stall. Knowing how easy it was to ignore the signals and to fail to turn to advantage the opportunities they offered, the Surrealists adopted a 'lyrical mode of behaviour'. They would prospect for the specifically modern marvellous of the great metropolis, following those eccentric

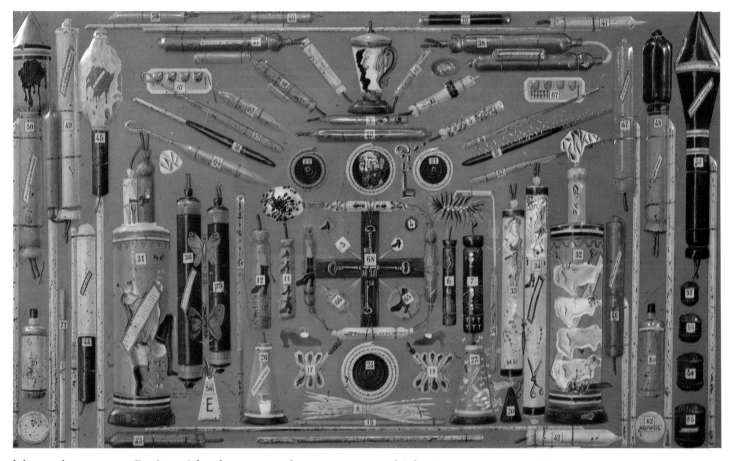

130. Salvador Dali, *Fireworks*, 1930–31. Oil on embossed tin, 16 × 26 in (40 × 65.5 cm). Private Collection.

itineraries across Paris with chance as the compass, which Aragon describes in *Anicet* and *Paris Peasant*. Banal thoroughfares bristled with significance: one day, Breton found himself able to predict the exact position of the sign 'Bois Charbons' before he turned the corner of each street in an unfamiliar quarter. In the *trouvaille* or found object, the Surrealists came upon substantiations of unconsciously harboured desires. In *L'Amour fou*, Breton describes how he and Giacometti were both furnished with such symbolic equivalents on a visit one day to the Marché aux Puces. The sculptor came across an antique metal fencing mask which he at once 'recognized' as the missing piece of the figure, *The Invisible object* (plate 135) which until then he had not been able to complete. The poet in his turn fell upon a spoon with a shoe for a handle which gave concrete form to the mental representation which had been obsessing him – the recurrent phrase '*le cendrier de Cendrillon*' (Cinderella's ash-tray). In the rapid equation which is typical of Surrealist analogical thought 'slipper = spoon = penis = perfect mould for this penis',[40] Breton recognized this object as a pure condensation of his desire.

As early as 1924, Breton had proposed the manufacture and circulation of objects that had appeared in dreams. But it was not until the early thirties, and largely thanks to the inventions of Giacometti and to Dali's extension of his paranoiac-critical method, that the Surrealist object came

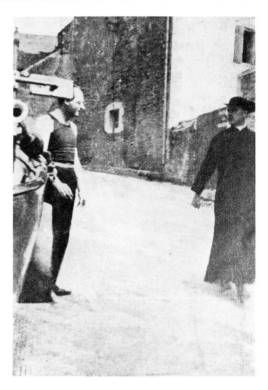

131. (*Top left*) Victor Brauner, *Wolf table*, 1939–47. 20 × 21¼ × 20 in (50 × 55 × 50 cm). Paris, Private Collection.

132. (*Top right*) Conroy Maddox, *Figure in a landscape,* 1939. Collage, 9 × 11½ in (22.7 × 29 cm). London, Victoria and Albert Museum. Since the early thirties Conroy Maddox has remained the most energetic of the English animators of Surrealism.

133. (*Above*) Brassaï, *Avenue de l'Observatoire, Paris*, 1934. Photograph. London, Victoria and Albert Museum.
With the possible exception of Atget, no photographer has better conveyed the everyday and every-night magic of the modern metropolis.

134. (*Above*) *Our collaborator Benjamin Péret insulting a priest,* from *La Révolution surréaliste*, No. 8 December 1926.

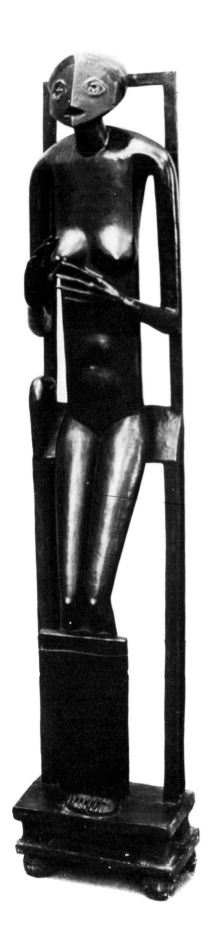

136. (*Above*) André Breton, *Poem-object*, 1937. Paper cloth, leaf and watch parts on paper, 15½ × 12 in (39.5 × 30.5 cm). Private Collection.

135. (*Left*) Alberto Giacometti, *Invisible object*, 1934. Bronze, 60 in (153 cm) high. Saint-Paul, Foundation Marguerite et Aimé Maeght.

137. René Magritte, *Perpetual motion*, 1935.
Oil on canvas, 21¼ × 29 in (54 × 73 cm).
London, Collection Mr and Mrs Estorick.

into its own as a veritable 'physics of poetry'. The spectrum of the genre took in interpreted found objects, incorporated objects, dreamt objects, mobiles and symbolically functioning objects.

Oscar Dominguez's first objects achieved a kind of synthesis between sculpture and picture: elements in relief appeared to be making their escape from the flat surface. The little painted rubber toy horse inserted through the frame of a minute bicycle in *Peregrinations of Georges Hugnet* (1935) recalled the poet's one-time job as a delivery-boy cycling round Paris replacing the prizes in slot-machines. Since the object, like the collage, which it largely displaced for several years, only required the reassembling of ready-made materials, it was a medium open to writers as well as artists. Nearly all the Surrealists contributed to the exhibition of objects at the Ratton Gallery in 1936. All such Surrealist objects differed radically from their Dada counterparts, such as Duchamp's readymades. Where the latter were conceived as ironic, self-denying statements about the impermanence or pretension of art and are relevant only within the context of aesthetic debate, Surrealist

objects are self-sufficient poetic images standing for the mysterious relationship between man's sensibility and the outer world. The proliferation of these objects was so rapid that artists' studios soon rivalled Schwitters' *Merzbau* in their baroque, three-dimensional extravagance. Ever since the great Paris International Surrealist Exhibition of 1938, Surrealist shows have therefore assumed the form of total environments, requiring visitors to undertake journeys through a labyrinth of solidified desires.

It could be said that Surrealism put objective chance in the place of the deposed divine principle. And as a resolutely world-oriented movement, Surrealism, in the footsteps of Nietzsche, set about a great 'transvaluation of all values'. Aragon once wrote that man himself is 'full of Gods', meaning that men have an infinite capacity to invest the objects of everyday life, even the human condition itself, with magical and symbolic properties. This power can be used for good or ill depending on whether the imagination is free or fettered. Surrealism tried to renew the whole structure of mythical representations on which our

138. René Magritte, *Act of violence*, c. 1932. Oil on canvas, 27½ × 39½ in (70 × 100 cm). Brugge, Groenigenmuseum.

mariën 1938

PIETÀ SURRÉALISTE

culture is based and which dictate our behaviour. The Surrealist *oeuvre* can be seen as a concerted effort to expose the unholy alliance of rationalism and aestheticism and to replace it with an affective interpretation based on the trinity of love, liberty and poetry. Thus it is no accident that the works of so many of its artists – Brauner, Lam, Camacho and Benoit in particular – resemble so many ikons, totems, fetishes and liturgical instruments of a libertarian cult.

It was one thing to celebrate the new magic and to collect poetic evidence; it was another to imprint that magic on the rebarbative surface of circumstantial reality. For all its ability to recruit followers across the globe, Surrealism was not an evangelical sect and the membership of the group at any time, even at the fountain-head in Paris, was usually limited to the number that could comfortably assemble round neighbouring tables in the Surrealists' favourite café. Their attempts to add muscle to the Surrealist revolution by joining up with overtly political forces such as the Communists and Trotskyists were more successful in enhancing the cohesion and commitment of their own group than in reconciling the disciples of Rimbaud with those of Marx. They refused to be blackmailed when the Communists ordered them to make a definite choice between 'pre-revolutionary' politics and 'post-revolutionary' poetry. They insisted that the claims of spiritual regeneration – the domain of the Surreal – should not be forfeited to social imperatives while the revolution was in the making. Instead, they anticipated Herbert Marcuse and other recent libertarian thinkers by extending the field of application of the Marxist dialectic beyond surplus value and the labour process. Thereby, they instantly relegated themselves to the opposition in the intolerant, totalitarian framework of Leftist politics between the wars.

Perhaps the life of the group itself may be seen as a prefiguration of what society might be if it were reorganized on Surrealist principles.

140. (*Above left*) Marcel Mariën, *Pieta Surréaliste*, 1938. 10½ × 8¾ in (27 × 22 cm). Collection the artist.
A typically off-hand blasphemy by Mariën who was eighteen years old at the time and who still gives expression to the sardonic and disabused attitudes characteristic of Belgian Surrealism.

141. (*Above*) Marcel Jean, *Tree with drawers*, 1941. Collection the artist.
In this furniture object Marcel Jean appears to have used the notion of 'elective affinities', which led Magritte, for example, to paint an egg, instead of a bird, in a cage, and other birds perched on the veins of a leaf instead of the branches of a tree.

139. (*Opposite*) Oscar Dominguez, *Peregrinations of Georges Hugnet*, 1935. Wood and metal, 16 × 13 in (41 × 33 cm). Milan, Galleria Milano.

142. (*Overleaf left*) René Magritte, *The reckless sleepers*, 1927. Oil on canvas, 45½ × 32 in (115.5 × 81 cm). London, Tate Gallery.

143. (*Overleaf right*) Enrico Baj, *Collage*. Oil and collage on board, 19 × 12½ in (48 × 31 cm). Private Collection.

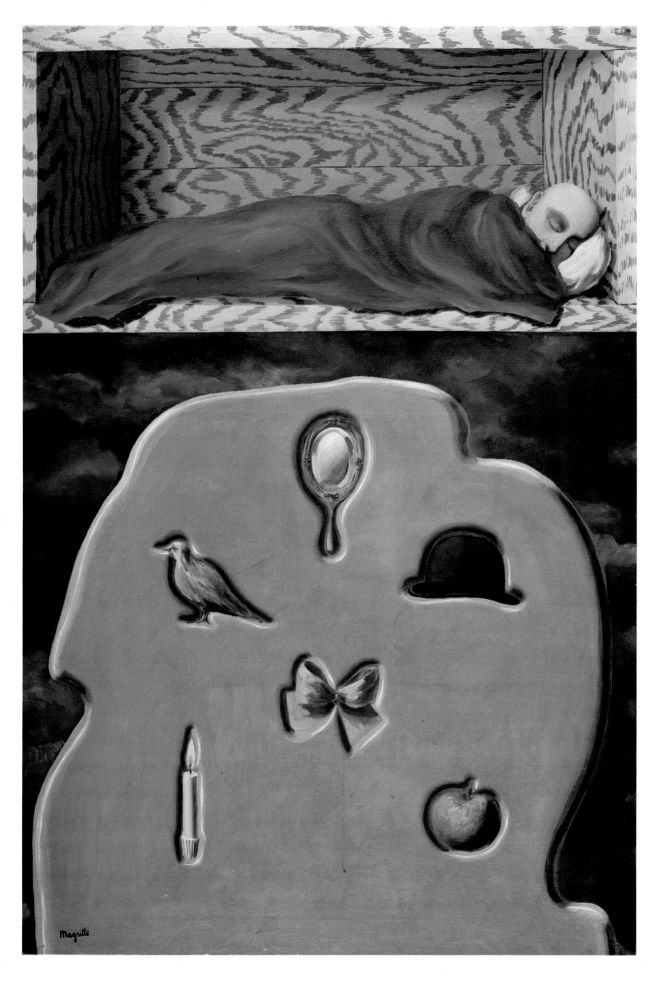

LE SURRÉALISME
AU SERVICE DE LA RÉVOLUTION

Directeur :
André BRETON

42, Rue Fontaine, PARIS (9ᵉ) Téléphone : Trinité 38-18

*Il a été tiré de ce numéro 15 exemplaires numérotés
sur Hollande van Gelder, dont 5 hors commerce.*

Les numéros 5 et 6 de cette revue paraissent simultanément le 15 mai 1933.

ABONNEMENT
les 6 numéros :
France..... 45 francs
Étranger ... 55 francs

DÉPOSITAIRE GÉNÉRAL :
EDITIONS DES CAHIERS LIBRES
25, passage d'Enfer
PARIS (XIVᵉ)

LE NUMÉRO :
France..... 8 francs
Étranger ... 10 francs

144. (*Opposite*) *The International Exhibition of Surrealism in Paris, 1938.* Photo Roger-Jean Ségalat.

145. (*Opposite below*) Still from *Juve contre Fantomas*, directed by Louis Feuillade, 1913–14. Like Rimbaud, the Surrealists were interested in all kinds of popular art which conventional good taste dismissed as beneath contempt. From the beginning they were interested in the cinema, which Buñuel said seemed to have been invented to express the life of the sub-conscious. Rather than highbrow films, the Surrealists preferred Feuillade's adventure series featuring the criminal master of disguise, Fantomas, based on the novels of Alain and Souvestre.

146. (*Left*) Cover of *Le surréalisme au service de la révolution.* This cover of the group's review indicates the prevailing sobriety of presentation in the early thirties. Only the otherwise austere cover was permitted the indulgence of a luminous logo.

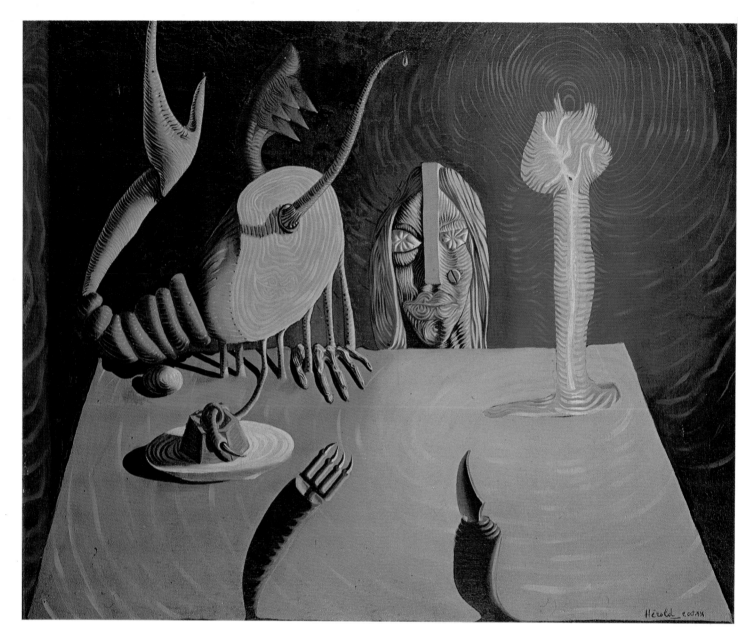

147. Jacques Hérold, *The night game*, 1936. Oil on canvas, 21¼ × 18 in (54 × 45 cm). Private Collection.

148. Remedios, *The double agent*, 1936. Oil on copper, 8¼ × 6¾ in (21 × 17 cm). Private Collection.

Certainly, the passionate memoirs of so many former members attest to the comradely excitement, constantly renewed, that prevailed within the privileged space extended by the group. Describing the atmosphere during games such as *Cadavre exquis* (Exquisite corpse) in which the marvellous revealed itself to be 'inter-subjective' and 'transpersonal', Paul Eluard wrote: 'All cares departed, all thought of suffering, boredom, routine, gone . . . we were playing with images and there were no losers. Each wanted his neighbour to win and go on winning so as to give everything to his neighbour. Wonder starved no more.'[41]

But, of course, this milieu was highly precarious and artificial. It might have collapsed as quickly as Dada but for the dynamism and authority of André Breton, who showed himself capable of exploiting the numerous schisms and ideological civil wars that beset the movement so that, rather than fragmenting it fatally, they contributed to the carving out of new positions and to the deepening of Surrealist self-consciousness. In the end, we have to acknowledge that the domain of the Surreal is not a territory that can be annexed and colonized. It is

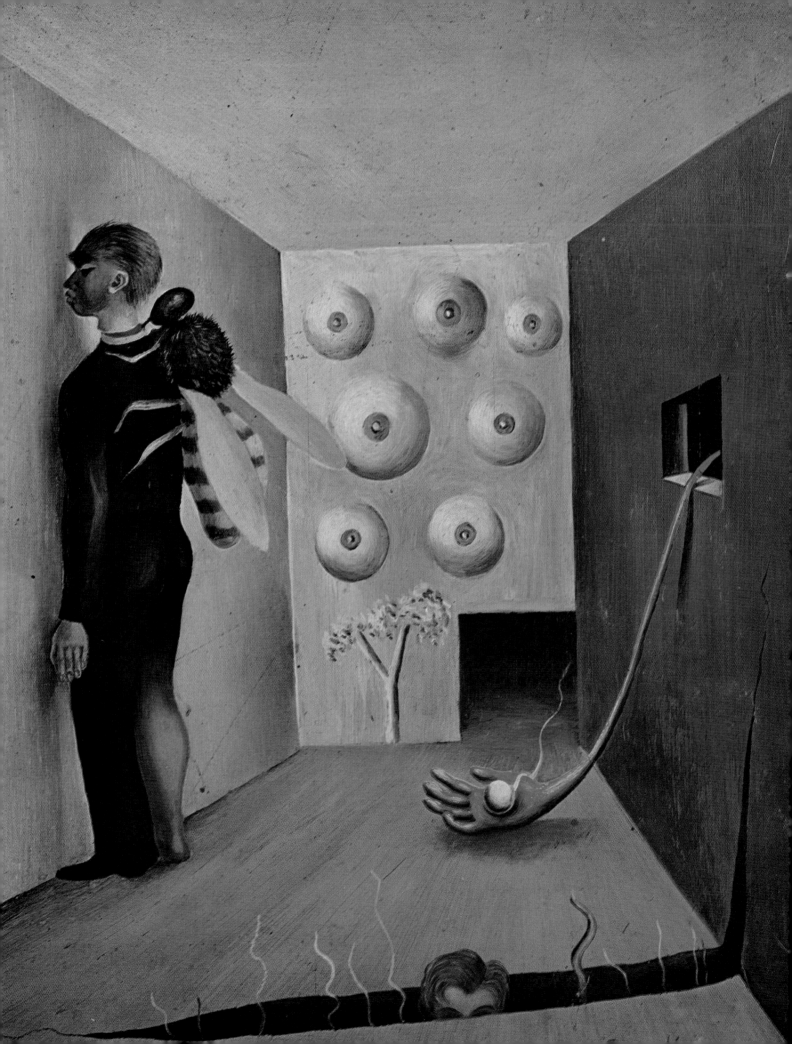

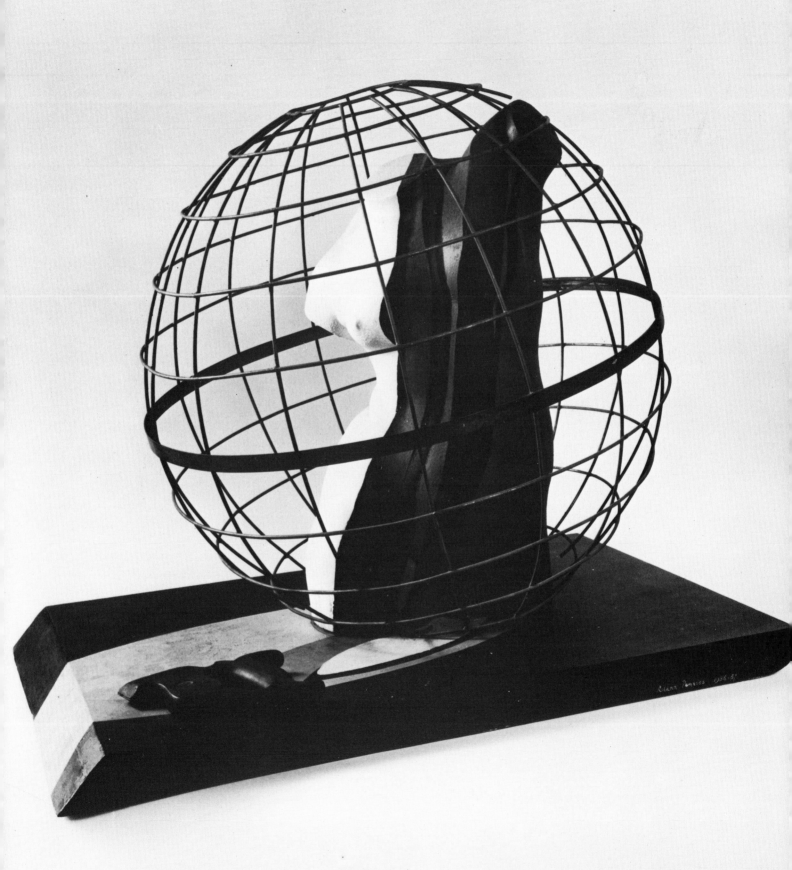

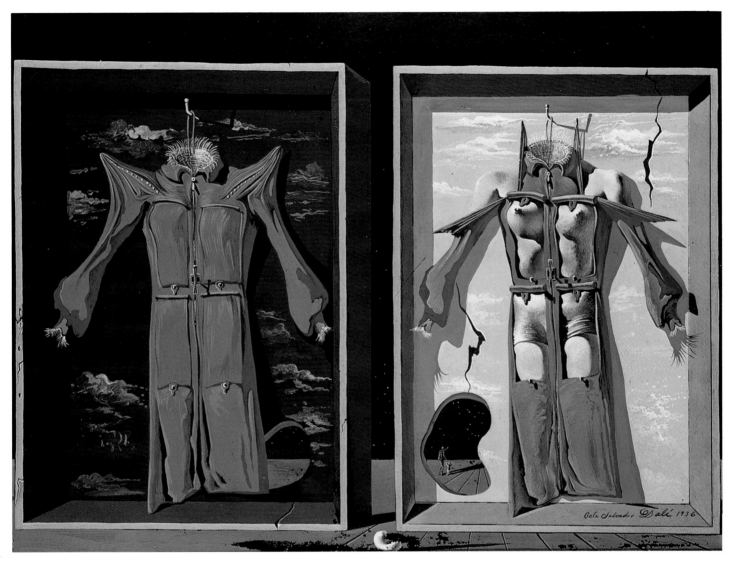

rather a promise and an aspiration – the suggestion of a great unknown that draws the mind onward and gives it hope. As Aragon described it in *Une Vague de rêves*: 'At best it is a notion that slips away like the horizon before the walker, for like the horizon, it is a relation between the spirit and that which it will never attain.'[42]

150. (*Above*) Salvador Dali, *The night and day of the body*, 1936. Gouache on paper, 12 × 16 in (30 × 40 cm). Brussels, Collection Baron and Baroness J. B. Urvater.

Erotic-veiled

'If you love love, you'll love Surrealism'; 'Joy, big as the balls of Hercules'; 'A naked woman is soon amorous' – these phrases on the Surrealists' visiting-cards testify to the erotic climate which Surrealism has always inhabited. Unlike misogynistic Dada which reduced love to the repetitive functioning of soulless machines, Surrealism has lyrically celebrated the centrality of erotic motivation in human life. Eroticism, 'the great nocturnal beat of desire', as Breton called it in the *Ode to Charles Fourier*, was the model for that tension which mobilized the whole being towards an unknown end. Love was to be exalted as the

149. (*Opposite*) Roland Penrose, *Captain Cook's last voyage*, 1936/67. Painted plaster, wood and wire, 27 × 26 × 34 in (69 × 66 × 86.5 cm). Collection the artist.

145

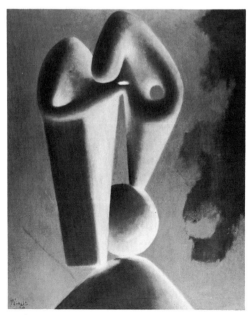

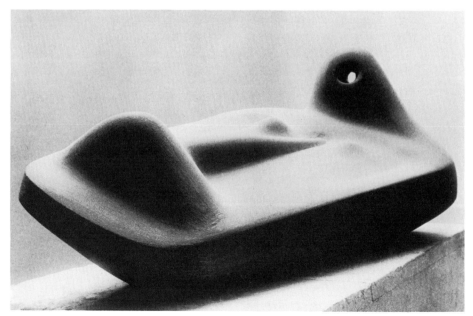

146

archetypal Surrealist act because it brought about the seemingly impossible fusion of the self with the other, because it was at once a perpetual challenge to the prevalent life-denying equation between the good and the useful, the highest manifestation of the pleasure principle, and the experience best able to assuage man's thirst for the absolute. ' "Of Eros and the struggle against Eros", in its enigmatic form, this exclamation of Freud's', mused Breton, 'obsesses me some days as only certain passages of poetry can.'[43] It was natural that Breton should associate Eros and poetry in this way since love and imagination share common roots and become inseparably intertwined at the level of myth and art. Freud had shown that the source of artistic drives lay in sexuality and, in automatism, the Surrealists had experienced for themselves the intimate relation between the verbal flow and the awakening of erotic desires. In 1924, Breton had written: 'We will reduce art to its simplest expression which is love.'[44] Eros presided over the Surrealist experience of beauty in all its forms. In *L'Amour fou*, Breton insisted that there was only a difference of degree between the emotion provoked by 'aesthetic' phenomena, such as poetry, and erotic pleasure.

Of all the areas of human experience in which the Surrealists have prospected for a richer consciousness, love offers the most intimate, the most immediate, most verifiable, most universally experienced revelations concerning man's unrealized possibilities. Surrealism meant restoring to sexual love all those energies which had been diverted

151. (*Opposite above left*) Joan Miró, Yves Tanguy, Man Ray, Max Morise, *Cadavre exquis*, 1927–28. Ink and pencil, 14 × 9½ in (36 × 24 cm). Paris, Collection Manou Pouderoux.
The 1938 'Abridged dictionary of Surrealism' defined the '*Cadavre exquis*' as a folded-paper game involving the composition of a sentence or drawing by several people none of whom is aware of the preceding contributions. The first classic phrase obtained in this manner gave its name to the game: 'The exquisite-corpse-will drink-the new-wine.' Like many other Surrealist games, this one also put a premium on collective invention and a discount on the individual signature.

152. (*Opposite above right*) *Cadavre exquis* by unknown artists, 1926–27. Pen, ink, pencil and crayon, 14½ × 9 in (36 × 23 cm). New York, Museum of Modern Art.

153. (*Opposite below left*) Pablo Picasso, *Woman*, 1930. Oil on wood, 25 × 18½ in (63 × 47 cm). Basel, Galerie Ernst Beyeler.
Although Picasso never formally joined the Surrealists, a constant exchange of innovative ideas occurred between the Spanish painter and the group in whose exhibitions he was always represented. In the twenties, it was the Surrealist example that encouraged Picasso to abandon the exhausted vein of Cubism for a fantastic art full of violence, humour, dreams and eroticism.

154. (*Opposite below right*) Henry Moore, *Reclining figure*, 1934–35. Corsehill stone, 24 in (61.5 cm) long. Private Collection.
A Surrealist group based in London was formed in 1936, the year of the International Surrealist Exhibition at the Burlington Gallery. It attracted many artists and writers who wanted to assume a revolutionary stance without submitting to the arid dogmas of Socialist Realism. Henry Moore was one of these.

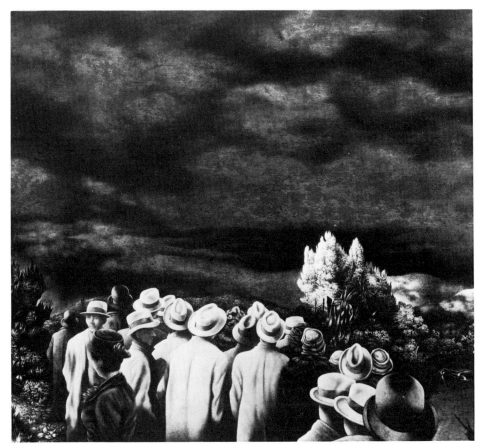

155. Richard Oelze, *Expectation*, 1935–36. Oil on canvas, 32 × 39½ in (81.5 × 100 cm). New York, Museum of Modern Art.
There is a strong feeling of science-fiction about this picture by Oelze, whose contacts with the Surrealists were always rather tenuous, and it is not surprising that Breton complained about his 'somewhat other-worldly attitude'. Nevertheless, Oelze did use a semi-automatic technique akin to frottage to conjure up apprehensive dream landscapes such as this.

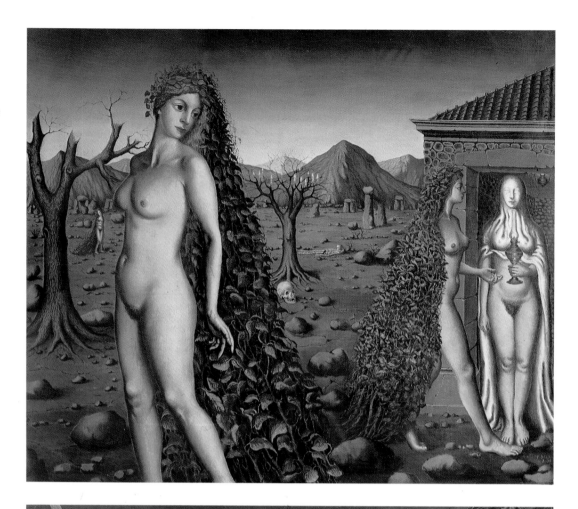

156. Paul Delvaux, *The call of the night*, 1938. Oil on canvas, 43¾ × 51½ in (111 × 132 cm). Private Collection.

157. Paul Delvaux, *The echo*, 1943. Oil on canvas, 41½ × 50½ in (105 × 128 cm). Private Collection.

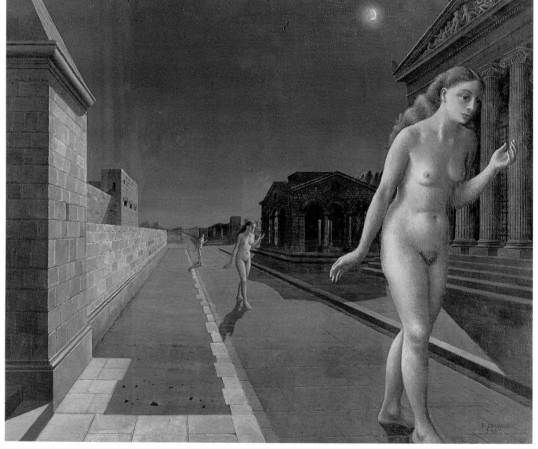

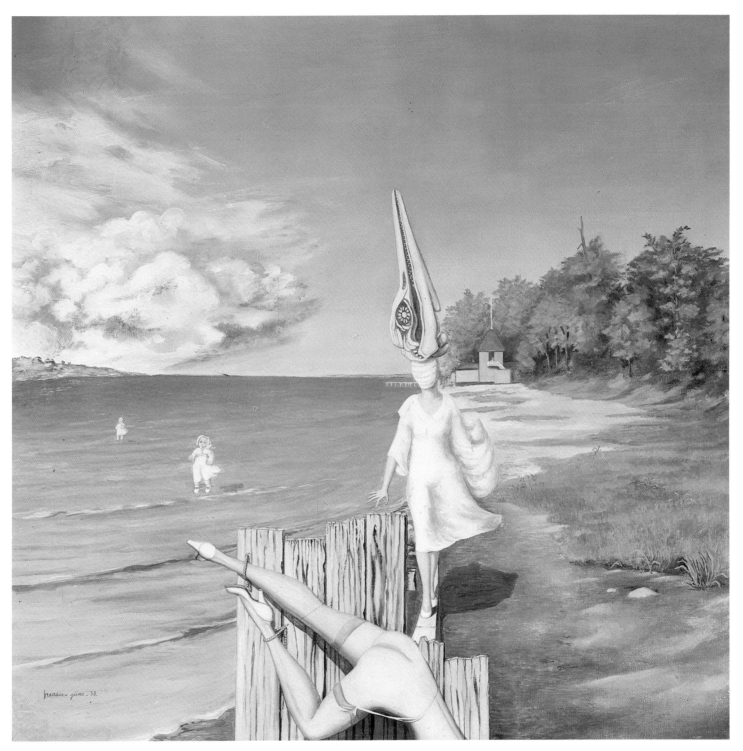

158. Wilhelm Freddie, *My two sisters*, 1938. Oil on canvas, 31½ × 32 in (80 × 81 cm). Brussels, Fine Art Exhibition.
For years, Freddie's work was confiscated and impounded by police and customs authorities throughout the world and the artist himself was prosecuted, fined and even imprisoned as a pornographer. Only in the early seventies, did the government of his native Denmark seek to make amends to this Nordic practitioner of the 'paranoiac-critical method' by granting him an annuity and a gold medal.

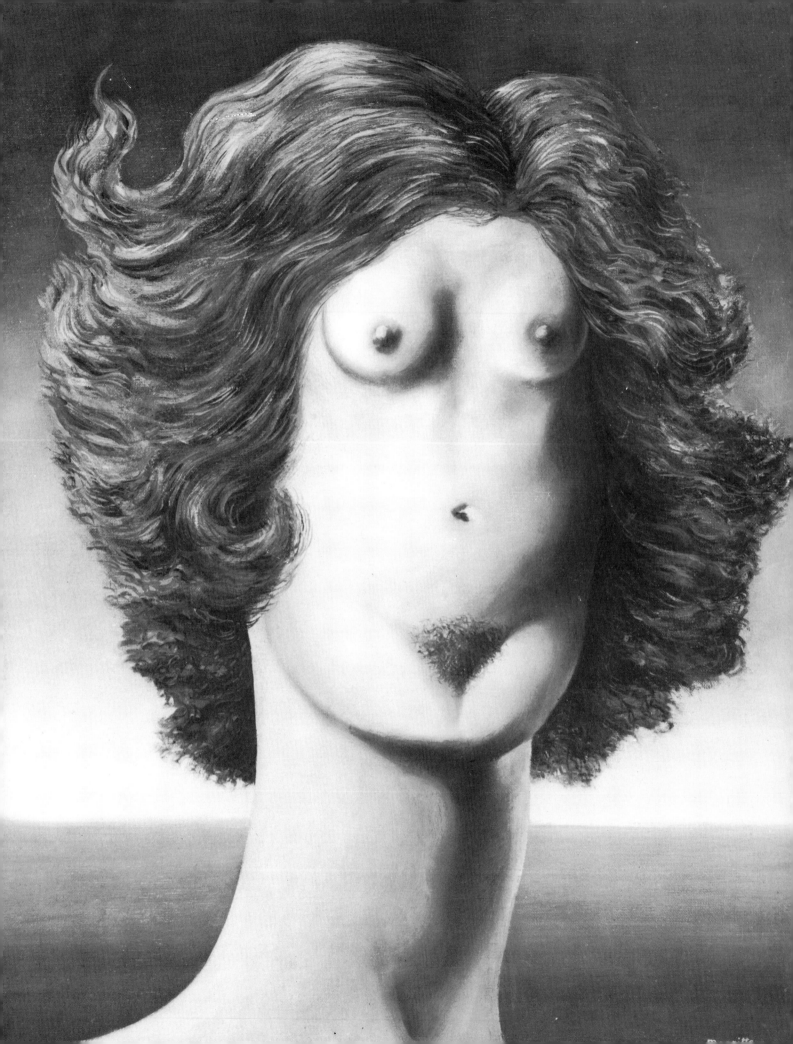

towards God in the form of sublimated adoration. During the late twenties, in a series of enquiries and questionnaires in *La Révolution Surréaliste*, the group debated hotly the ethical problems raised by their exaltation of love: should a Surrealist, for instance, sacrifice liberty for love's sake? Was love a diversion from the revolutionary struggle? Breton and Péret urged that it was only through the love of a particular human being that one could come to love humanity. So, in the *Second Manifesto*, faith in love was extolled as a revolutionary attitude, love being seen as a spur to join the social struggle, especially as one came up against the obstacles thrown by society in the path of love.

Argument over a second question, whether Surrealism stood for 'libertinage' or 'elective love', was even more acrimonious and was probably responsible for more schisms and excommunications than any other issue. It was easier to affirm the permanence of passion than the singularity of the loved one. Eluard, for example, argued that love always brought the same quality of revelation but not necessarily with the same partner. Breton, on the other hand, stood for an exclusive, unique love with one predestined woman. Both parties to the quarrel could refer to the part played by objective chance in the act of falling in love but Breton carried this notion to the point of reviving the Platonic

159. (*Opposite*) René Magritte, *Rape*, 1934. Oil on canvas, 28½ × 21 in (72.5 × 53.5 cm). Houston, de Menil Foundation.

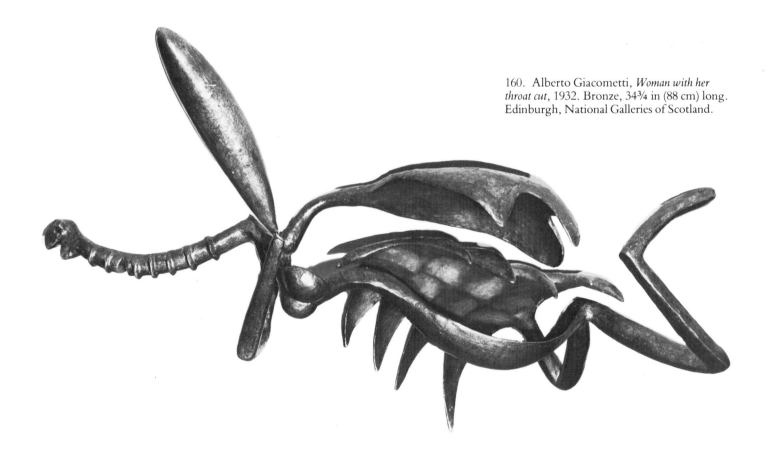

160. Alberto Giacometti, *Woman with her throat cut*, 1932. Bronze, 34¾ in (88 cm) long. Edinburgh, National Galleries of Scotland.

161. Salvador Dali, *The birth of liquid desire*, 1932. Oil on canvas, 37½ × 44 in (95 × 112 cm). Venice, Peggy Guggenheim Collection.

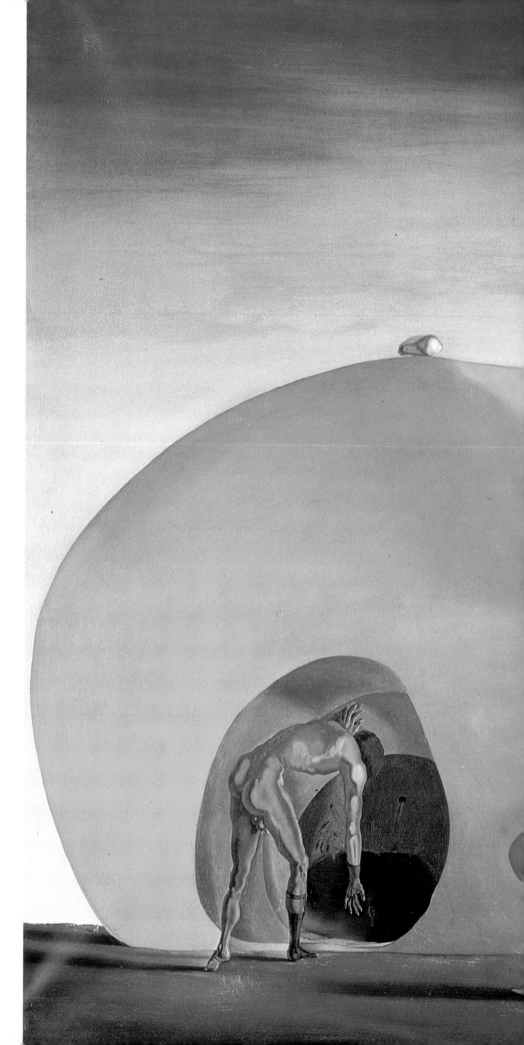

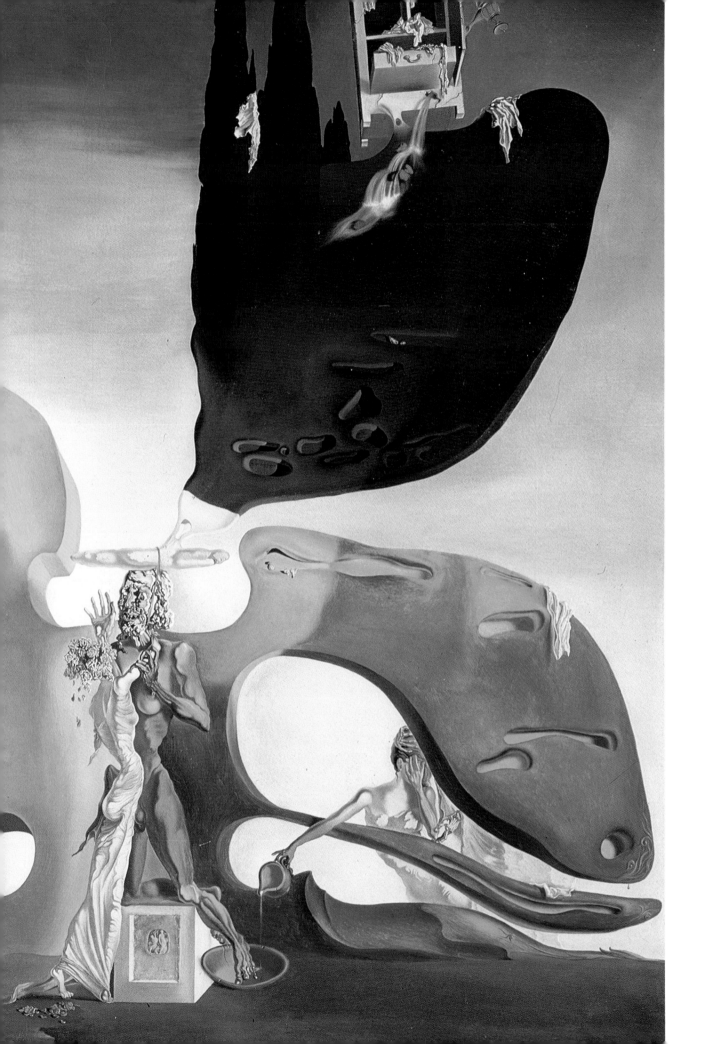

153

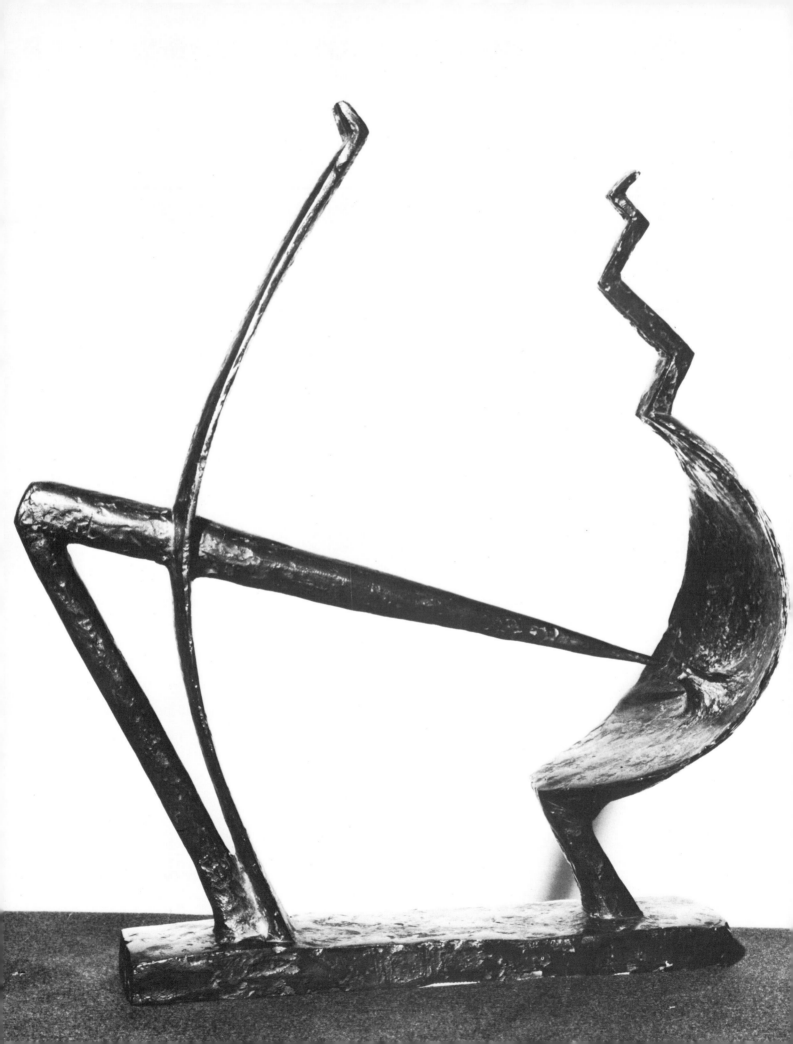

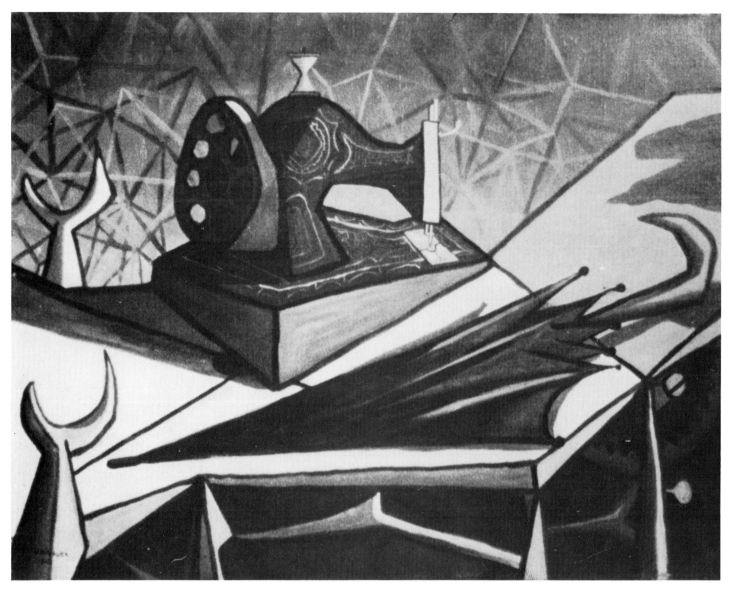

163. (*Above*) Oscar Dominguez, *Umbrella and sewing machine*, 1943. Oil on canvas, 20 × 25½ in (50 × 65 cm). Collection Henriette Gomes.

164. (*Left*) Still from *Wuthering Heights*, directed by Buñuel, 1953.
The Surrealists celebrated Emily Brontë's novel as a supreme example of '*l'amour fou*'. In the final scene of Buñuel's film version, the distraught Heathcliffe, in the act of violating Cathy's tomb, is discovered by Hindley, carrying a shot-gun. But the lover 'sees' Hindley as Cathy robed in a white dress, which could be seen both as a wedding gown or as a shroud.

162. (*Opposite*) Alberto Giacometti, *Man and woman*, c. 1928–29. Bronze, 18 in (45.5 cm) high. Collection Henriette Gomes.

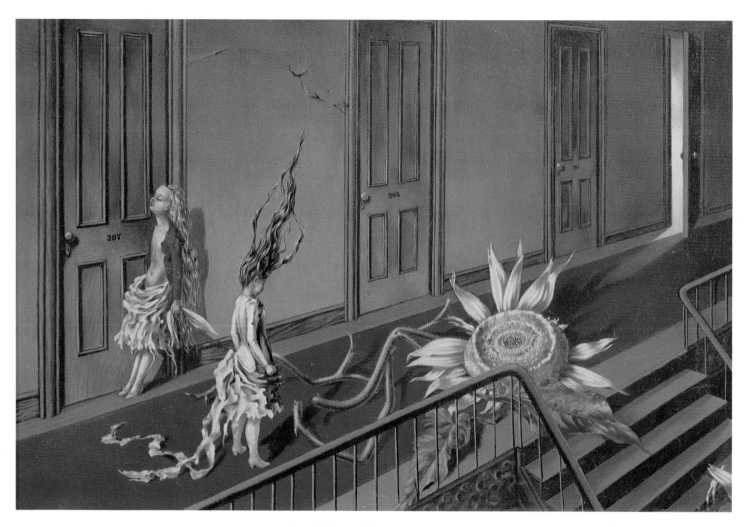

165. (*Above*) Dorothea Tanning, *Eine kleine Nacht Musik*, 1944. Oil on canvas, 16× 24 in (40 × 60 cm). London, Private Collection.

166. (*Opposite*) Dorothea Tanning, *The friends' room*, 1950–52. Oil on canvas, 60 × 42 in (153 × 107 cm). Brussels, Collection Baron and Baroness J. B. Urvater.

myth of the androgyne. In *Arcane XVII*, he proposed that each of us is but one half of a being divided by a curse; and each of us in love is pursuing the lost other half in order to restore the primordial unity.

Surrealism combined two of the principal liberation struggles of this century: that of desire and that of woman. No comparable movement outside specifically feminist organizations has had such a high proportion of active woman participants, as the illustrations in this volume of work by Toyen, Remedios, Valentine Hugo, Leonora Carrington, Dorothea Tanning, Mimi Parent and Meret Oppenheim, to mention only the painters, go a little way to suggest. And no movement since Romanticism has hymned so ecstatically 'she who projects the deepest shadow and the brightest light in our dreams'.[45] The song is the same in the allusive limpidity of Eluard's verse, the incantation of Peret's 'Allo' and Breton's famous 'Free union' in which the loved one's every attribute is named as if the poem were a ritual to accomplish complete sexual possession. In its campaign against the stifling stereotypes of angel and courtesan – Virgin Mary and the Magdalen – to which Christian civilization had confined the image of woman, Surrealism proposed an open-ended range of alternatives such as the 'child-woman',

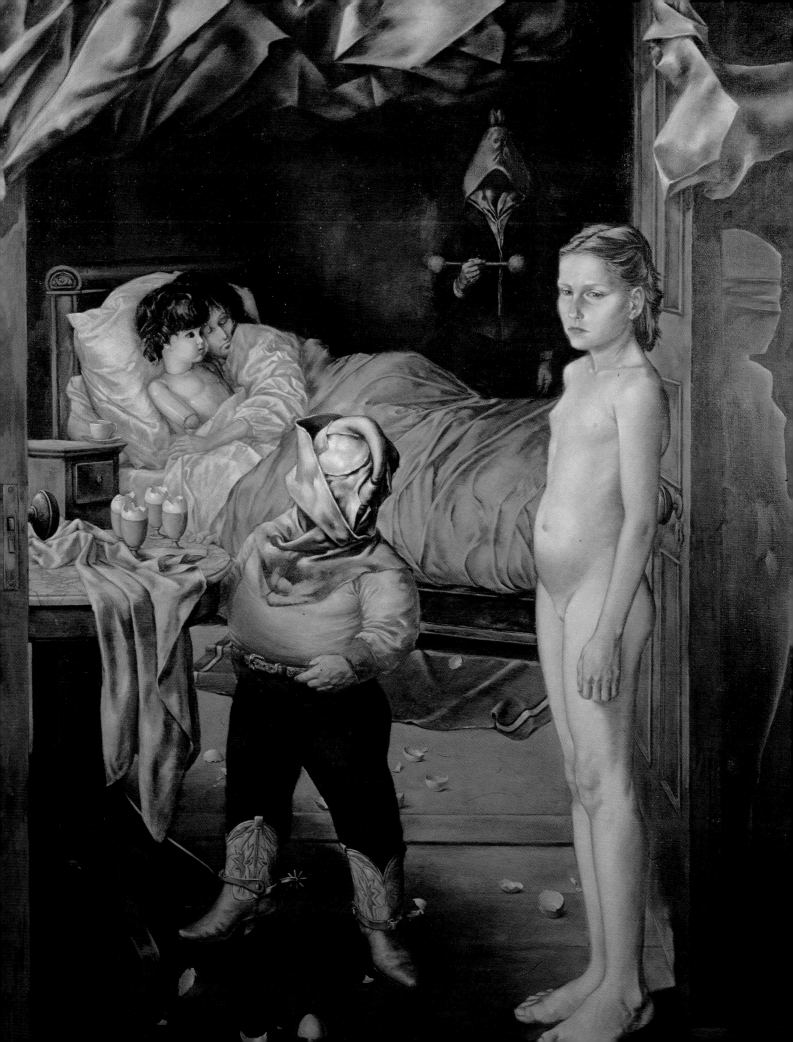

167. (*Above*) Leonora Carrington, *The house opposite*, 1958. Oil on panel, 13 × 32 in (33 × 82 cm). Collection Edward James. The spirit of Bosch, Uccello and the alchemists presides over the gothic fantasies of Leonora Carrington. For some years the companion of Max Ernst, she now lives in Mexico and is the author of remarkable short stories (e.g. *The Oval Lady*, 1939) for which her paintings might be illustrations.

168. (*Right*) Jorge Camacho, *Madam, you are descending into darkness (Portrait of Rosa Keller)*. Oil on canvas. Collection José Pierre.

169. (*Opposite*) Man Ray, *Imaginary portrait of D. A. F. de Sade*, 1940. Oil on canvas, 20 × 16 in (50.8 × 40.5 cm). Private Collection.

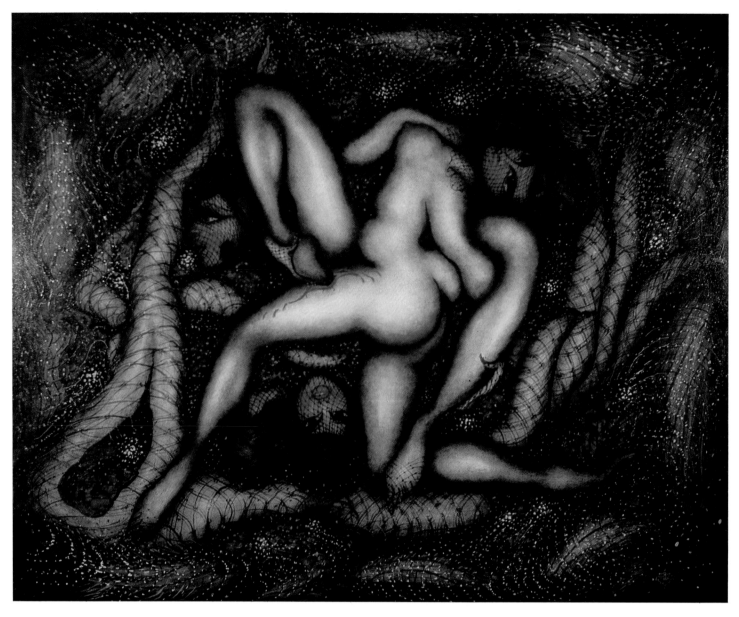

170. Pierre Molinier, *Skin d'Amourdo*, c. 1950. Oil on canvas. Private Collection.

171. (*Opposite*) Jean Benoit, *The Necrophile*, 1965. This life-size figure was inspired by Sergeant Bertrand, the violator of graves.

172. (*Overleaf*) Meret Oppenheim, *Object (fur breakfast)*, 1936. Fur covered cup, saucer and spoon, 3 × 9½ in (7.5 × 23.5 cm). New York, Museum of Modern Art.

'femme-fée' and 'femme sorcière', which vindicate the autonomy and self-will of woman and insist on the reciprocal nature of love.

If one tendency within Surrealism's '*merveilleux sexuel*' aspires to the ideals of courtly love, the other descends into the noxious basements and torture-chambers of the Marquis de Sade. As with the other antimonies which strike the spark of 'convulsive beauty', Surrealist love acknowledges the legitimate pull of both magnetic poles – the zenith of Eros and the nadir of Thanatos. Sade was admitted to the pantheon of ancestors listed in the first *Manifesto*, because he was 'Surrealist in Sadism'. In a century of optimism based on the faith in reason, the lonely figure of Sade had anticipated Romanticism and Freud in illuminating the devious routes taken by desire and in fearlessly exposing the connections between the pleasurable and the forbidden. Above all, the Surrealists revered Sade for his refusal to obey any exterior injunctions, for having maintained a sovereignty over his destiny no matter what the cost. Like Sade, the Surrealists also understood eroticism to be the dynamic behind the most intransigent expressions of human subjectivity: revolt, hysteria, perversion and crime. Unleashed eroticism,

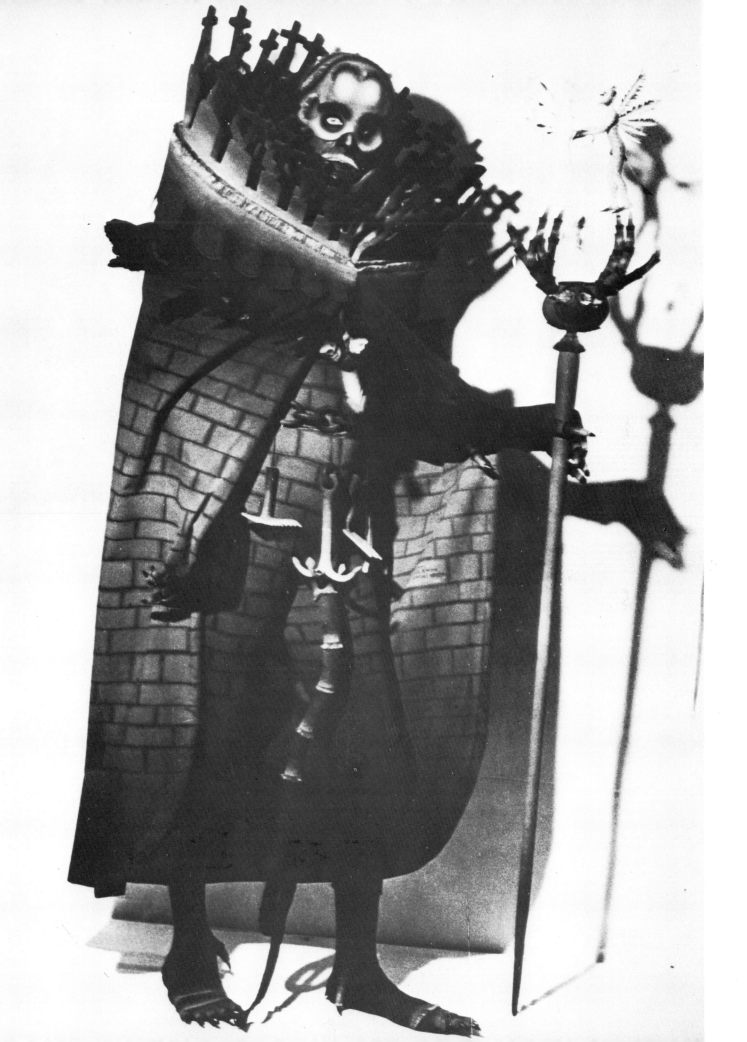

they conceded, might demand excess, blasphemy, subversion, the blood-letting of the sadistic act. Feeding on itself it might lead, ultimately, according to Georges Bataille, to dissolution of the personality and to death.

A significant proportion of Surrealist erotic imagery would be at home within Sade's castle. There is the long series of 'Massacres' and 'Rapes' (plate 58) by André Masson from the thirties, many of which appear to have been drawn with a single line. There are the flagellations and dismemberments of Max Ernst's collage novel *A week of happiness* (plate 89), where the 'cut-up' technique lends itself to the wholesale severing of comely limbs. Numerous objects fetishize the loved one, or, like Oppenheim's *Furry Breakfast* (plate 172), hint at perverse embraces. Surrealist pictorial art from Dali to Camacho abounds with images of fire, blood, fever, torrent and lightning. But it is too simple to dismiss such work as the mere fantasy of frustrated males with overheated imaginations. The truth is more complex. Magritte's *Rape*, for instance, a portrait in which breasts and pubis stand in for eyes and mouth, is as much a rape of the spectator's preconceptions as it is of the female face.

We must not be blinded by the Surrealist 'chamber of horrors' into mistaking the manifest for the latent content of these images. Following

176. (*Above*) Clovis Trouille, *My obsequies*, 1940. Oil on canvas, 32 × 25½ in (81 × 65 cm). A Sunday painter who worked as a make-up artist for advertising models, Trouille deploys an unpretentious imagery whose roots were in fairground art as much as in Freud. His work is just one example of the great body of art and objects which have been 'discovered' by the Surrealists or have acquired an unsuspectedly rich significance since being through the Surrealist lens.

173. (*Opposite above*) Hans Bellmer, *Articulation of globes, the doll*, 1934. Painted wood, glass, material, paper, 18 × 18 × 3 in (45 × 45 × 7 cm). Paris, Collection Charles Ratton.

174. (*Opposite below left*) Hans Bellmer, *The doll*, 1935. Photograph. Paris, Collection F. Petit.

175. (*Opposite below right*) Hans Bellmer, *Iridescent cephalopod*, 1939. Oil on board, 17½ × 19½ in (49 × 44 cm). Paris, Collection F. Petit.

178. (*Opposite*) Konrad Klaphek, *Demi-virgin*, 1972. Oil on canvas, 63½ × 51½ in (160 × 130 cm). Geneva, Galerie Jan Krugier.

Freud, these artists were well aware of the detours taken by the mind during the 'dream-work' and of its fondness for metonymy and synechdoche, for example. If woman appears metamorphosed or distorted, this may be merely the expression of the agitation felt by the artist whose sensibility has been overwhelmed by desire. And woman is not singled out for such treatment by the Surrealists; she shares in overall transmutation of reality which sexualizes things, furniture, architecture, the city street, even, apparently, in the canvases of Matta, for instance, the whole cosmos (plate 114).

This argument may best be tested, perhaps, by looking at the case of the most overtly 'pornographic' of all Surrealist artists, the German Hans Bellmer. In the early thirties, Bellmer constructed a somewhat less than life-size doll which became the inspiration for most of his subsequent erotic researches. By converting the toys of innocent girlhood into all-purpose puppet Lolitas, which could be manipulated, dismantled and reassembled according to the whims of perversity, Bellmer was both transgressing millennial taboos and seeking revenge on the objects of an impossible love. But the *poupée* was much more than the refined expression of sadistic urges. Beyond the provocation and anti-humanism explicit in the violence done to the figure of the loved one, lay a very positive, if desperate, effort to reintegrate mind and body, to possess the loved one more completely than physical love allows. Justifying the 'axis of reversibility' at the navel of the doll which permitted the artist to identify the mouth with the sex or buttocks with breasts, Bellmer replied: 'An object identical to itself is without reality. An object, a feminine foot for instance, is real only if desire does not take it fatally to be a foot'. Bellmer invites us to explore our 'physical unconscious', following the migrations of desire in a 'game without frontiers'. The body is 'comparable to a sentence which incites us to disarticulate it, so that, through an endless series of anagrams, its true contents may be

177. (*Right*) André Masson, *The metamorphosis of Gradiva*, 1939. 38 × 50 in (97 × 130 cm). Knokke, Collection Nellens.
Gradiva is the central figure in a story by the nineteenth-century German writer, Wilhelm Jensen, which was analysed by Sigmund Freud. Gradiva, the obsession of a young archaeologist, is at once a living figure, a statue and a dream image who turns to stone in the larvae of Pompeii. Freud used to liken psychoanalysis to archaeology, with burial as the analogy of repression and excavation as that of enlightenment under therapy. Variations on the Gradiva legend occur frequently in Surrealist work and Breton named after her an art gallery which he ran for a short while in the thirties.

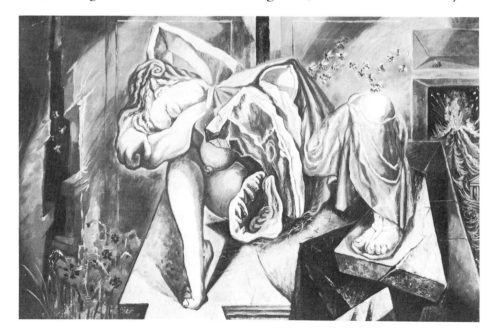

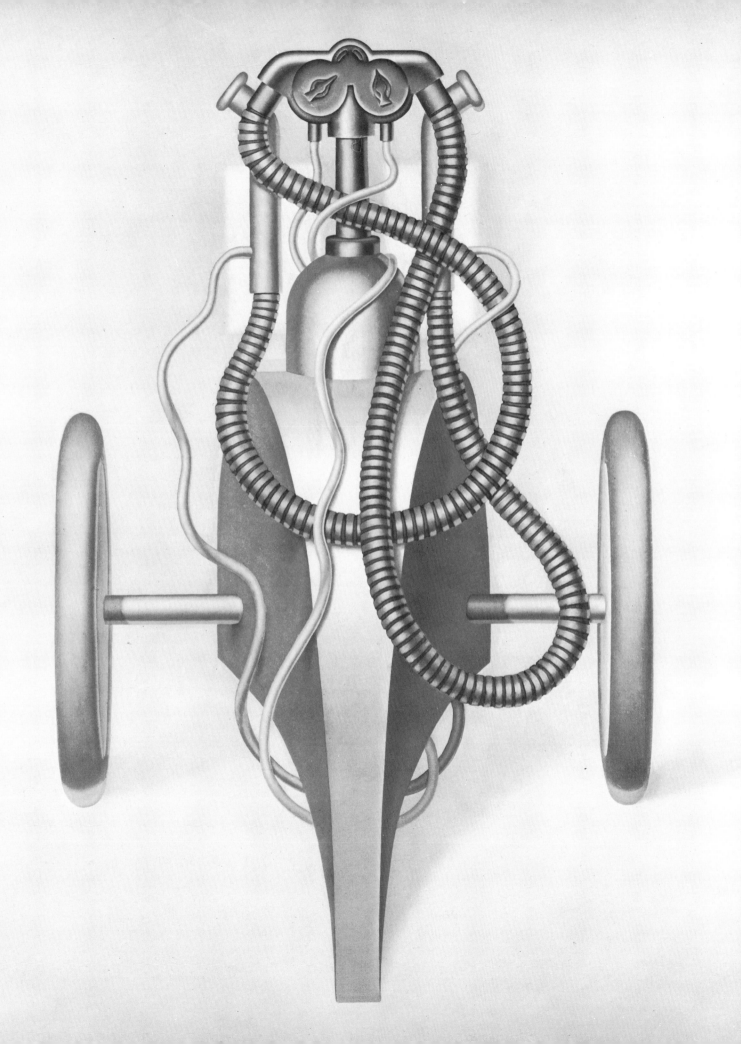

recombined'.[46] Like other Surrealists, Bellmer rejects the concentration of erotic interest on the genital areas alone, convenient though the latter may be for the work ethic since it leaves the rest of the body available as an instrument of labour. He carries the invention of erotic analogies to the point of converting the whole body into an erogenous zone, revealing the multiple correspondences between the physiological and the psychical, rebuilding our unity as creatures of body and spirit, moving also, though by a very different route from Breton, towards the ideal of the androgyne.

Eros pervades Surrealist art, whether in the serene bacchanalia of Miró, the interuterine liquidity of Tanguy or in the suggestion of the imminent approach of the forbidden – incest or homosexuality – in the inscapes of De Chirico. If Surrealists have joyfully unleashed the disruptive energies of the libido, they have also sought to survey this scene of ecstasy and abandon which Dali has called 'the blind lucidity of desire'. Most Surrealist erotic art appeals, not to the senses, as does that of the Impressionists or Expressionists, but to the mind. Following Eluard's early summons: 'We must desensibilize the universe', Surrealist art retreats from pure sensation as surely as it eschews the exterior model. Its preferred subject is therefore the fantasm and the succubus rather than the flesh. If it sometimes seeks like Picabia 'to see love close up', then it also views it with a nostalgic eye which yearns for a lost paradise. The most disturbing dreams acquire a hieratic fixity, for instance, in the paintings of Paul Delvaux. In a mood of cold purity and of emotional detachment, his languid nudes remain inaccessible despite their inviting gestures, and their besuited menfolk pursue their own affairs on a different mental wavelength. The tramways and stations suggest the chance of escape but Delvaux's men and women carry on waiting as if their open prison extends for ever.

If there is a Surrealist pornography – and Aragon's *Le con d'Irène*, Péret's *Les Rouilles encagées*, the collaborative work titled *1929*, Bataille's *Histoire de l'oeil*, Bellmer's illustrations for Sade and Bataille, would be among the works that come to mind – then it overruns the usual limits of the genre. The Surrealists object to literal representations of sexuality for the same reasons as to any other form of naturalism which slavishly copies the surface of reality and does not transpose it through the imagination and the subconscious. Without this continual interaction between mental stimuli and physical impulses, they see sexuality as a poor thing. While fighting prejudice, repressive censorship and their corollary, furtive lubricity, Surrealism is no pansexualism and it opposes the reduction of sex to the instant gratification of lust. The Surrealist looks to his imagination to sensitize, poeticize and amplify the instinctual drives, to discover enhancing equivalents, fetishes and dream-symbols. While acknowledging that at the last, Eros, like Ernst's *Woman with a hundred heads* (plate 88), will 'keep its secret', Surrealism finds no terrain more propitious for permitting consciousness, urged on by imagination, continually to surpass itself.

180. (*Above*) Salvador Dali, *Aphrodisiac waistcoat*, 1936. Partially reconstructed. Paris, Collection Charles Ratton.

179. (*Opposite*) Hans Bellmer, *Drawing for Sade*, 1946. Pencil on paper, 10 × 8 in (25 × 21 cm). Paris, Collection F. Petit.

Footnotes

1. John Richardson, 'The Dada Movement', *Times Literary Supplement*, 23 October 1953, p. 669.
2. Richard Sheppard, *Aspects of European Dada: the limitations of vitalism*, p. 147, unpublished doctoral thesis, University of East Anglia, 1979. To his magisterial scholarship this chapter is greatly indebted.
3. André Breton, 'Géographie Dada', *Littérature*, No. 13, May 1920.
4. Gabrielle Buffet-Picabia, *Aires abstraites*, (Geneva, 1967).
5. André Breton, 'Phare de la Mariée', in *Le surréalisme et la peinture*, (Paris, 1965) p. 94.
6. Francis Picabia, 'French artists spur on American art', *New York Tribune*, 24 October 1915.
7. Hans Arp, *Dadaland*, quoted by Rudolf E. Kuenzli in 'Dada Centers', in *Dada Artifacts* (University of Iowa Museum of Art, 1978).
8. Gabrielle Buffet-Picabia, *Aires abstraites*, (Geneva, 1967) p. 177.
9. Raoul Hausmann, *Courrier Dada*, (Paris, 1958) p. 47.
10. Lucy Lippard, 'Notes on Dada and Surrealism: The Museum of Modern Art', in *Changing*, (New York, 1971) pp. 487–560.
11. For an extended version of this argument see Robert Short, 'Paris Dada and Surrealism', *Journal of European Studies*, ix, 1979, pp. 75–98.
12. Francis Picabia, 'Manifeste Cannibale Dada', *Dadaphone*, No. 7, March 1920.
13. Philippe Soupault, *Le bon apôtre*, (Paris, 1923) pp. 217–218.
14. André Breton and Philippe Soupault, *Les Champs magnétiques*, (Paris, 1967) p. 17 and p. 77.
15. Philippe Soupault, *Profils perdus*, (Paris, 1963) pp. 166–167.
16. Anna Balakian, *André Breton*, (New York, 1971) p. 30.
17. André Breton, 'Il y aura une fois', in *Poésie et autre*, (Paris, 1960) p. 124.
18. André Breton, *Le Surréalisme et la peinture*, (Paris, 1965) p. 64.
19. Max Ernst, 'Au delà de la peinture', *Cahiers d'art*, No. 6–7, 1936, pp. 149–184.
20. Giuseppe Gatt, *Max Ernst*, (London, 1968) p. 9.
21. André Breton, *Le surréalisme et la peinture*, (Paris, 1965) p. 13.
22. Marcel Jean, *History of Surrealist painting*, (London, 1960) p. 49.
23. André Breton, 'Les Chants de Maldoror', in *Les Pas Perdus*, (Paris, 1924) pp. 79–84.
24. André Breton, *Manifestes du surréalisme*, (Paris, 1962) p. 35.
25. André Breton, *L'Amour fou*, (Paris, 1937) p. 11.
26. André Breton, *Manifestes du surréalisme*, (Paris, 1962) p. 40.
27. Christian Zervos, quoted by J. T. Soby, *Joan Miró*, (New York, 1959) p. 66.
28. Joan Miró, quoted in *Surrealists on art*, ed. Lucy Lippard, (New York, 1970) p. 172.
29. André Breton, *Le surréalisme et la peinture*, (Paris, 1965) p. 70.
30. Alberto Giacometti, quoted in *Surrealists on art,* ed. Lucy Lippard, (New York, 1970) p. 144.
31. Yves Tanguy, quoted in J. T. Soby, *Yves Tanguy*, (New York, 1953) p. 17.
32. Salvador Dali, *The Conquest of the Irrational*, quoted by William S. Rubin, *Dada and Surrealist Art*, (London, 1969) p. 218.
33. Salvador Dali, 'The stinking ass', *Le Surréalisme au service de la révolution*, No. 1, July 1930, p. 9.
34. André Breton, *Le surréalisme et la peinture*, (Paris, 1965) p. 72.
35. André Breton, *Nadja*, (Paris, 1963) p. 154.
36. André Breton, *La Clé des champs*, (Paris, 1953), p. 115.
37. René Passeron, *Encyclopedia of Surrealism*, (London, 1975) p. 261.
38. Michel Carrouges, 'Le Hasard objectif' in *Le Surréalisme*, ed. Ferdinand Alquié, (The Hague, 1968) p. 272.
39. Marcel Jean, *History of Surrealist Painting*, (London, 1960) p. 47.
40. André Breton, *L'Amour fou*, (Paris, 1937) p. 49.
41. Paul Eluard, *Donner à voir*, (Paris, 1939) p. 165.
42. For an extended version of this argument, see my book *Surrealism: Permanent Revelation*, (London, 1970), co-authored by Roger Cardinal.
43. André Breton, *L'Amour fou*, (Paris, 1937) p. 50.
44. André Breton, 'Poisson soluble' in *Les Manifestes du surréalisme*, (Paris, 1962).
45. Charles Baudelaire, quoted in *La Révolution surréaliste*, No. 1, December 1924, p. 17.
46. Hans Bellmer, *L'Anatomie de l'image*, (Paris, 1957).

Bibliography

Sarane Alexandrian, *Surrealist Art*. London, Thames and Hudson, 1970.

Ferdinand Alquié, *Philosophy of Surrealism*. Ann Arbor, 1965.

Louis Aragon, *Paris Peasant* (trans. Simon Watson Taylor). London, Jonathan Cape, 1971.

Robert Benayoun, *Erotique du surréalisme*. Paris, J.-J. Pauvert, 1965.

André Breton, *Manifestos of Surrealism* (trans. Richard Seaver & Helen R. Lane). Ann Arbor, 1969.

André Breton, *Nadja* (trans. Richard Howard). New York, Grove Press, 1960.

André Breton, *Surrealism and Painting* (trans. Simon Watson Taylor). London, Macdonald, 1972.

Roger Cardinal & Robert Short, *Surrealism: Permanent Revelation*. London, Studio Vista, 1970.

Salvador Dali, *The Secret Life of Salvador Dali*. London, Vision Press, 1961.

Herbert S. Gershman, *The Surrealist Revolution in France*. Ann Arbor, 1969.

Manuel L. Grossman, *Dada*. New York, Pegasus, 1971.

Paul Hammond ed., *The Shadow and its shadow: Surrealist writings on the cinema*. London, British Film Institute, 1978.

Marcel Jean, *History of Surrealist Painting*. London, Weidenfeld and Nicolson, 1959.

Lucy Lippard ed., *Dadas on Art*. New Jersey, Spectrum, 1971.

Lucy Lippard ed., *Surrealists on Art*. New Jersey, Spectrum, 1970.

J. H. Matthews, *The Imagery of Surrealism*. Syracuse University Press, 1977.

J. H. Matthews ed., *An Anthology of French Surrealist Poetry*. London, University of London Press, 1966.

Robert Motherwell ed., *The Dada painters and poets: an Anthology*. New York, Wittenborn, Schulz Inc., 1951.

Maurice Nadeau, *History of Surrealism*. London, Jonathan Cape, 1968.

Hans Richter, *Dada: Art and anti-art*. London, Thames and Hudson, 1965.

William S. Rubin, *Dada and Surrealist Art*. London, Thames and Hudson, 1969.

Richard Sheppard ed., *Dada*.

Tristan Tzara, *Approximate Man and other writings* (trans. Mary Ann Caws). Detroit, Wayne State University Press, 1973.

Patrick Waldberg, *Surrealism*. London, Thames and Hudson, 1965.

Acknowledgements and List of Illustrations

The author and John Calmann & Cooper Limited would like to thank the museums, galleries and collectors who allowed works from their collections to be reproduced in this book. They would also like to thank the photographers and photographic libraries who provided photographs.

1. Max Ernst, *Of this men shall now nothing,* Tate Gallery, London
2. George Grosz, *Life Model,* Fischer Fine Art Ltd., London
3. Max Ernst, *Dada Siegt,* Collection of Arthur and Elaine Cohen, New York
4. Francis Picabia, *Machine without a name,* Carnegie Institute, Pittsburgh Museum of Art
5. Jean Crotti, *Mechanical Twilight,* Collection Guido Rossi, Milan
6. Raoul Hausmann, *Tatlin at home,* Moderna Museet, Stockholm. Photo Giraudon
7. Francis Picabia, *That's the girl born without a mother,* Private Collection
8. Man Ray, *The rope dancer accompanies herself with her shadows,* Museum of Modern Art (Gift of G. David Thompson), New York
9. Marcel Duchamp, *Trap,* Xavier Fourcade Inc., New York
10. Raoul Hausmann, *Dada cino,* Collection Philippe-Guy E. Woog
11. Jean Arp, *Earth Forms,* Private Collection
12. Kurt Schwitters, *MZ.439,* Marlborough Fine Art (London) Ltd., London
13. Paul Citroen, *Metropolis,* Printroom of the University of Leiden, Holland
14. Raoul Hausmann, *The spirit of our time,* Musée National d'Art Moderne, Paris
15. Sophie Taeuber-Arp, *Dada head, portrait of Jean Arp,* Private Collection
16. Hans Richter, *Portrait of Baader,* Collection Guido Rossi, Milan
17. George Grosz, *In the street,* Galerie Claude Bernard, Paris
18. Marcel Janco, *Project for a Dada poster in the Cabaret Voltaire,* Private Collection, Milan
19. Francis Picabia, *Here, this is Stieglitz,* Metropolitan Museum (Alfred Stieglitz Collection), New York
20. Man Ray, *The rope dancer accompanies herself with her shadows,* Collection Mr and Mrs Morton Neumann, Chicago
21. Francis Picabia, *City of New York seen across the body,* Galerie Jan Krugier, Geneva
22. Marcel Duchamp, *Fountain,* Sidney Janis Gallery, New York
23. Marcel Duchamp, *Why not sneeze Rrose Sélavy,* Private Collection, Paris
24. Man Ray, *The breeding ground of dust,* Private Collection, Paris
25. Marcel Duchamp, *Chocolate Grinder,* Philadelphia Museum of Art (Louise and Walter Arensburg Collection), Philadelphia
26. Man Ray, *Coat-stand,* Private Collection, Paris
27. Marcel Duchamp, *The large glass (The bride stripped bare by her bachelors even),* Collection Jean-Jacques Lebel, Paris
28. Johannes Baader, *Letztes Manifest,* Private Collection
29. Christian Schad, *Untitled,* Collection Guido Rossi, Milan
30. Jean Arp, *Collage with squares arranged according to the laws of chance,* Museum of Modern Art (Gift of Philip Johnson), New York
31. Jean Arp, *Oiseau hippique,* Private Collection, Basle
32. Hans Richter, *Visionary portrait,* Musée National d'Art Moderne, Paris
33. Hans Richter, *Portrait of Hugo Ball,* Private Collection, Milan
34. *Jedermann sein eigner Fussball,* British Library, London
35. Raoul Hausmann, *Phonetic poem poster,* Musée National d'Art Moderne, Paris
36. Hannah Höch, *Da-dandy,* Private Collection
37. John Heartfield, *Self-portrait,* Private Collection, Milan
38. Hannah Höch, *Vagabond,* Collection Guido Rossi, Milan
39. John Heartfield, *Hurrah, the butter is finished,* Akademie der Kunst der DDR, Berlin
40. George Grosz, *Remember Uncle August the unhappy inventor,* Musée National d'Art Moderne, Paris
41. George Grosz, *The face of the ruling class,* Kupferstichkabinett, Staatliche Museen Preussischer Kulturbesitz, Berlin
42. Kurt Schwitters, *Funny animal,* Marlborough Fine Art (London) Ltd., London
43. Johannes Baargeld, *Fördebär,* Collection Guido Rossi, Milan
44. Max Ernst, *Katherina Ondulata,* Private Collection
45. Max Ernst, *The Sandworm,* Private Collection
46. Max Ernst, *Etching dedicated to Angelica and Heinz Hoerle,* Collection Ernst O. E. Fischer, Krefeld
47. Kurt Schwitters, *Mirror Collage,* Private Collection
48. Max Ernst, *Massacre of the innocents,* Private Collection, Chicago
49. Man Ray, *Indestructible object,* Private Collection
50. Francis Picabia, *Dada portrait,* Musée National d'Art Moderne, Paris. Photo Giraudon
51. Giorgio De Chirico, *Portrait of Guillaume Apollinaire,* Musée National d'Art Moderne, Paris
52. Francis Picabia, The cover of *391,* Collection of Arthur and Elaine Cohen, New York
53. Giorgio De Chirico, *Gare Montparnasse,* Museum of Modern Art (Gift of James Thrall Soby), New York
54. Giorgio De Chirico, *Metaphysical interior,* Von der Heydt Museum, Wuppertal. Photo Giraudon
55. Georges Ribemont-Dessaignes, *God on a bicycle,* Private Collection, Milan
56. Pablo Picasso, *Assemblage,* Tate Gallery, London
57. Robert Desnos, *Untitled automatic watercolour,* Collection Alain Brieux, Paris
58. André Masson, *Enlèvement,* Musée National d'Art Moderne, Paris. Photo Giraudon
59. Max Ernst, *Pièta ou la Révolution la nuit,* Private Collection. Photo Giraudon
60. Max Klinger, *Die Entführung,* Staatliche Graphische Sammlung, Munich
61. Arcimboldo, *Water,* Collection Jean-Jacques Lebel, Paris
62. Male figure from the Ramu Delta in New Guinea, British Museum, London
63. Henri Rousseau, *L'Octroi,* Courtauld Institute Galleries, London
64. Jean Scutenaire, *From Marat to the Bonnot Gang – the Surrealist Pantheon*
65. André Masson, *Automatic drawing,* Collection Rose and André Masson
66. Gustave Moreau, *Salome dancing,* Musée Gustave Moreau, Paris. Photo Bulloz
67. André Breton, *Self-portrait: automatic writing,* Private Collection, Milan
68. Germaine Berton surrounded by portraits of the Surrealist group in 1924
69. Max Ernst, *Surrealism and Painting,* William N. Copley Collection, New York
70. Max Ernst, *Lesson in automatic writing,* Galerie A. F. Petit, Paris
71. Max Ernst, *The voice of God the Father,* Collection Rosamund Bernier, New York
72. Max Ernst, *The elephant Célèbes,* Tate Gallery, London
73. Max Ernst, *Saint Cecilia,* Staatsgalerie, Stuttgart
74. Giorgio De Chirico, *The poet and the philosopher,* Private Collection
75. Giorgio De Chirico, *Two Heads,* Private Collection. Photo Cooper-Bridgeman
76. Max Ernst, *At the Rendez-vous of friends,* Collection Dr Lydia Ban, Hamburg
77. Max Ernst, *The forest,* Galerie Isy Brachot, Brussels
78. Georges Hugnet, *Photocollage,* Collection Jean Armbruster, Paris
79. Wolfgang Paalen, *Land of Medusa,* Galerie Lefebvre-Foinet, Paris
80. Yves Tanguy, *Shadow country,* Detroit Institute of Art (Gift of Mrs Lydia Winston Malbin), Detroit
81. Jindrich Styrsky, *The Statue of Liberty,* Collection Jean-Jacques Lebel, Paris
82. Mimi Parent, *The age of reason,* Collection of the artist
83. Joan Miró, *Harlequin's carnival,* Albright-Knox Art Gallery (Room of Contemporary Art Fund), Buffalo
84. Paul Eluard, *To each his own anger,* Private Collection
85. Robert Desnos, *The death of Morise,* Private Collection, Paris
86. Yves Tanguy, *This morning,* Collection Selma and Nesuhi Ertegun, New York
87. Yves Tanguy, *Through birds, through fire, but not through glass,* Minneapolis Institute of Art (given in tribute to Richard S. Davis by Mr and Mrs Donald Winston), Minneapolis
88. Max Ernst, *The woman with an hundred heads opens her august sleeve,* Collection D. and J. de Menil
89. Max Ernst, *A week of happiness*
90. Joan Miró, *The cry,* Private Collection
91. Jacques Prévert, *Puss in boots,* Private Collection, Milan
92. Max Ernst, *She keeps her secret,* Private Collection. Photo Eileen Tweedy
93. Max Ernst, *A flanc d'abime,* Private Collection
94. Max Ernst, *The horde,* Stedelijk Museum, Amsterdam
95. Max Ernst, *Jardin Gobe-avions,* Private Collection, Switzerland
96. Oscar Dominguez, *Untitled,* Museum of Modern Art, New York
97. Georges Hugnet, *Untitled decalcomania and collage,* Collection Jean Ambruster, Paris
98. André Masson, *Massacre,* Private Collection, Paris
99. Joan Miró, *Photo, Ceci est la couleur de mes rêves,* Private Collection
100. Alberto Giacometti, *The palace at 4 a.m.,* Kunstmuseum, Basle
101. Man Ray, *Erotic-veiled,* Private Collection
102. Salvador Dali, *The phenomenon of ecstasy*
103. Salvador Dali, *The roses bleed,* Collection J. Bourjou, Brussels
104. Salvador Dali, *Drawing for 'Nuits partagés' by Paul Eluard*

174

Index